Choosing Fatherhood

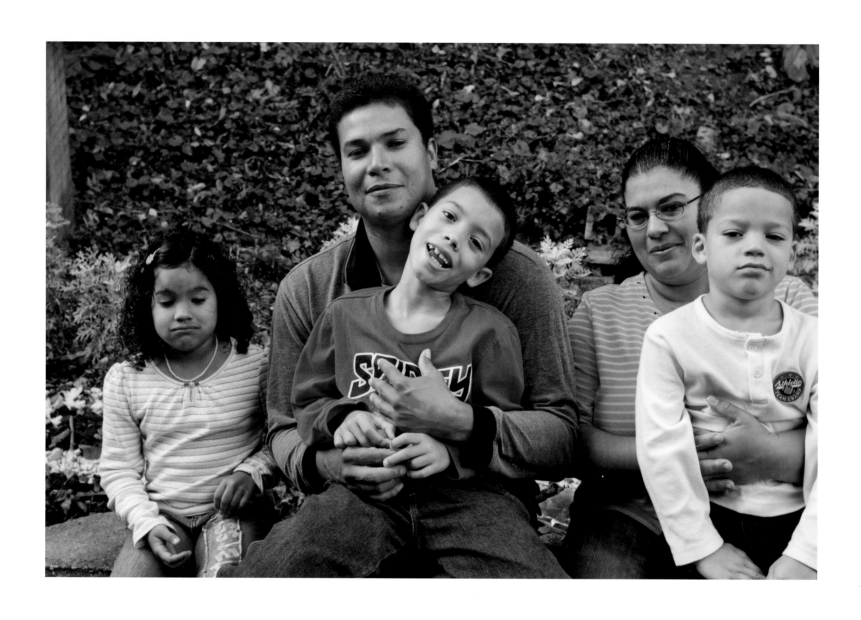

JOSE RIVERA, HIS WIFE, AND CHILDREN, PITTSBURGH, PENNSYLVANIA.

Choosing Fatherhood

America's Second Chance

PHOTOGRAPHS AND STORIES
BY LEWIS KOSTINER

with an introduction by Juan Williams
and essays by David Travis, Shipra S. Parikh,
Roland C. Warren, and Derrick M. Bryan

George F. Thompson Publishing
in association with National Fatherhood Initiative

To Annie, who guides and inspires me with her love and insights.

To Rickie and Tess, for giving me a greater purpose in life.

• Contents

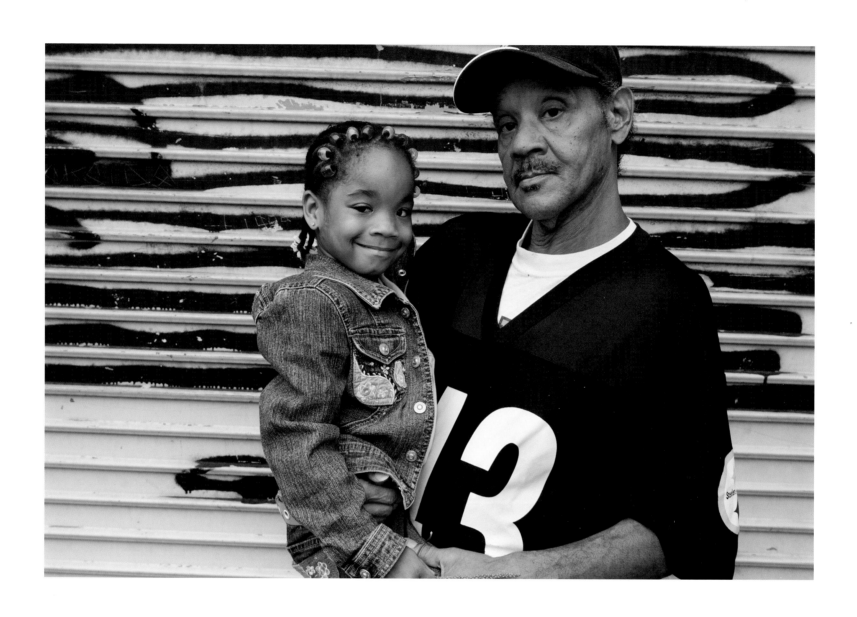

KEVIN WASHINGTON AND DAUGHTER, INDIA, PITTSBURGH, PENNSYLVANIA.

• Preface: The Beginning

by Lewis Kostiner

IN THE SPRING OF 2007, Annie, my wife, suggested that we attend a fundraiser luncheon for a local fatherhood organization in Chicago, our hometown. I knew then that this event would have a deeper meaning, since Annie wanted to go. Little did I know how deep.

As lunch progressed and the speakers made their cases, the facts left me deeply disturbed: in my country, the United States of America, more than 24,000,000 children are living in homes with no fathers present to help raise the kids. I had known there was a high degree of dysfunctional behavior in American families, but to this extent was a shock. How does one explain that one out of every three American children live without their dads?

During the fundraiser, I sat with Roland Warren, President of National Fatherhood Initiative (NFI), which brings dads back into the lives of their children by supporting local organizations, such as the one hosting the luncheon. As we talked about the enormity of the problem, I realized I wanted to help NFI, but I was unsure how. The usual manner—just giving money—felt too easy and disconnected. I wanted to assist in a more vibrant way.

The next time that Roland and I met, I told him that, like many of the fathers whom NFI assists, I, too, am a product of a home with a missing father. My dad essentially left the house when I was just three. Although I saw him on weekends and during summers, my childhood was often void of his presence. Somehow I felt that helping NFI might, in turn, help me face my hidden and denied feelings about my dad.

Rather than offer a financial contribution to NFI, I proposed what I thought would be a much stronger, more significant, and lasting commitment: I asked Roland if I could travel to where community-based programs were using NFI's

resources, meet with some of the fathers and children, and photograph them in their homes, schools, and other surroundings. If all went well, we could produce a meaningful piece of work combining images, guest essays about the state of fatherhood, and interviews of the actual fathers whom NFI educated. He gave it some thought and said yes.

I traveled to Pittsburgh to begin my work. There I met Milt Scott, NFI's senior program specialist. For the next three years, Milt would meet me in all the cities we worked in. During our three- or four-day shoots; I photographed while Milt painstakingly arranged and collected the interviews that he and colleagues Carnelle Batiste and Lisa Tate conducted.

I have always loved Leica cameras and had just purchased two new Leica M8 digital bodies that were compatible with my very old Leica lenses. In anticipation of that first field trip to Pittsburgh, I thought that this simple, old-looking, and very quiet camera, with no extra equipment and flash, would put my subjects at ease. It did, as did other strategies Milt and I used. When I returned home, with the help of Matt Kosterman at Deltaquest Imaging in Chicago, I posted on my Website a selection of images that I liked a week or so after every shoot. My Website allowed the families with whom I had worked to see what I had done, and it showed future families what to expect. Milt kept all of our current and future subjects informed of how we would work and what they could anticipate. This also created an aura of trust.

My travels normally occurred over a long weekend and involved anywhere from eight to twelve fathers, most with their kids and some with mothers or girlfriends, grandmothers or step-parents. I wanted to get right to work, so I quickly took control of the shoots and spent two to three hours with each family. Milt and

his colleagues conducted the interviews in their homes after the shoots, and most of the questions were similarly structured. For example, each father was asked about his relationship with his dad. Sooner or later, all but a few reached the same conclusion: their own young lives had either lacked a fatherly structure or their dad was incapable of showing love or both, and these were the main reasons they were led astray in their parenting responsibilities. This was also why they wanted to be different, and "just being there" for their kids was a common aspiration. It all made sense to me.

After I completed a few trips, I met George F. Thompson, my editor and publisher, and told him of my desire to do this book. He was very receptive but added a caveat: what I had done looked promising, but, to create a book of lasting value, I would need to cover a vast cross-section of the United States to show how the project's issues concerned every region of the country. And so he proceeded to draw a map of the United States on a standard sheet of paper that I still possess, located the places I had visited, and then suggested other states and places throughout the U.S. I might visit. With this map in hand, I set out like an explorer with a mission and ended up photographing more than 150 fathers in some thirty-nine cities and towns in seventeen states, coast to coast.

While I was working, I cut the fathers no slack. I understand what it is like to be a child left by his father, and, with help from Annie and our two daughters, Rickie and Tess, I understand what it means to be a dad. It is not easy to extend praise to men who are doing what they should be doing, but I took into account the adverse socio-economic circumstances that many (not all) had been born into.

Each field trip introduced me to innocent children who were not judging but seemed to understand their dad's circumstances. In Des Moines, there was the

four-year-old boy whose father, Jose, had just been released from prison after an arrest for a murder he did not commit. That man carried his son on his shoulders the whole time we were together. The little boy cried when his father had to leave for another meeting after our shoot. At the U.S. Army base in Fort Riley, Kansas, there was the young boy who dressed in uniform to have his picture taken beside his soldier father. I saw little boys dress up as football players to hang out with their dad and others cling to their father for the entire two or three hours I photographed them. Again and again, I saw how important it was for these men just to *be* with their children.

As the trips continued, the mission of NFI became even more clear to me, and I saw its work as essential. I am not alone. Recently, the Brookings Institute declared that the state of fatherhood in the United States is among the most serious problems confronting the nation: equal to or greater than the economy, education, the environment, health care, infrastructure, poverty, you name it.

My travels around the nation with my camera took me deep into this new realm of social awareness and responsibility: the need to help fathers reunite with their children. And I am here to say that I met fine men all across our country who showed me what circumstances can be overcome and what good can be accomplished with determination and help from NFI's programs. I saw the pride in the eyes of Robert Mirabal, the famous flute player and flute maker, at home with his daughters on the Taos Pueblo. I vividly remember the seventy-year-old Kevin Washington of Pittsburgh, who fought for three years in court to wrestle his daughter away from her often-missing mother. I extolled upon the virtues of these men and so many others when Annie would meet me at Chicago's Midway Airport after each weekend trip, 1,000 raw files later. I confided in her that I hoped I am as good a father as some of the dads I got to meet.

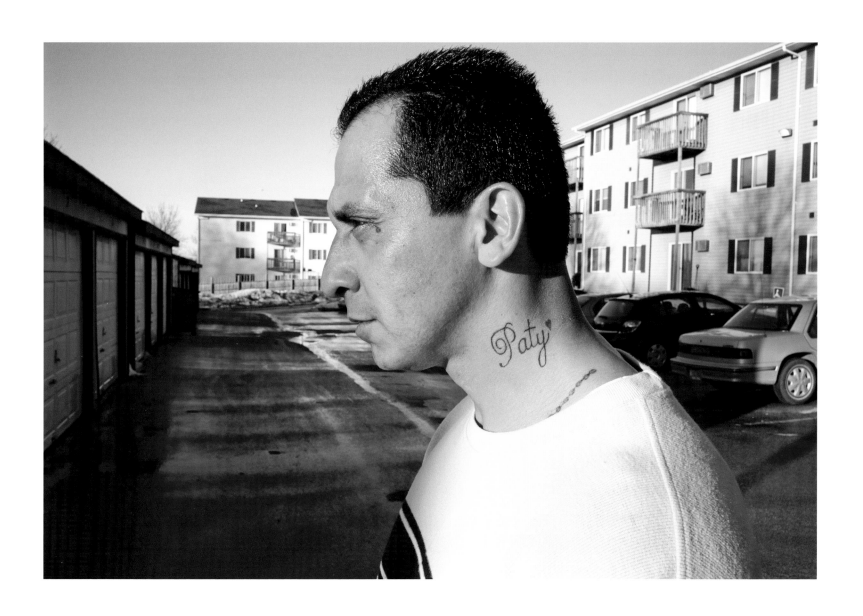

JOSE OCHOA, SR., DES MOINES, IOWA.

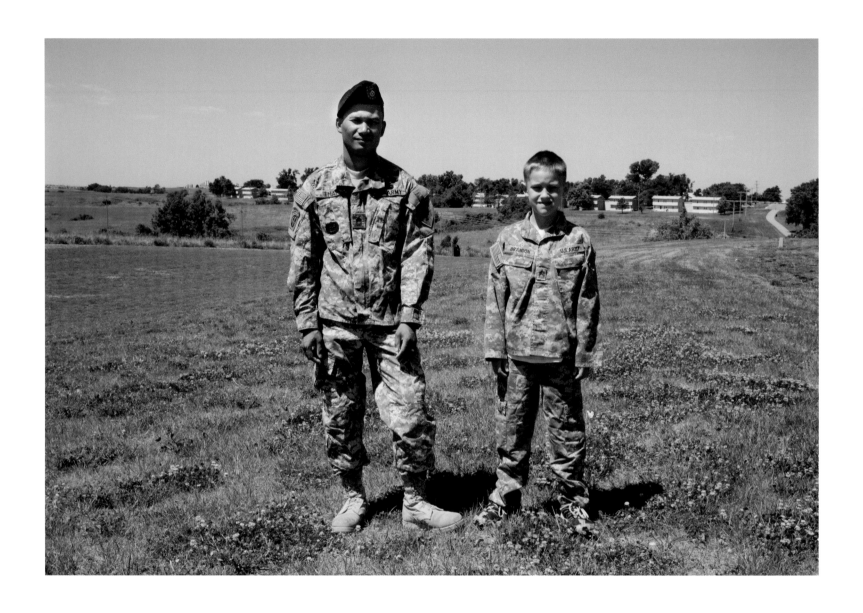

BUNTHY THAP AND SON, MANHATTAN, KANSAS.

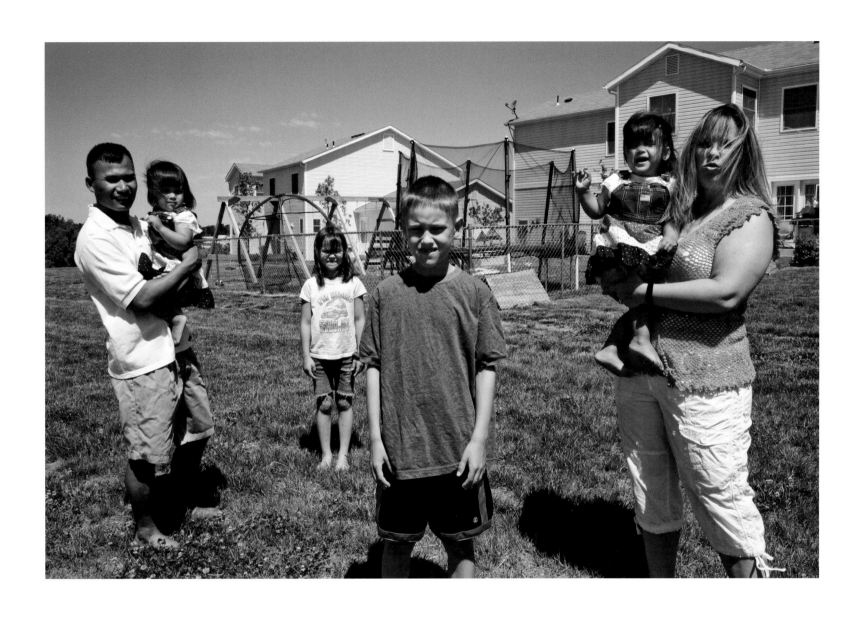

BUNTHY THAP AND FAMILY, MANHATTAN, KANSAS.

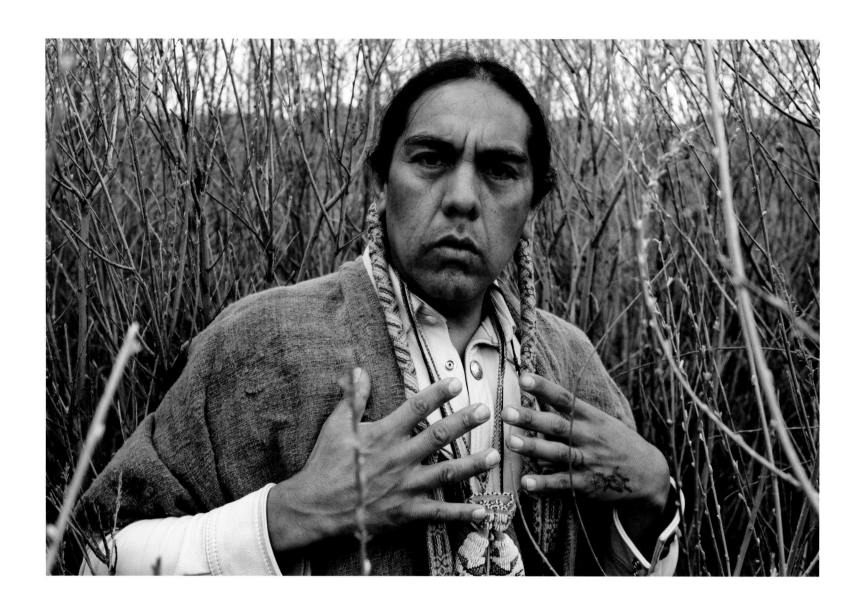

ROBERT MIRABAL, TAOS PUEBLO, NEW MEXICO.

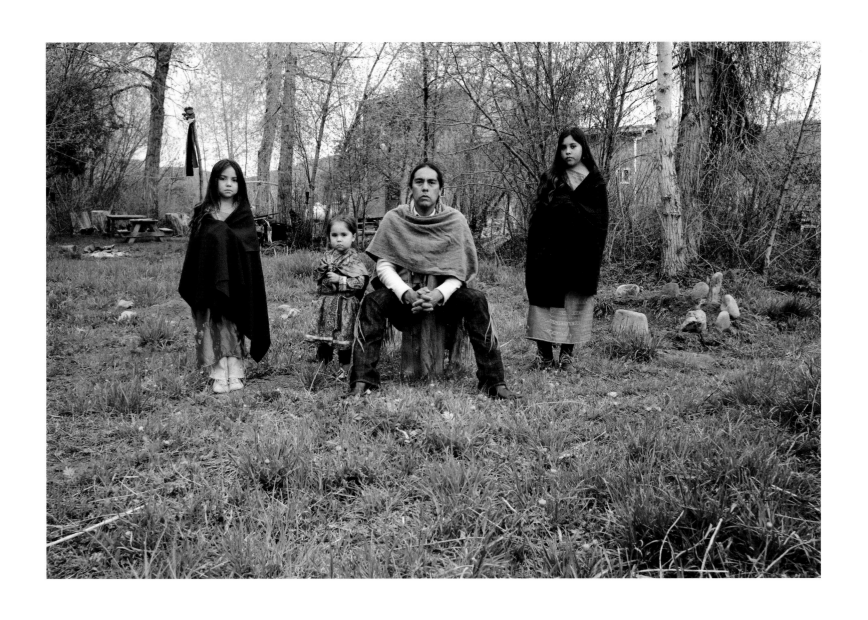

ROBERT MIRABAL AND DAUGHTERS, TAOS PUEBLO, NEW MEXICO.

CHAD HEBDON AND DAUGHTERS, PRESTON, IDAHO.

They helped me to realize that we all need to have a father figure in our lives. After all, how can we function as a complete and viable society if so many millions of our children are raised in families without fathers and committed parents? The answer is obvious: we cannot, and those who think we can are either in denial or irrational. The solution is obvious, too. We have to find a way to join or rejoin these dads with their children in any way possible and to overcome current misunderstandings about what it means to be a father and a parent. This nation can no longer afford a casual approach to the father-child relationship.

In the end, my travels to see these men brought me back to my own father by making me confront my own demons about the dad who left me. I was naturally close to my stepfather, but, after he passed away, I realized that I needed my birth father to reenter fully in my life again. In the end, happily, I was eventually blessed to have two dads, though my birth father needed a bit of coaxing to become involved.

I will always remember the luncheon that Annie took me to in 2007, which gave me the opportunity to meet Roland Warren and to hear about the amazing work of NFI. Annie knew what I needed. Throughout the course of my journey, I learned that the primal love between a father and his child never dies. It may pass through a liminal phase of hard times, but this is not a precursor to a lost relationship. My hope is that this book, with its photographs and text, will help to create a collective perspective, one that touches all aspects of the relationships between "lost and found" dads and their forgiving children.

HENRY, SON OF HENRY STROTHERS, SR., PITTSBURGH, PENNSYLVANIA.

• Introduction: The Missing Link

by Juan Williams

OPEN YOUR EYES. Open your arms. Embrace these family pictures! They capture the joys and complexities of fatherhood.

Here are images that stand as a compelling alternative to this generation's commonplace picture of children without fathers. As the father of two black boys, it drives me crazy to see some of the images of fathers on television, in the movies, and in much of our literature. When my sons turn on the television, they generally see a distorted picture of fatherhood, especially among minorities. Fathers of all races are often portrayed as dull-witted characters; think of Homer on *The Simpsons* or Al Bundy on *Married with Children*. Images of black men, including black fathers, overwhelmingly focus on them as totally absent or oversexed, under arrest, utterly profane, or, alternately, raging and boastful athletes.

America's children, my sons included, rarely see images of black men as loving fathers or as intellectuals who spend their time with families and cherish the role of the caring dad. The images of black and Hispanic men in these photographs by Lewis Kostiner are different from any you have ever seen before through popular media. They depict real fathers. They stand out particularly at this time because they put fathers back into the picture and make it clear what's missing in too many families and communities: the presence of loving fathers.

No man is born a father. A male child is born a son and, perhaps, a brother. When that male becomes a father, he undergoes a stunning, sometimes terrifying, shift in self-image. Suddenly, he is responsible for the financial and emotional well-being of a child and, one hopes, a family.

We know now that the consequences of absentee fathers are far-reaching in minority communities. Fatherlessness can be tied directly to high poverty rates; today, about twenty-five percent of all blacks and Hispanics in the United States of America live in poverty due to the high numbers of fatherless children. But the impact of fatherlessness doesn't stop with that statistic.

Fatherless children currently are nine times more likely to drop out of school and twenty times more likely to end up in prison. They are also more likely, though we cannot measure this exactly, to have more emotional and behavioral problems and to be unprepared to succeed both in school and in the job market. This is particularly true in minority communities, where fifty-three percent of all Hispanic babies and seventy-three percent of all black babies are born to single mothers, compared to twenty-nine percent of white babies.

This is a national crisis, but it is more than that. In the daily life of any child, the absence of a father is sometimes a life-shattering tragedy; it creates a massive emotional hole. As fatherless children try to find their way in the world, they inevitably act out their feelings of abandonment and resentment. Yet, when people speak out about the obvious importance of fatherhood, it often sparks controversy. It is as if even mentioning absentee fathers touches a nerve and makes people defensive.

In 2008, for example, then-Senator Barack Obama, in the midst of his campaign for President, told Chicago's Apostolic Church of God that, ". . . if we're honest with ourselves, we'll admit that too many fathers are . . . missing . . . from too many lives and too many homes. They have abandoned their responsibilities; they're acting like boys instead of men. And the foundations of our families have suffered because of it." Mr. Obama added that men need to realize that "what makes

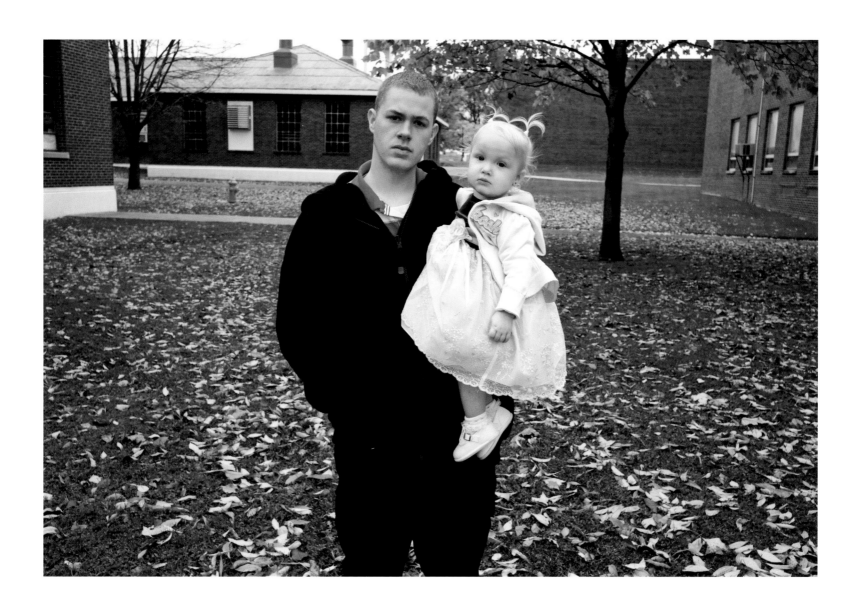

RIKI EATON AND DAUGHTER, ALEXIS, PLAINFIELD, INDIANA.

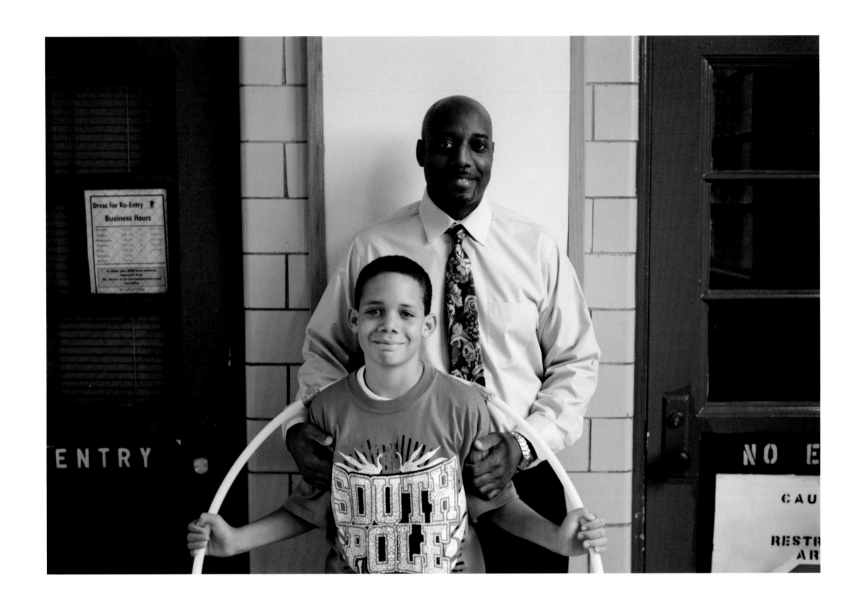

DAVID MARTIN AND SON, JADON, PLAINFIELD, INDIANA.

you a man is not the ability to have a child—any fool can have a child, that doesn't make you a father—it's the courage to raise the child that makes you a father."[1]

After Mr. Obama made those prophetic statements, however, Reverend Jesse Jackson accused the then-candidate of "talking down to black people." Jackson went even further, saying he wanted to castrate Obama for making such comments. Jackson subsequently suggested that, if Obama was going to talk about the need for personal and moral responsibility among black males, he needed to talk more about the "collective moral responsibility of government and the public policy which would be a corrective action for the lack of good choices that often led to their irresponsibility."[2]

Essentially, Rev. Jackson rationalized the epidemic of absent fathers in the black community by arguing that high levels of unemployment can make it difficult for men to be responsible dads, even if they understand the importance of fatherhood. Interestingly, for his first Father's Day address as President, Barack Obama wrote about how his father's departure, when he was only two years old, had a profound impact on him. The President related that his experience taught him ". . . the hole a man leaves when he abandons his responsibility to his children is one that no government can fill. We can do everything possible to provide good jobs and good schools and safe streets for our kids, but it will never be enough to fully make up the difference."[3]

The President's words should end any debate. There is no reply to the hard truth: no government can hold a child's hand or read to a child at bedtime, and no child will ever call a government "Daddy." And, regardless of a man's job status or the struggles inherent in every romantic relationship, a child ideally needs two parents.

In this amazing book, we see photographs of fathers in relation to their children. The power of these images goes beyond the statistics that tell us about the importance of families and the tragedy of their breakdown. The joy or feeling of pride or even look of concern on a dad's face, the admiration and affection in a child's eyes, and the inherent magic to be found in the relationship between a father and child are the result of a man taking personal responsibility for his love and actions. But that serious-sounding phrase "taking personal responsibility" doesn't convey what a man gets in return for such an endeavor. It does not capture the pleasure that a man gets from knowing that he is helping to build a legacy—from knowing that *he* is guiding and positioning his sons and daughters to be loving, involved parents.

I recently became a grandfather to Elias, Pepper, and Wesley. Elias was born in San Francisco, and I live in Washington, DC. As a result of the distance between us, it was more than a month until I first held him. Everyone told me that becoming a grandfather is a life-changing event, but I always figured that expression was only a cliché. "He's just a baby," I thought to myself, and babies are wonderful, but how much more wonderful could he be than any other baby?

So, imagine my surprise when I held Elias for the first time. Without realizing it, I found myself crying. I felt so insignificant in his presence. For the first time, I understood that being a good father means building a strong family, an act that traverses time. Being a good father reverberates long beyond our own life spans as an echo across the ages. The absence of a father has a similarly long-lasting impact.

Here, in Lewis Kostiner's extraordinary book, is photographic evidence of the power of fatherhood from one generation to the next. On the faces in these pages you can see that what truly makes a man is his ability to stand on the side of love and be a good dad.

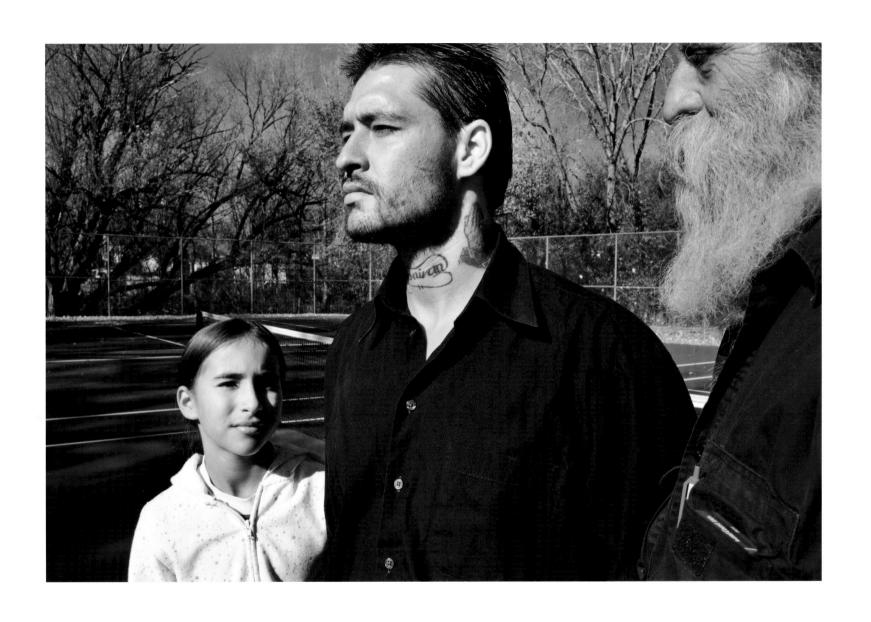

DONALD BADER, DAUGHTER, ANGELICA, AND FATHER, JIM, COLORADO SPRINGS, COLORADO.

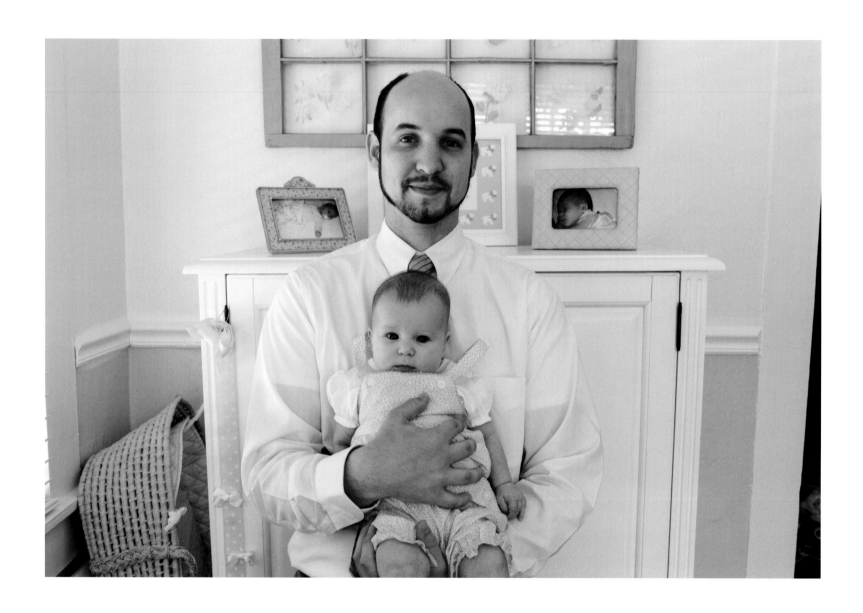

SHAWN KENNEDY AND DAUGHTER, AVA JOY, MOBILE, ALABAMA.

Notes

1. Barack Obama's Speech on Father's Day, http://www.youtube.com/ watch?v=Hj1hCDjwG6M (accessed October 4, 2011).

2. As quoted in Jeff Zeleny, "Jesse Jackson Apologizes for Remarks on Obama," *New York Times* (July 10, 2008), http://www.nytimes.com/2008/07/10/us/politics/10jackson.html (accessed October 4, 2011).

3. As quoted in President's Advisory Council on Faith-Based and Neighborhood Partnerships, *Fatherhood and Healthy Families* (March 2010), http://www.whitehouse.gov/ sites/default/files/partnerships-fatherhood-healthy-families.pdf (accessed October 4, 2011).

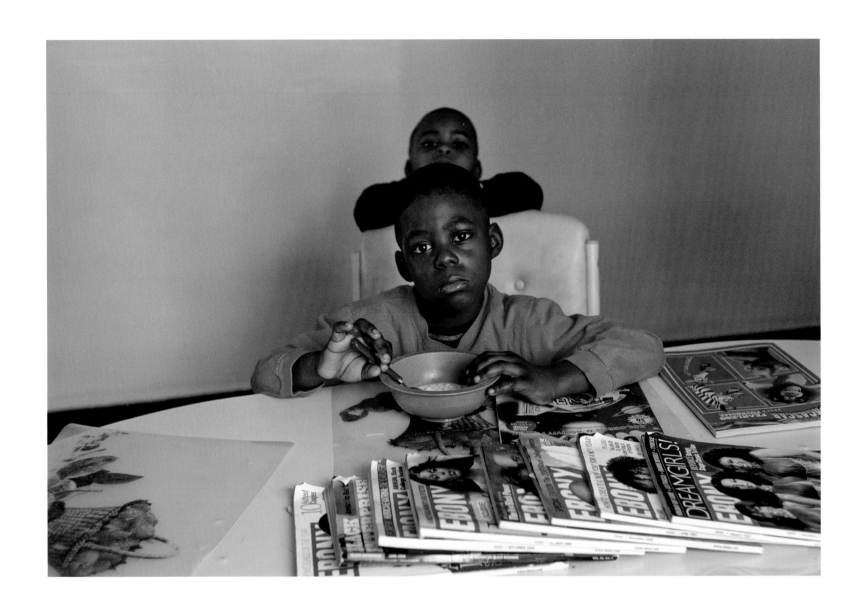

MALCOLM AND MICHAEL, SONS OF MICHAEL TAYLOR, MILWAUKEE, WISCONSIN.

• The Art of Fatherhood

by David Travis

Son:

What must I do that is most difficult?

Father:

You must meet your death face to face,

You must, like one in an old play,

Decide, once for all, your heart's place[1]

—DELMORE SCHWARTZ, FROM "FATHER AND SON"

LEWIS KOSTINER became engaged in the subject of American fatherhood because of a current crisis in our society. Far too many fathers are absent from their children's lives. Some are forced away by circumstances beyond their control, such as immigrants starting from scratch or men struggling to make a living during economic catastrophes. Workaholic business travelers and soldiers also find there is scant time to enjoy a family, even if they are living at home. But millions of others are missing because, poetically stated, they did not know their own heart's place. They were separated from or decided on their own to abandon their families. Sometimes they were divorced. Sometimes they were addicts. And too often they have acted as adventurous boys or mercenary warriors rather than as responsible men facing up to their life and the life they created. This has come to affect a vast population of children and thus the future for all of us.

Through Kostiner's portraits of fathers around the country, we make our first impressions of sixty-eight men (of the some 150 he photographed) who are

not missing but active in their family's life. In light of the crisis, what do his photographs show? First, one sees that these are of men proud of being fathers and willing to present themselves and their stories to strangers. Second, they are modest people without extravagant means or resources who are, nevertheless, rich in self-awareness and determination. Third, they are not unlike many of us, and it is possible that we could encounter them on the street, in a store, or at a sporting event on any given day.

Of course, should we bother to look, we can see fathers of all kinds are around us every day. But, unless we know them personally or they are with their children, we do not recognize them as such. It is a strange invisibility for so important a role. Who are these men, these good fathers, who we might honor as role models for the rest? This is why we need introductions.

Marvin Charles, of Seattle, Washington, was adopted into a family with a workaholic father who spent little time with him. When his adopted mother died, his adopted father suddenly revealed that they were not his biological parents; but, instead of sending him to the custody of the state, he placed Marvin with an aunt and uncle. Years later, without an example of decent fathering, he started repeating the cycle by neglecting the children of his own family, even sending them off to other families that proved to be worse than his own. A threatened suicide by his ten-year-old son caused him to awaken to the situation he was creating through his negligence and drug problem. Eventually, he sought help and training. Reflecting back on his life, he now speaks for tens of thousands of men who were not shown how to overcome their circumstances when he says, ". . . Somebody taught us how to do crime, somebody taught us to do time, but nobody taught us how to do fathering." His own experience of "when the light came on" and finding a religious faith brought him to a conscious effort to become a good father and cherish his

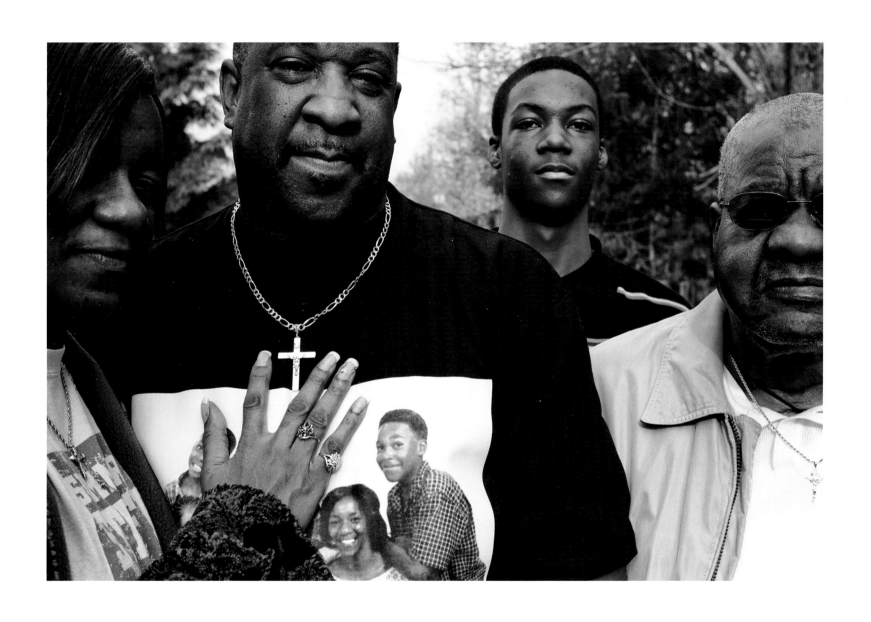

MARVIN CHARLES, HIS WIFE, SON, AND FATHER, SEATTLE, WASHINGTON.

family. You can see much of the outcome of this story in his face as well as in the attitudes of those who surround and love him, the cross around his neck, and the family portrait silkscreened onto the front of what is certainly a treasured shirt.

Anthony Maiden of Sacramento, California, found his model of what a father could be in his grandfather and the men of his church. "And then I had a wonderful mother who, by herself, could not be a father, but she gave all that she had . . . " His father had left the family when he was three or four, and in his forty-seven years he has spoken to the man perhaps seven times. This estrangement caused Mr. Maiden to realize what he could correct if he should raise a family himself. He is now a father of three girls and one boy, and he works as a counselor and therapist in a public school. He shares his failures and successes in fathering with other men in a course partly formulated by National Fatherhood Institute (NFI). And then there are the two portraits of Freddy Caamal, of Dale City, California: the first (page 62) is memorable for his deeply contented smile, the kind that gives him an air of trust and understanding, and the most joyful of the two (page 63) is the one in which his little girl enthusiastically squeezes him around the neck, exaggerating the smile that must have been there the instant he saw her coming.

Jonathan Coughlin of Fort Riley, Kansas, was adopted at the age of three. His adopted father was supportive and has remained so throughout his life. His adopted father was a patient man who did not yell at him when he made "some pretty large mistakes." Mr. Coughlin embraces this quality of patience with his five children. Although being a soldier has taken him away from his family on the base and during three deployments, he makes every effort to be with his family as much as possible and with each child individually. There is, as he sees it, a proper discipline within the family; ". . . we have a lot of rules, but we're very loving and we're very open-minded to suggestions. We allow them to speak their mind, as long as

ANTHONY MAIDEN, SACRAMENTO, CALIFORNIA.

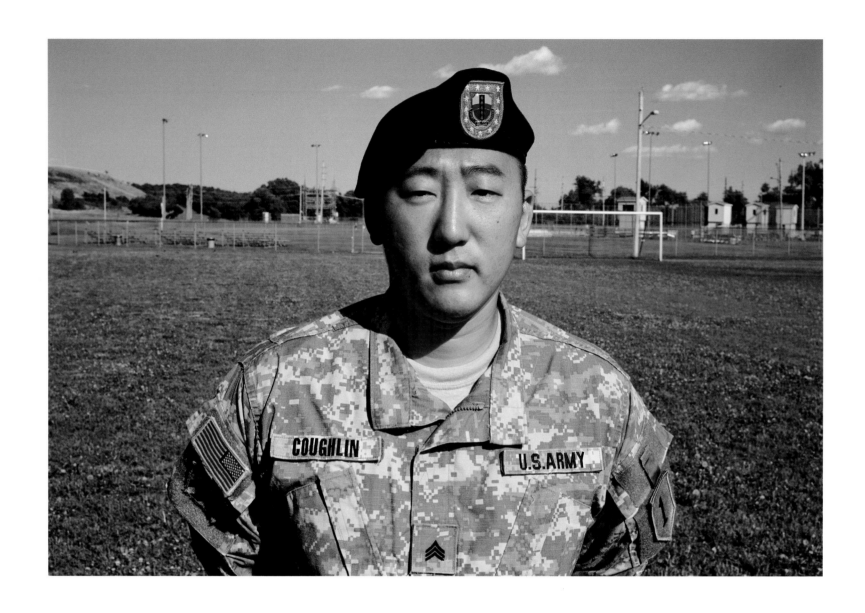

JONATHAN COUGHLIN, MANHATTAN, KANSAS.

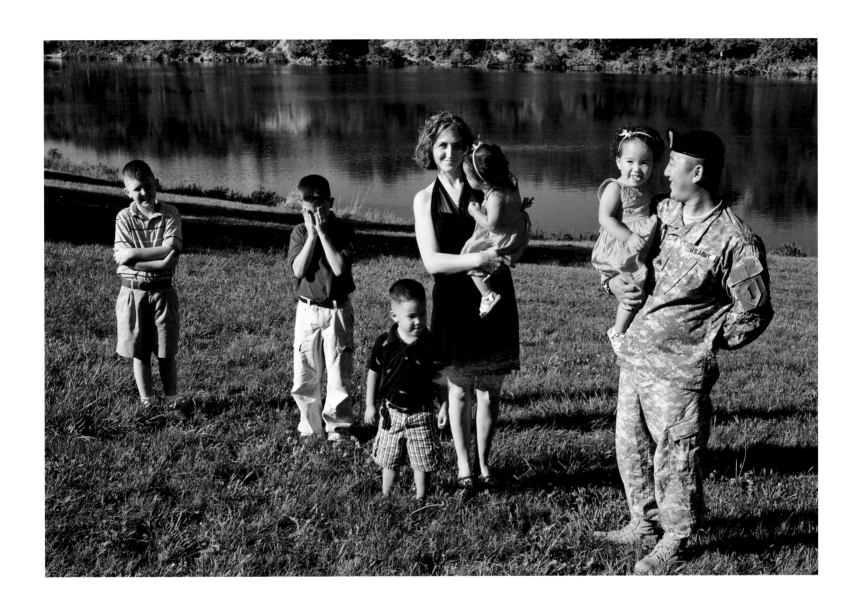

JONATHON COUGHLIN AND FAMILY, MANHATTAN, KANSAS.

it's in turn." He and his wife have demonstrated an admirable wisdom in handling their situation and are conscious "not to misuse the children's childhood, because you don't ever get it back."

Kostiner, himself, was without the daily presence of his father from the age of three. His father was, however, with him on certain weekends and for part of his summers. He and his wife are the parents of two adult daughters, with whom they are close. This is the personal history that naturally informs his vision and feelings. A sympathetic state of mind is apparent in several of the portraits, abundantly so in the case of two of his best pictures of daughters. In one, a girl dressed as a princess with a tiara is so affectionately attached to her father that one imagines that nothing could ever disturb the calm, loving bond they portray. In another, a young girl with sweet longing holds a snapshot of her father on a "crotch rocket" motorcycle—that male symbol of danger, wild exhilaration, and individual freedom—before he becomes a paraplegic from a crash.

Despite his opinions and sympathies, Kostiner does not insert a dogmatic ideology or overt sentimentality into these portraits of fathers and their families. Rather, he respects that aspect of photography that sidles up upon neutral expression and concerns itself with sensitive and perceptive fact gathering. After all, his subject is not a fairytale but a serious reality that needs to be understood from what actually exists.

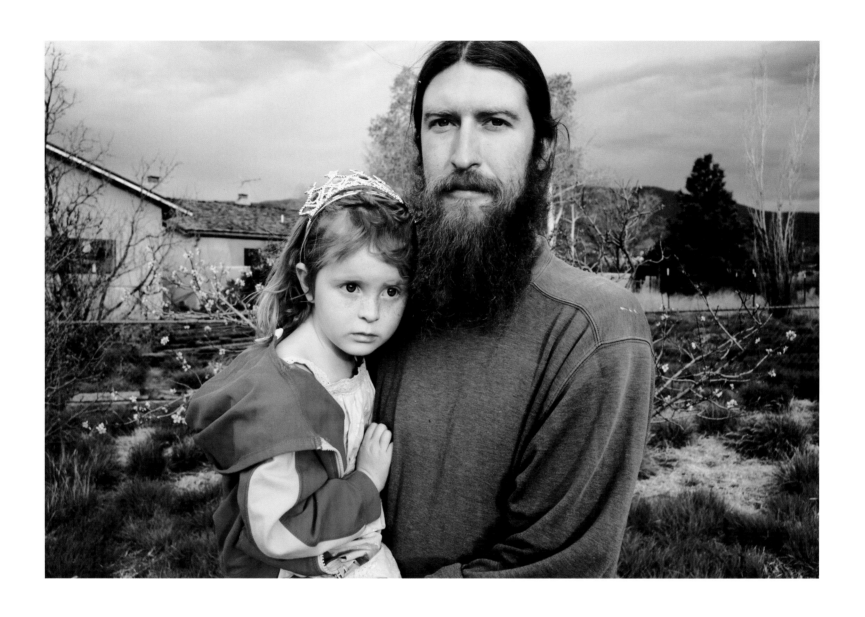

JOHN TAFOYA AND DAUGHTER, TAOS, NEW MEXICO.

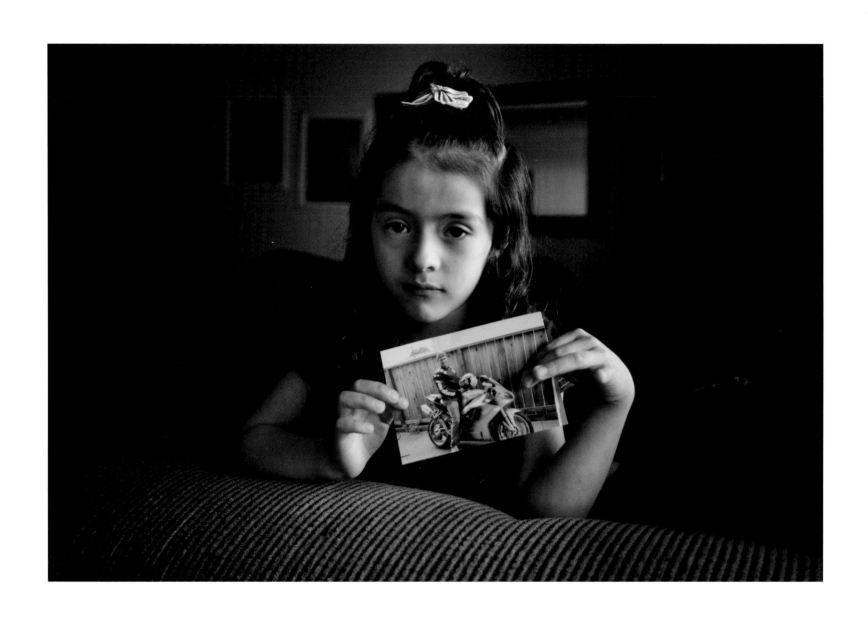

NATALIE, HOLDING A PHOTOGRAPH OF HER FATHER, REYNOL RUIZ, REDWOOD CITY, CALIFORNIA.

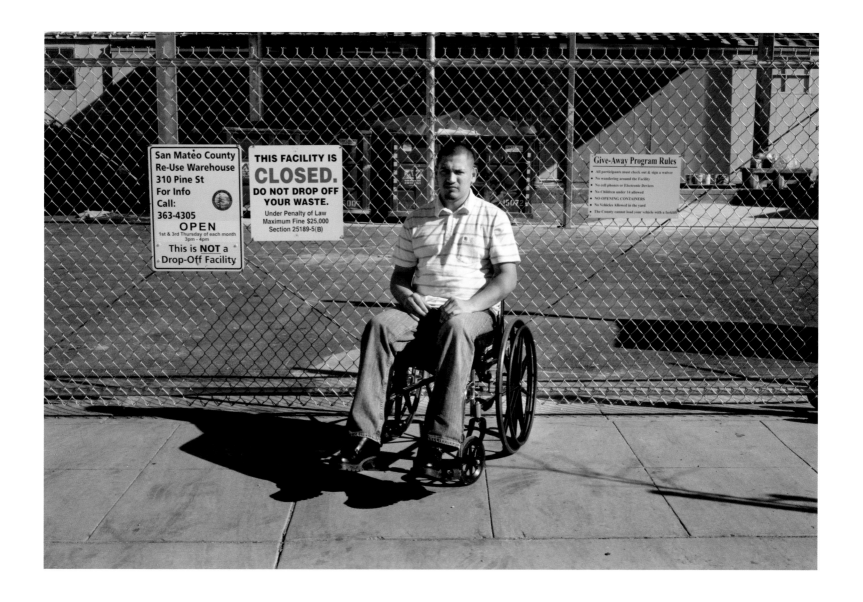

REYNOL RUIZ, REDWOOD CITY, CALIFORNIA.

PRINCE, SON OF JUSTIN LAUGHLIN, COLORADO SPRINGS, COLORADO.

Many people think that photographs are truthful pictures. If that were so, the veracity of a photograph would enable viewers to sort out the devoted fathers from those who have abandoned their children. That is not the case. Although photographs register surfaces perfectly well, no technology can penetrate very far in the substance of the matters it treats. That penetration requires human qualities: perception, judgment, life experience, and, of course, heart. That is no secret, and all veteran photographers know what the fashion and portrait photographer Richard Avedon meant when he wrote: "All photographs are accurate. None of them is the truth."[2]

Kostiner knows this well. He also has experienced his medium in many forms from bulky, tripod-mounted view cameras to hand-held Leicas, from film exposures to digital captures. He recognizes that a chosen technique must match the purpose. And he has been careful with his choices in making these photographs. Beyond all the technology and equipment, he is aware of what kind of portraits these are as photographs and what the situation in which they were taken allows them to be.

One of the most salient factors in describing the character of portrait photographs is the initial reason the images were made. Passport photographs and mug shots are for visual identification. Studio portraits commissioned by the sitters are usually for the subject's or a loved one's gratification. Journalistic and publicity images are depictions of newsmakers and celebrities, made for editorial purposes and mass consumption through the media. Intimate psychological studies are often emotional responses of artistic and personal expressions. And then there is the snapshot, our most common type of photograph.

To be precise, Kostiner's photographs are not snapshots, even though they retain many of the virtues of snapshots. Like other snapshot subjects, his fathers and their families pose in their own environments, displaying themselves at a mutually agreeable moment. These portraits are not like those candid snapshot exposures taken unawares or obliquely but instead are images in which the subject is a compliant as well as a controlling presence. Those portrayed seem to say: "Here I am, this is me." It is a proper and comfortable way to make an introduction, which is the purpose of these pictures.

Even though Kostiner's subjects are clearly positioned directly in front of the camera, a compositional format employed by photojournalists and snapshooters alike, these portraits are not news reports because only a private, self-directed event is happening. They are journalistic in one aspect, however: they form a contemporary rebuttal to the distressing problem of the absence of fathers in the lives of their children. They bring the problem of American fatherhood to mind and set it in clear relief. With the accompanying interviews, selections of which appear later in *A Gathering of Fathers: American Stories* (pages 51–135), these photographs are a report of both the challenge and the pleasure of fatherhood of those who care intensely for their children. This accumulation of consistent and careful images taken in every region of the United States over a three-year period establishes a story of current urgency and, at the same time, assembles a document for the future that attempts to show a positive side of the story of fatherhood in America.

The documentary mode that Kostiner uses has been developed during the last eighty years, accommodating both the snapshot and the journalistic approach. Its strongest roots were formed during another crisis for American families: the Great Depression. Among the photographs made for the Farm Security Administration during the 1930s, the work produced by Walker Evans (1903–1975), in

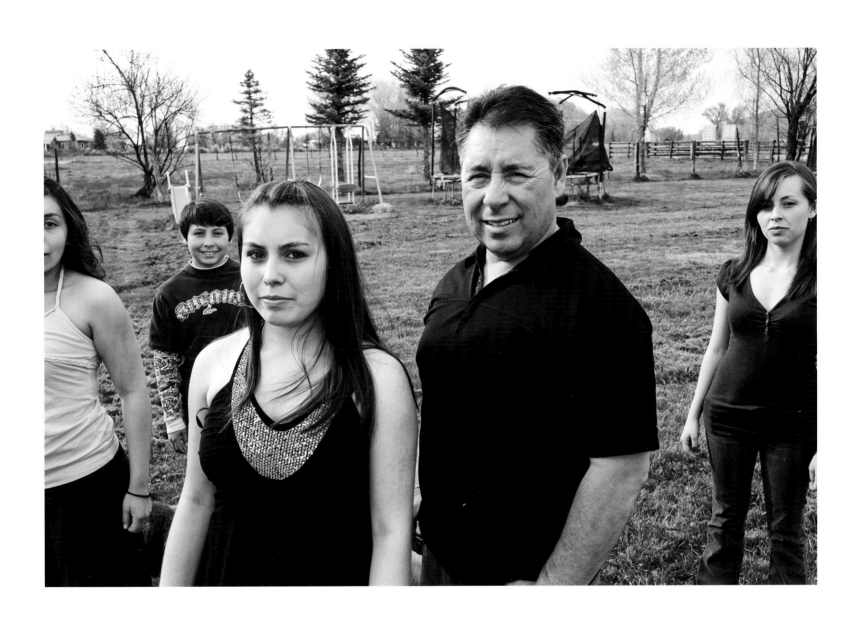

JOEY PRADO AND CHILDREN, EL PRADO, NEW MEXICO.

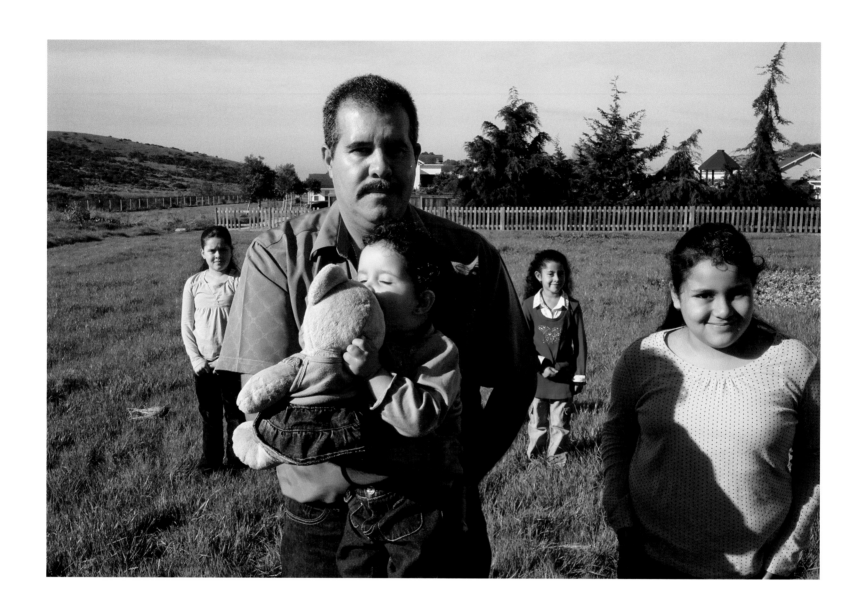

EMILIANO RAMOS AND DAUGHTERS, HALF MOON BAY, CALIFORNIA.

particular, became the example of how to see a subject clearly by eliminating the self-indulgent, emotional character from so many of the artistically contrived photographs of his day. This is not to say that Kostiner has no intentions as an artist.

Even if all photographs are accurate, it does not mean that they must be impersonally objective. After all, in portraits the resulting image has both the subject's attitude in pose and the photographer's temperament of vision melded into a single picture. The American poet Wallace Stevens (1879–1955) lent some clarity to this mélange that artists produce when he said: "One is always writing about two things at the same time in poetry . . . One is the true subject and the other is the poetry of the subject."[3] By analogy, we might say that there is a true subject (that which is in front of the camera) and the photography of the subject (that which is the photographer's perception, often informed by an overarching idea, which results in decisions about selective composition and timing).

Over decades of photographic experience, Kostiner has developed the skilled reflexes to see the potential of what the "snapshooter" sees at first glance in a direct and less mediated experience. Then, through an evolution of arrangements and stances, he creates another complexity that hints at what cannot be known of his subjects. In this search for what he feels is the photography of the subject, he encourages his subjects to partner with him and, perhaps, reveal themselves a bit more, even though they are just newly introduced. He is careful, however, not to overplay his compositional staging, in the way grab-your-attention magazine illustrators often do, gravitating toward the traditional idiom of photographic documents. And if his subjects do not seem completely at ease, it is proper. After all, an hour or so after meeting, they are still more strangers than acquaintances.

If the many statistics of our social sciences paint an exasperating picture of father-hood in present-day America, mythology does not treat them much better. Myths and fairytales do have examples of "the kindly old Geppetto" in *The Adventures of Pinocchio* (1881–1993) by Carlo Collodi, but more often we encounter figures such as Cronos in Hesiod's *Theogony* (ca. 700 BCE) eating his five children. In Robert Bly's influential book, *Iron John: A Book About Men,* the poet writes, "Mythology is full of stories of the bad father, the son-swallower, the remote adventurer, the possessive and jealous giant. Good fathering of the kind that each of us wants is rare in fairy tales or in mythology. There are no good fathers in the major stories of Greek mythology—a shocking fact—and very few in the Old Testament. Uranus, Cronos, and Zeus exhibit three styles of horrendous fatherhood. Abraham, a famous Old Testament father, was ultimately willing to sacrifice Isaac, and his grandson Jacob was good to Joseph but apparently not to his other eleven sons . . . King Arthur radiates generosity, but as an uncle, an initiator, and guide of young men, not as a father."[4]

Bly does not lay all the blame on the character or structure of our society or government, but, like Delmore Schwartz in "Father and Son," speaks about deeper things: the heart's place. This suggests that abandonment is not the only cause of the problem of fatherhood. Bly identifies the genesis of the problem as another kind of absence. Beginning in the nineteenth century, the system of labor during the Industrial Revolution took the agrarian father out of the family and placed him in factories and offices. This separated him from his son, who had been work-ing along his side and who had been learning from him directly. In this era, moth-ers usually remained in the home where daughters could acquire a female mode

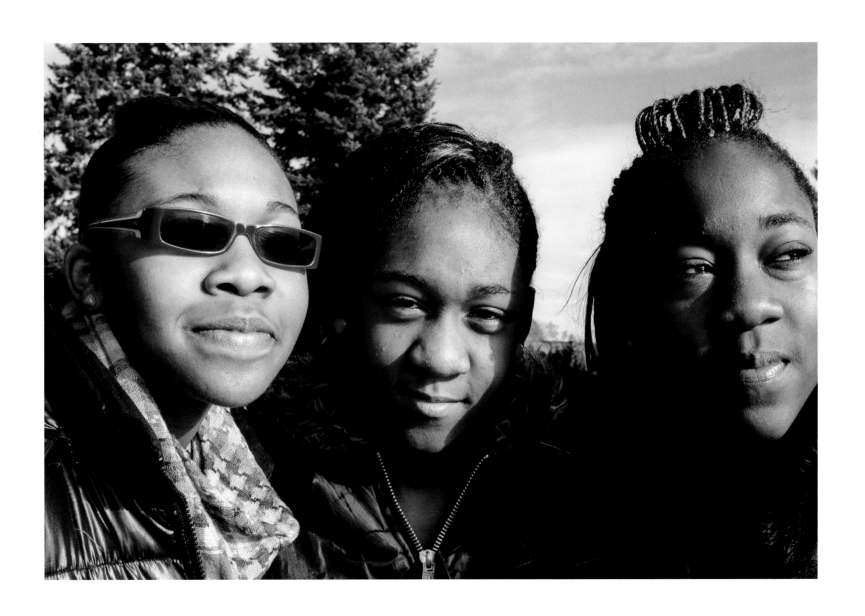

MARVIN CHARLES'S DAUGHTERS, SEATTLE, WASHINGTON.

SHAWN KENNEDY'S FAMILY, MOBILE, ALABAMA.

of feeling. The sons and daughters acquired less and less of the male mode of feeling from their fathers. But this situation was more of a tragedy for the son because, as Bly believes, a woman can raise a fetus to be a boy, but she cannot move him from being a boy to being a man. Only other men can do that. And this is the reason that the abandonment of their children, especially of their sons, has made problems of American fatherhood so acute: being left to their own resources or to chance encounters, the sons learn little about being caring fathers themselves.

Our national crisis, thus, will not be solved by merely bringing estranged fathers back into their families or into active contact with them. They must not be absent in the other ways. They must somehow become devoted and teaching fathers, which is difficult for anyone; even the good fathers in our culture are constantly struggling toward this goal. Nevertheless, reconnecting fathers with their families is a necessary condition for beginning to address the problem and, more importantly, in finding the right place for their hearts. As for the photographs presented in this book, even if they can only be introductions, each of the fathers portrayed is demonstrating that good fathering has been a blessing to him and an enrichment to every life it touches.

Notes

1. Delmore Schwartz, "Father and Son," from *Selected Poems (1938–1958): Summer Knowledge* (New York: New Directions, 1967).

2. Richard Avedon, *In the American West* (New York: Harry Abrams, 1985), unpaginated (20).

3. Wallace Stevens, "The Irrational Element in Poetry," in *Wallace Stevens, Collected Poetry and Prose,* selected by Frank Kermode and Joan Richardson (New York: The Library of America, 1997), 785.

4. Robert Bly, *Iron John: A Book About Men* (Reading, MA: Addison-Wesley Publishing Company, 1990), 120–21.

A Gathering of Fathers

American Stories

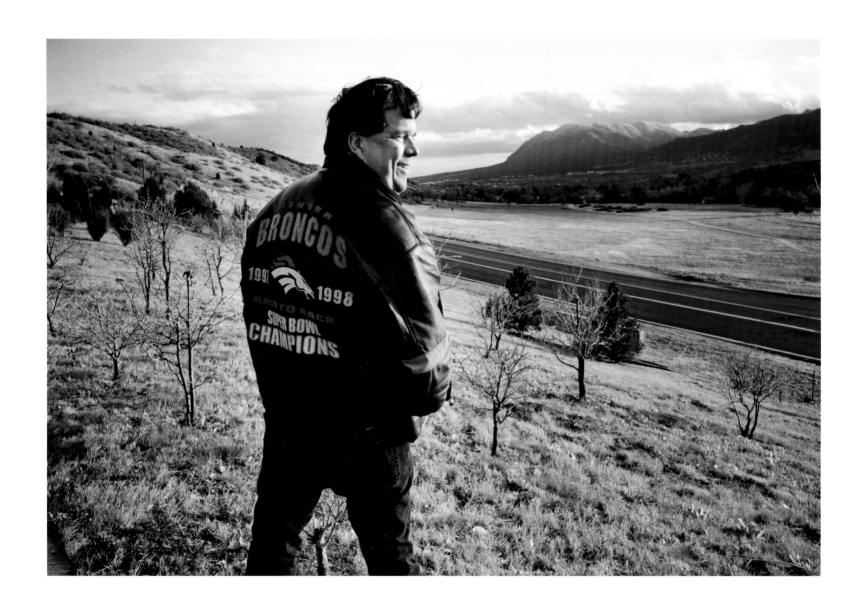

WADE ANTENER, COLORADO SPRINGS, COLORADO.

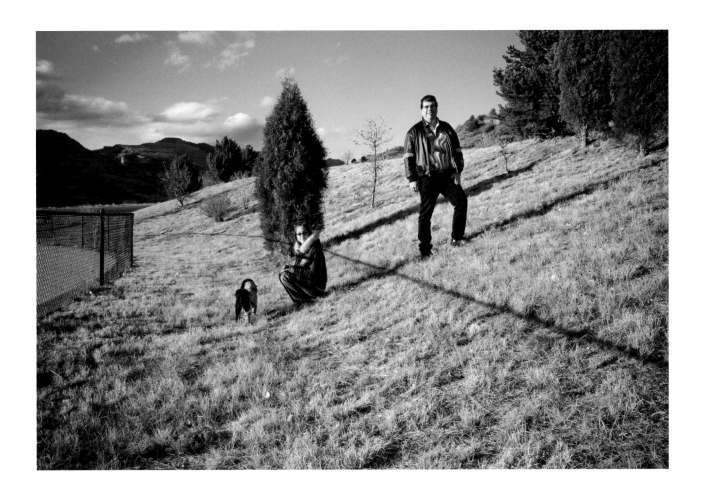

"My relationship with my own father is a very tight and good relationship.
I have so many fond memories. My dad, he always taught me honesty. Stay true
to your values. The saying, 'Look in the mirror,' if you can stand looking at that
image in the mirror, then you know you're a good man. You know. Integrity
is not what you show in public but what you do when people don't see you.
I've taken those values and am trying to instill those in my daughter."

WADE ANTENER, DAUGHTER, TIFFANY, AND DOG, DIAMOND,
COLORADO SPRINGS, COLORADO.

MIKE BEERBOWER, DES MOINES, IOWA.

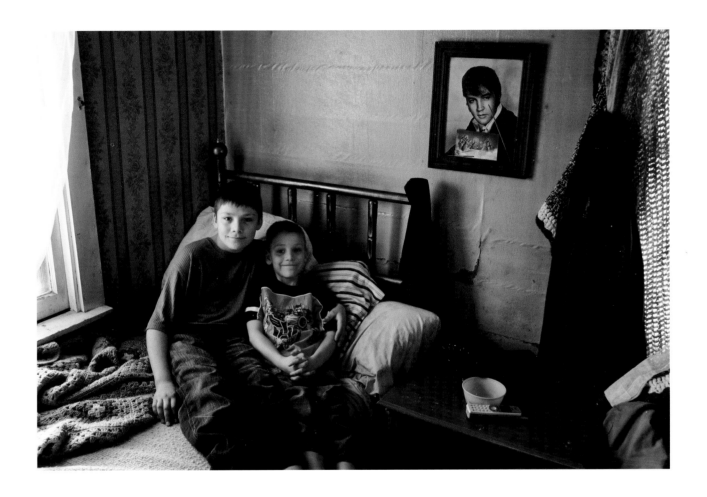

"My father, he worked most of his life hanging Sheetrock. My relationship with him could be a little better. There's times when we don't see eye to eye, but I'm hoping me and my kids don't end up like that, that me and my kids have a better relationship than me and my father. The most challenging part of being a dad is trying to raise them to be a better person than what I ended up growing to be. I don't want them to get hooked on drugs. I kind of hope they go to college and become something, because, me, I got a GED through prison, and I don't want to see my kids go the same way I went."

MIKE BEERBOWER'S SONS, DES MOINES, IOWA.

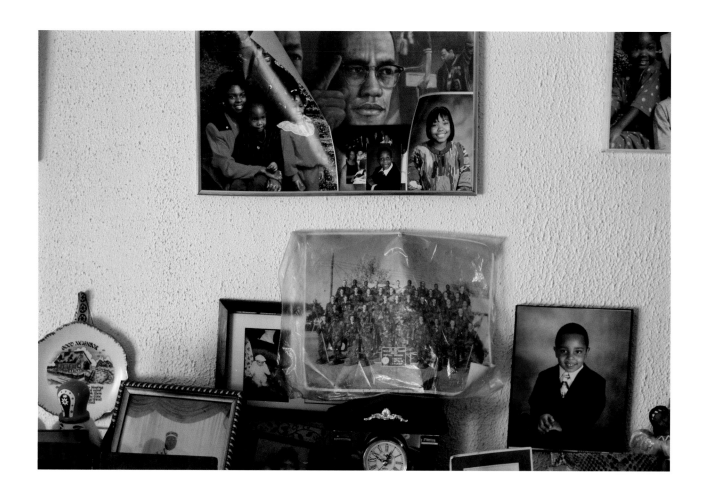

"The way you treat your spouse is the way your sons or your daughters will want to be treated and to treat other people. I think the roles of both moms and dads are important. My wife wouldn't make a decision without me, and I wouldn't make one without her. And we both were involved in their life, their education, their extracurricular activities. Concerned about their grades and schoolwork. I think it paid off. We have two kids in college, and one is about to graduate. I think it worked out pretty good."

INSIDE PETE BARLEY'S HOME, MILWAUKEE, WISCONSIN.

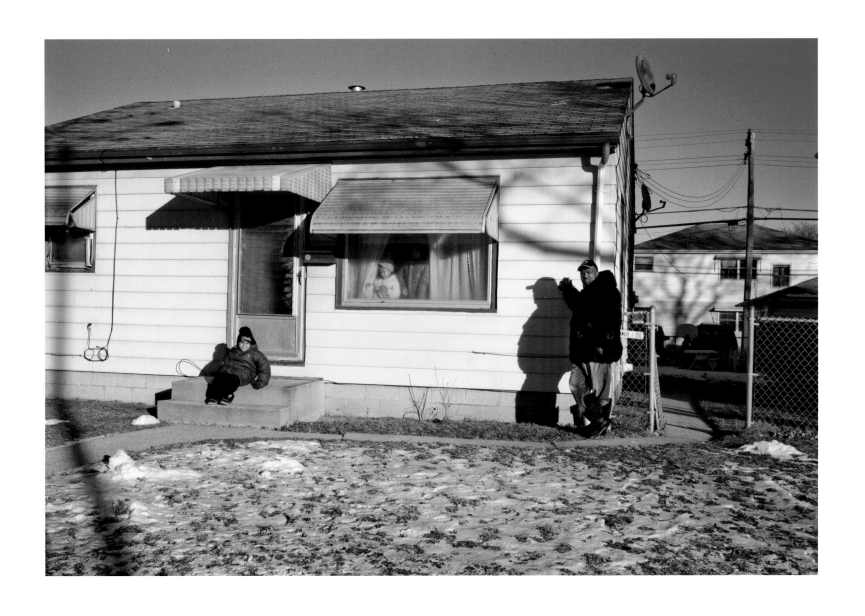

PETE BARLEY, GRANDFATHER, AND FAMILY, MILWAUKEE, WISCONSIN.

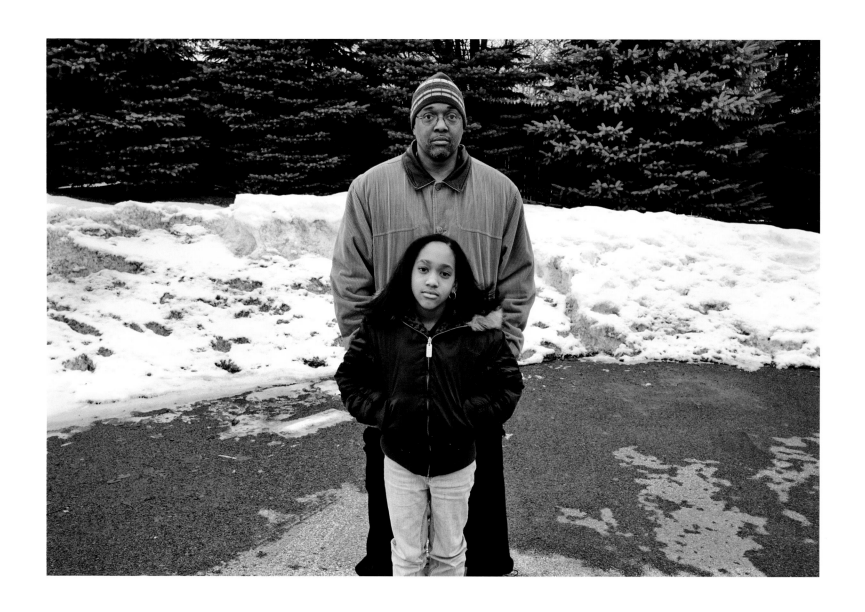

KENNETH BRASWELL AND DAUGHTER, ALBANY, NEW YORK.

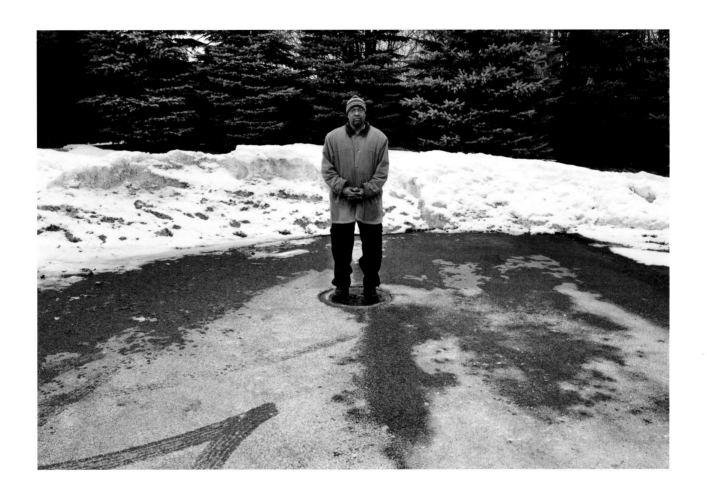

"I did not meet my father until I was twenty-three years old, and we had a brief encounter and some brief connections over the next six months. The next time I saw my biological father he was in a casket. I did not ever want my family to experience having to go through that. I learned a lot from my mom, that unselfishness is at the top of the list of character traits not only for a mom or a dad, but for parents, period. In order to be a great parent you have to be unselfish. At times you have to be compassionate. At times you have to be loyal. At times you have to be honest. At times you have to be consistent."

KENNETH BRASWELL, ALBANY, NEW YORK.

AARON BREGENZER AND GIRLFRIEND, ALPHARETTA, GEORGIA.

"My dad and I didn't connect a whole lot. He owned his own landscape company. He probably worked about eighty to ninety hours a week. He was always working. Most of the time, when he was around and he was available, he was affectionate, but he wasn't there a whole lot. The way he was raised was his parents were not nurturing, so he never had that nurturing side. So, when we were together, he wasn't emotionally available. He was never taught that. Outside of sports and spending some guy-time together, there really wasn't a whole lot of interaction. I still don't have the relationship I want with my father, but I know I can do differently with my son."

AARON BREGENZER AND GIRLFRIEND, ALPHARETTA, GEORGIA.

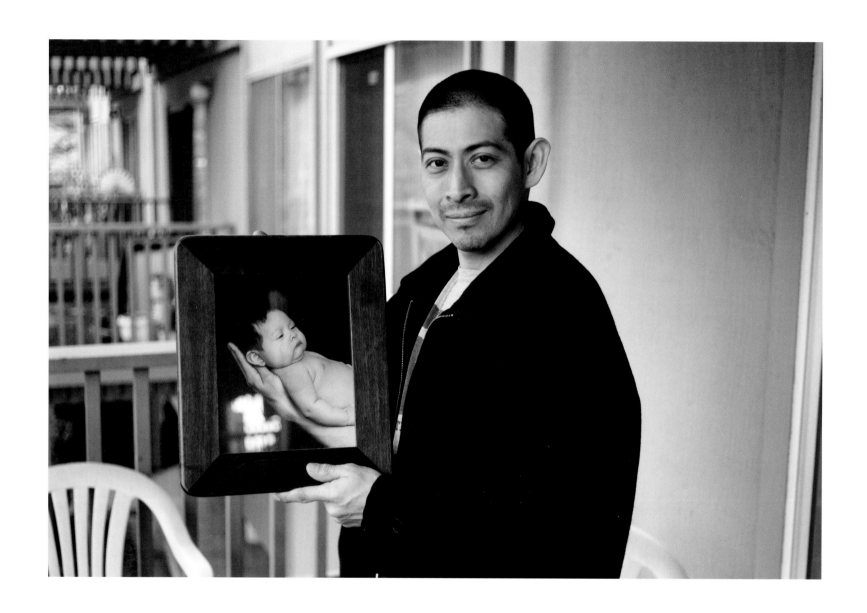

FREDDY CAAMAL AND DAUGHTER, GENEVIEVE, DALE CITY, CALIFORNIA.

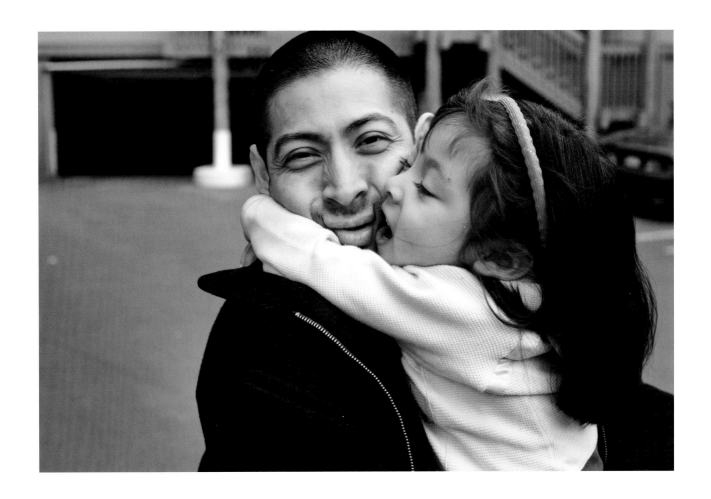

"I never realized how much of an impact my dad can make not being there for me. It affected me in a way where I made a decision in my own life where I didn't want to be the same way my dad was. What I can tell fathers is, 'Be there for your kids.' Don't just look at them and it's like, 'Oh, my God, I got extra baggage,' because they are *not* extra baggage. They are a *part* of you. I cannot imagine myself being away from my girl, because it would just rip my heart apart. I'd rather be there for her through thick and thin. I know she's going to make mistakes throughout the years, but she's my girl, and, hey, she will always be my little girl. I'll just tell her, as a dad, to just hang in there and do the best you can."

FREDDY CAAMAL AND DAUGHTER, GENEVIEVE, DALE CITY, CALIFORNIA.

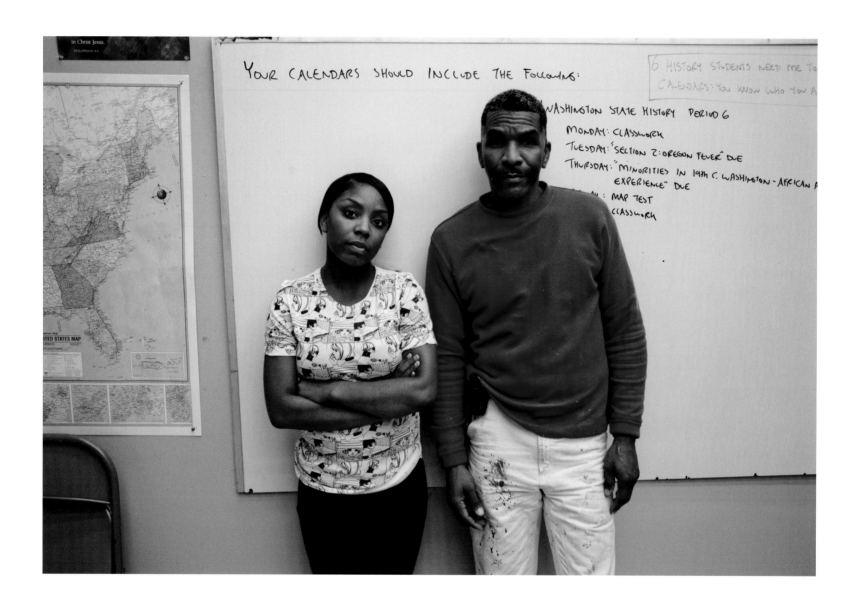

WILBURN CARVER AND DAUGHTER, SEATTLE, WASHINGTON.

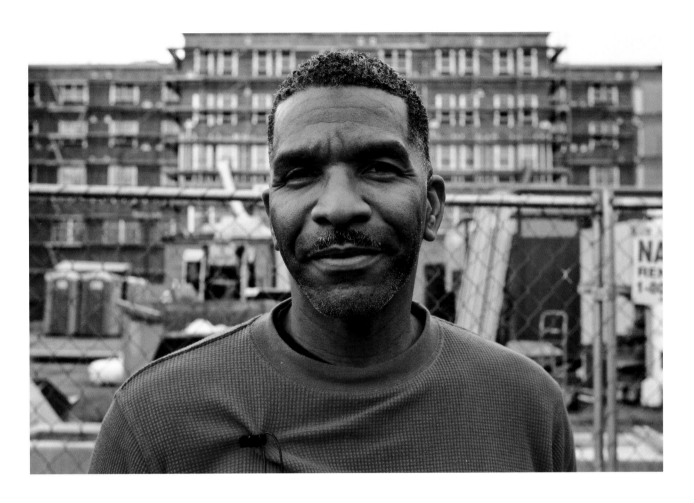

"I grew up with my father. My mother and father divorced when I was about two or three. My mom ended up dying when I was about six or seven. My father remarried about a year after my mom passed. So I learned watching my father, how to take responsibility, not only to provide, but also to maintain the house. My father could sew, clean, cook, do dishes, iron, you know, as well as any woman that I ever seen. We have a lot of men, primarily African-American men, who don't have fathers at home, and so they don't see that model. I think it's the culture of the society we live in, too, is not promoting family in the context in which we're talking about. It's promoting a single lifestyle, alternative lifestyle. I think one of the key things I've learned as a father with my daughter is to admit when I'm wrong and to apologize for hypocrisy."

WILBURN CARVER, SEATTLE, WASHINGTON.

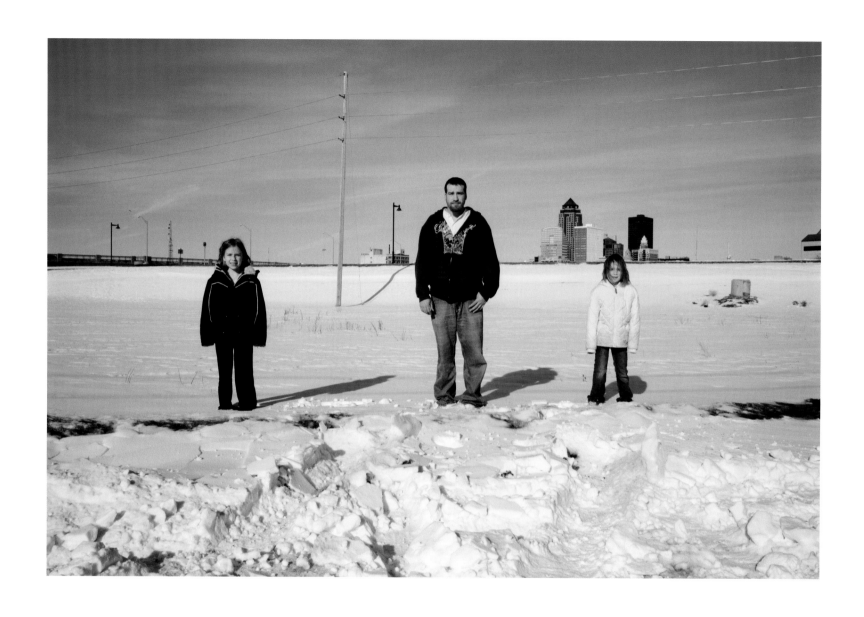

JOSHUA CHILES AND DAUGHTERS, EMILY AND TAYLOR, DES MOINES, IOWA.

"I get along with my father great. I try to have the same relationship with
my kids. Sometimes, I'm not there as much as I'd like to be because
of work. I remember, when I was a kid, it was always nice growing up.
There's a lot of kids that didn't have a stable family, and I think it's nice
to grow up having both of your parents around. I think I learned a lot
from having both my parents around and seeing them together,
even the arguments, because that's a part of everybody's marriage.
Nobody's perfect at parenting. Just be as good as you can be. That's it."

JOSHUA CHILES, DES MOINES, IOWA.

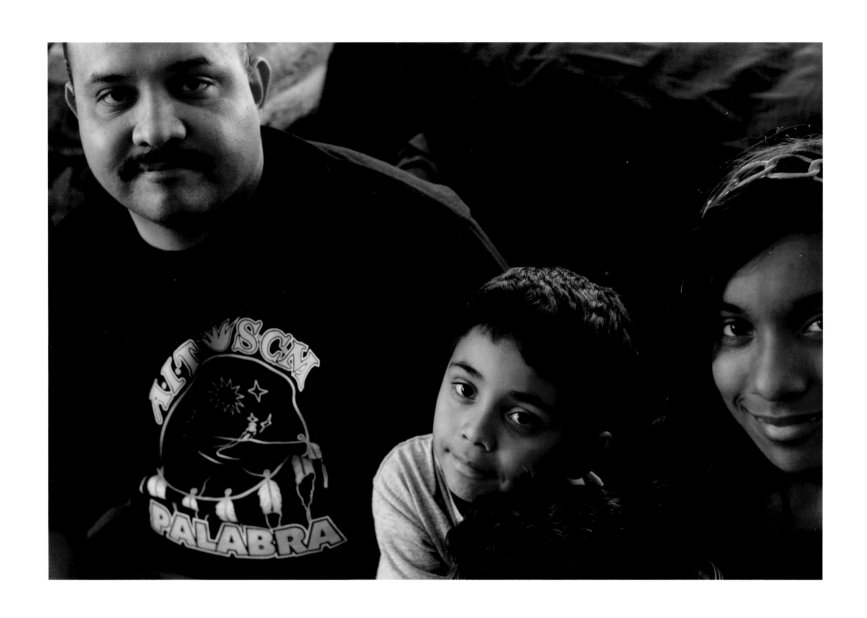

MARTIN CORONA, SON, MANUEL, AND DAUGHTER, KALA, SAN ANTONIO, TEXAS.

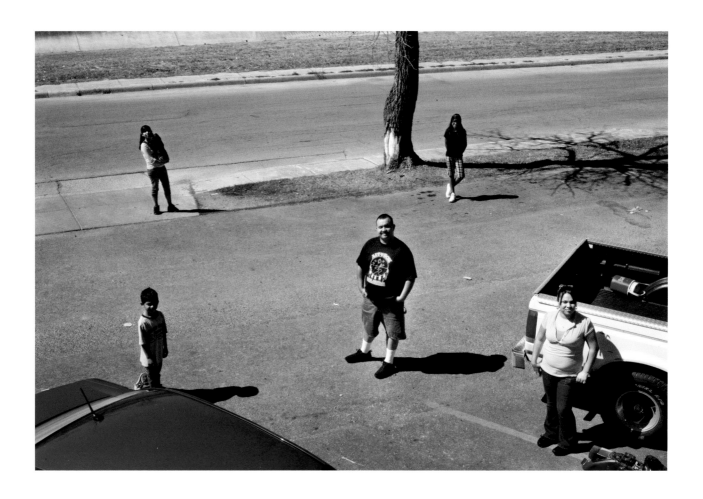

"I wasn't really prepared to be a father. It just happened all of a sudden. I wasn't showing that fatherly love to my kids. I never thought it was going to be that hard. My dad was not in my life half of the time, so I had to learn everything on my own."

MARTIN CORONA, HIS WIFE, AND CHILDREN, SAN ANTONIO, TEXAS.

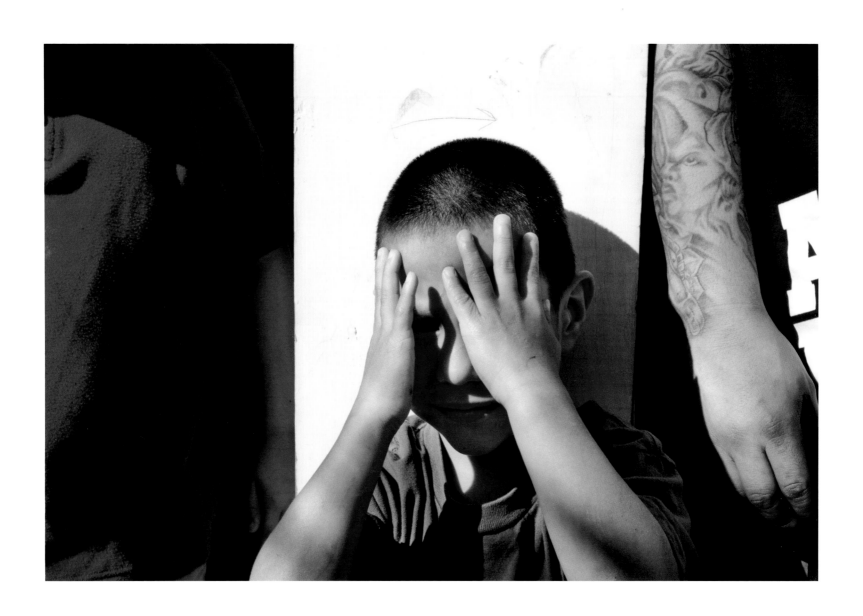

AARON, SON OF ROLAND DAVIS, SAN ANTONIO, TEXAS.

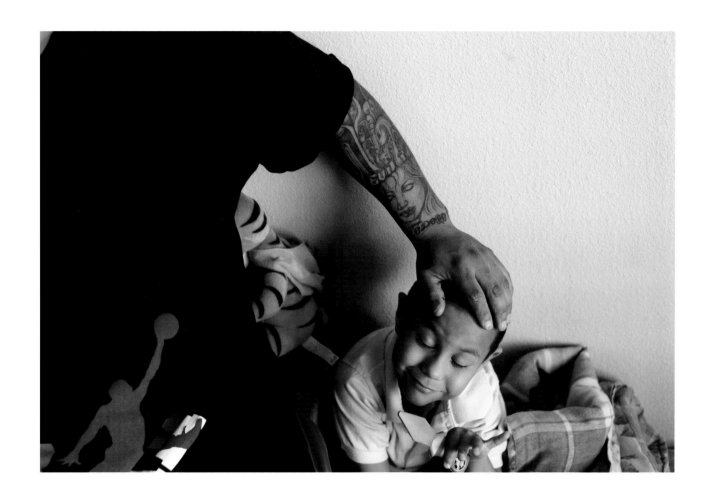

"If you love your kids, just squeeze them tight. We don't know what God has planned for us from one day to the next. Me being a father, I've been able to give a lot of gratitude. My kids have had to struggle. Sometimes we still struggle financially. We participate in church. I am also a recovering addict. I am attempting to do something to better our relationship as father and children."

ROLAND DAVIS AND SON, AARON, SAN ANTONIO, TEXAS.

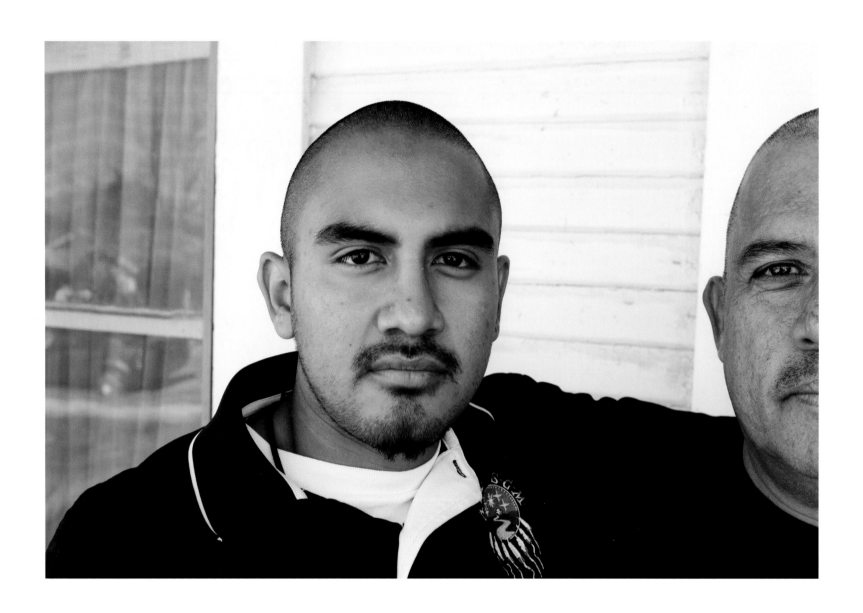

VINCENT ESCOBENDO AND FATHER, SAN ANTONIO, TEXAS.

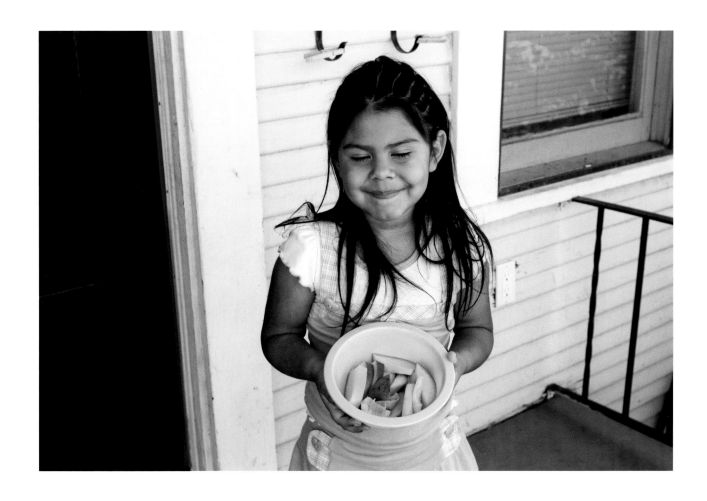

"I know how difficult it is to be a young teen dad. I know if I wasn't there
for my daughter, it would be a lot more difficult for her life, too.
The best advice I can give is to be positive, being supportive.
Be involved and stay involved."

SALINA, DAUGHTER OF VINCENT ESCOBENDO, SAN ANTONIO, TEXAS.

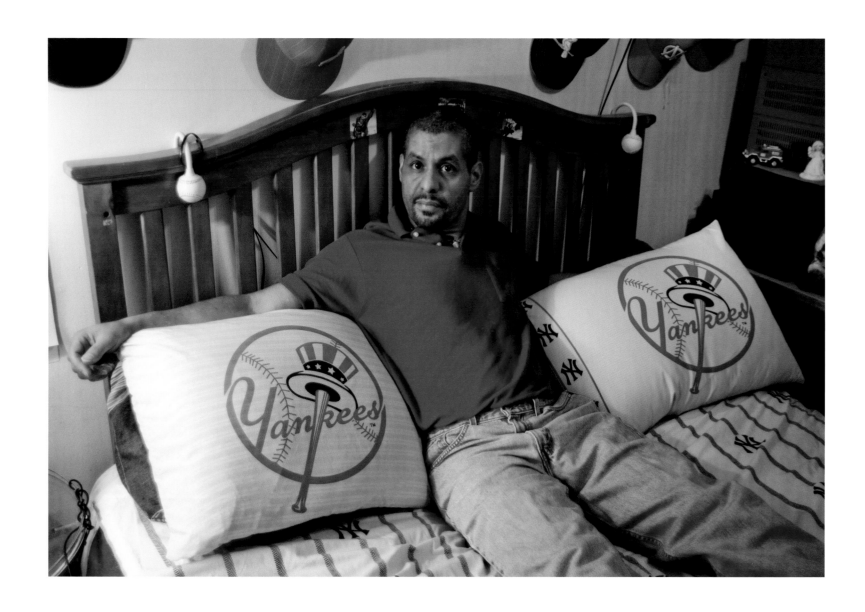

JOSE ESPADA, ALBANY, NEW YORK.

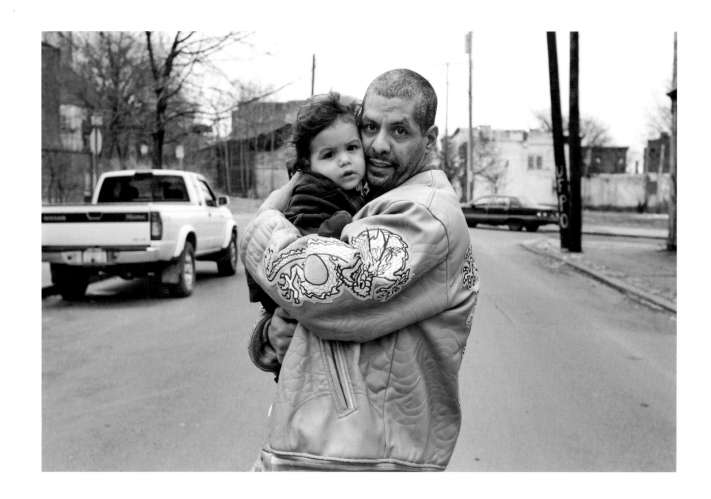

"I was the youngest of twelve. I had eleven sisters, three sets of twins. At the age of four, my mother died of cancer, and my father went to the Navy and never came back. We were raised by my grandmother until I was nine. She passed away, and then I was raised by my sisters. I can see all the stress and trouble I gave my parents through the example that the kids are giving me. It's difficult, but I take it one day at a time. If women can do it, why not men? The most joyful part of being a dad? It's the time you spend with them, watching them grow up, their first steps, their first words. When you see it actually happening every day, right in front of you, it's like a miracle."

JOSE ESPADA AND SON, ALBANY, NEW YORK.

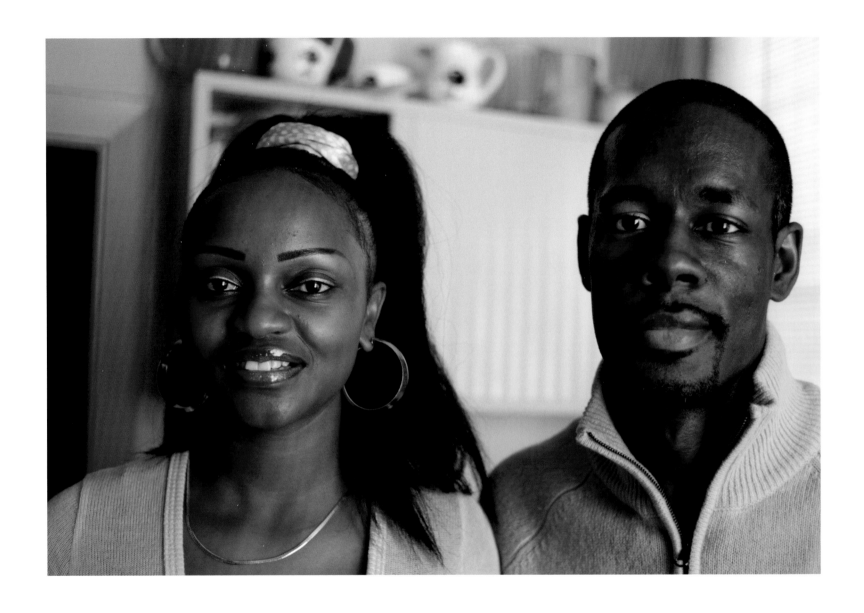

JERRE FIELDS AND WIFE, PITTSBURGH, PENNSYLVANIA.

"My advice to other dads? Get involved with your family. Make sure that you're there with them every day, from the morning through the evening. Just try to keep up with the education. Education is the number-one thing when you're raising your kids, so that they can definitely have a better way of life once they leave the home. Just talking to your kids, playing games every day will help their social skills a lot better once they are able to get out there in the real world. Just all the love you can give them, hugs, just reading stories at night is one of the best things I can see now and maybe in my past."

JERRE FIELD'S DAUGHTER, PITTSBURGH, PENNSYLVANIA.

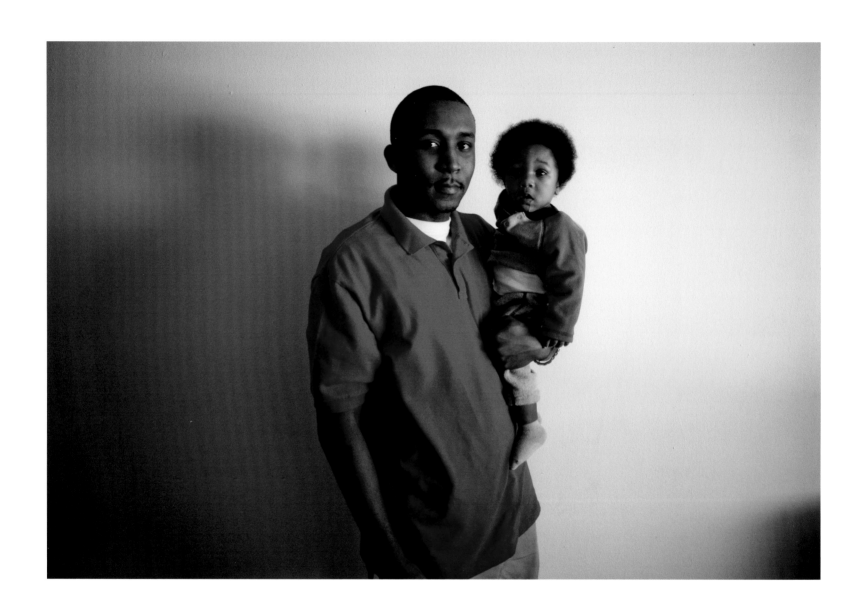

KEITH GLASS, JR., AND SON, KEEMARI, MILWAUKEE, WISCONSIN.

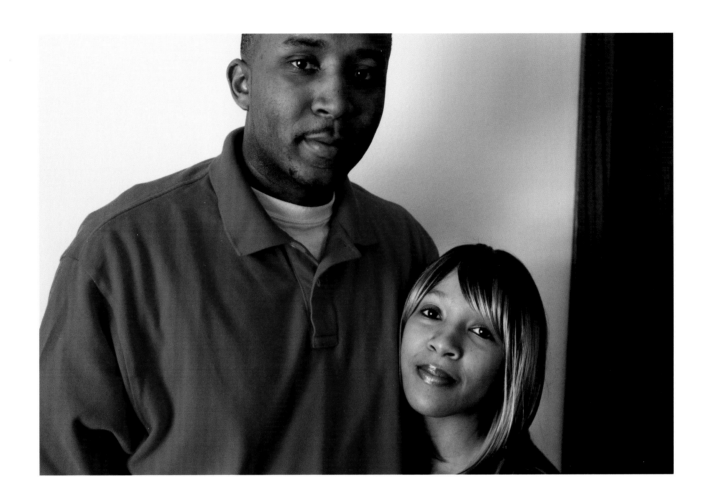

"The woman's and the man's role in a relationship as parents, that's very important, even if they are not together or married or whatever. But they came together at some point and made the children. And I feel that it's a team effort that will always be, no matter what. And it really does take two. The children need to see the mother and the father at least working together, making some form of togetherness. They'll feel that both of my parents care for me. It makes them walk a little straighter. The more nurturing and love that is put into the children, they grow up to be better loving and caring adults. And so, when they have children, you know, they can keep passing it on. That just makes the world better."

KEITH GLASS, JR., AND WIFE, MARKEETA, MILWAUKEE, WISCONSIN.

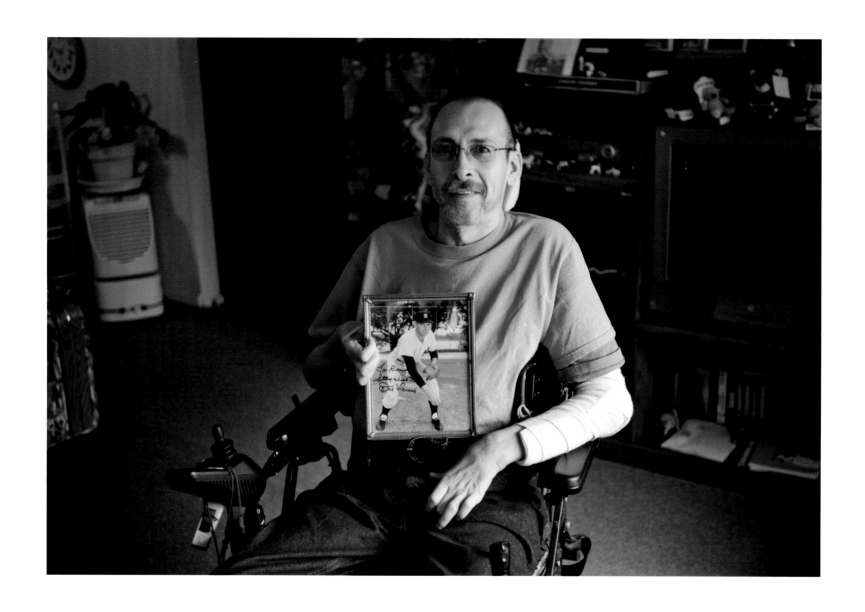

RANDALL GONZALES, SAN ANTONIO, TEXAS

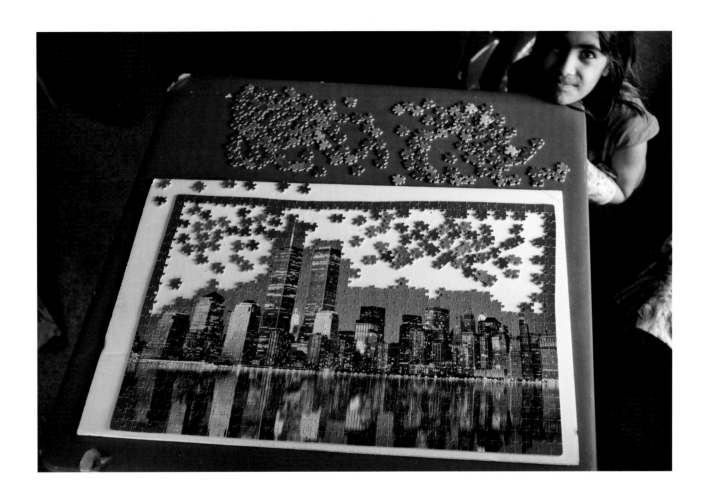

"I tell my daughter from time to time, 'Remember, you can ask me anything you want. Even if I'm embarrassed, I'm still gonna answer you.' I remind her that I don't get embarrassed about my handicap. I'm trying to build a good rapport with her and talking to her about trust. And I try to let her make as many decisions on her own as she can while she is young, so that she gets better at it when she is older. I am not going to expose her to everything. I am not going to hide things from her. I just want to make sure she is ready for life and ready to be happy. Another thing, I refuse to spank. My father spanked me. His father spanked him and on up the line, so I'm breaking the chain. It takes a little more time and a little bit more patience, but I think in the end it's going to be better for her."

RANDI RAIN, DAUGHTER OF RANDALL GONZALES, SAN ANTONIO, TEXAS.

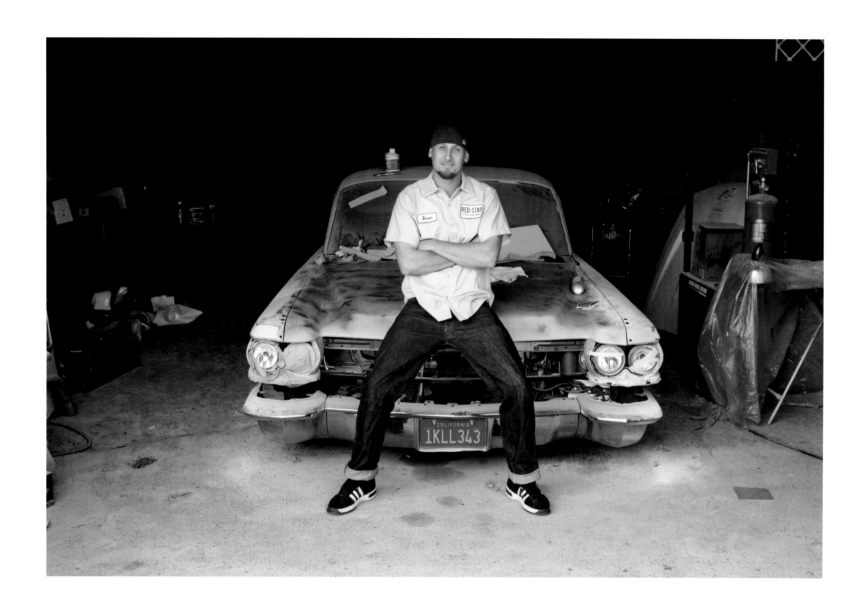

STEVE GONZALES, SACRAMENTO, CALIFORNIA.

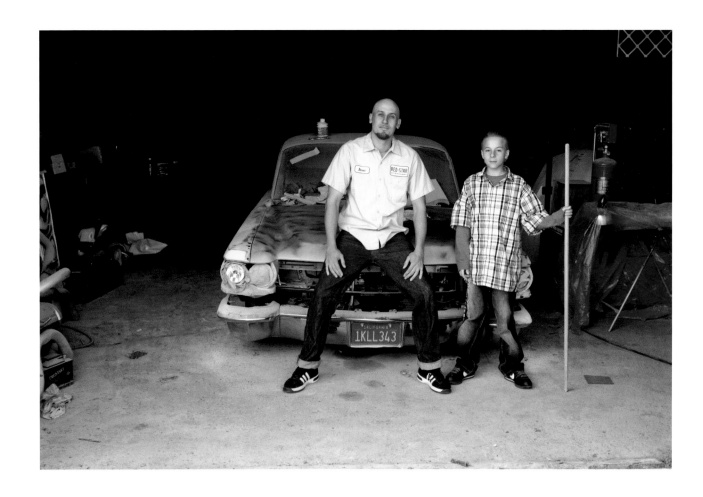

"My parents separated when I was two, so I grew up making a lot of my own decisions without the discipline of a father. We lived many miles apart, but my dad always reminded me that he was my dad and that he loved me very much, even though we couldn't be together. So that always helped me make decisions that I thought he would want me to make when we weren't together. We have a good relationship now. It has come full circle. We live back here in Sacramento with him. He helps me out a lot at the shop. I employ him part-time. I also employ him part-time as a babysitter. So he is extremely happy that we're back. It makes me happy that I was able to make a choice to come back and be with him after growing up most of my life without him."

STEVEN GONZALES AND SON, SACRAMENTO, CALIFORNIA.

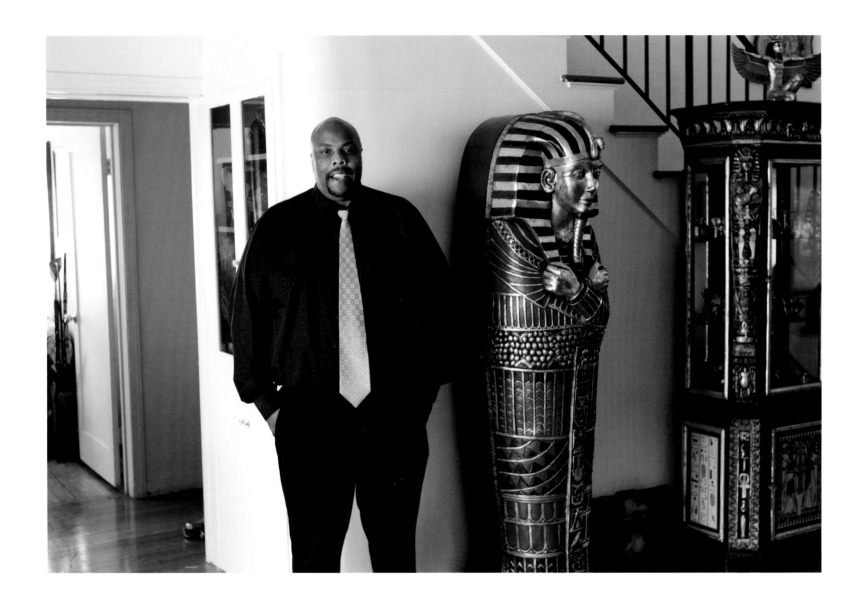

TERRANCE HALL, SACRAMENTO, CALIFORNIA.

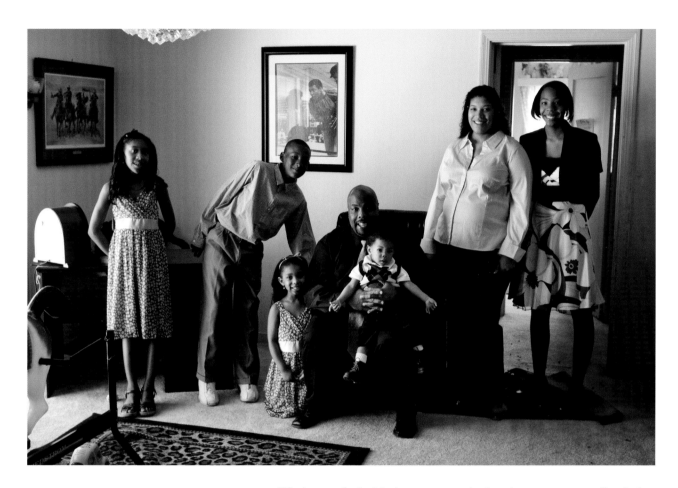

"Having worked with the county probation department as well as in law enforcement for ten to eleven years, particularly with juveniles, and seeing them incarcerated and seeing the recidivism rate as high as it was, I felt it was my duty to give back to the community. My wife and I give back to the community in the way of housing a foster child. So we are lodging Myers, age eleven, who has been in and out of approximately twelve foster homes. We are trying to make a suitable home here until he is eighteen and hopefully is ready to go on to college. I think what is important for the children that I have, the children that I will foster in the future, is to be consistent. Be consistent in their values. Be consistent in their discipline. Be consistent in their education. Be consistent in their hygiene, their ethics, and their moral codes. I think that is probably one of the foundations or the common denominator in which we need to stand by in raising our youth."

TERRANCE HALL AND FAMILY, SACRAMENTO, CALIFORNIA.

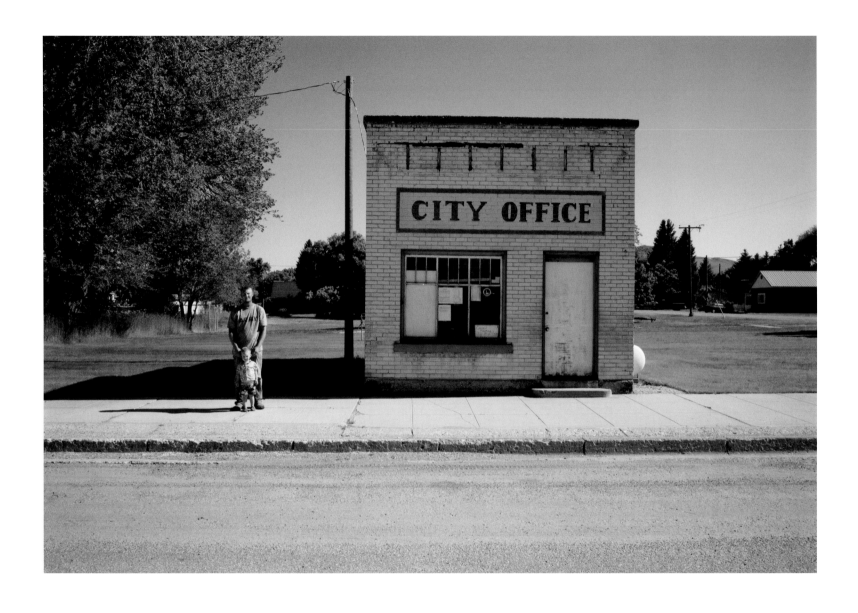

JEFFREY HATHCOCK AND SON, WESTON, IDAHO.

"The most enjoyable part of being a father is mainly just being a dad.
The most challenging part is knowing that you're doing it right.
You're always second-guessing yourself. Am I disciplining him right?
Am I raising him right or what? But, if you can't step up and be
a parent, then you're not going to make it through life."

JEFFREY HATHCOCK, WESTON, IDAHO.

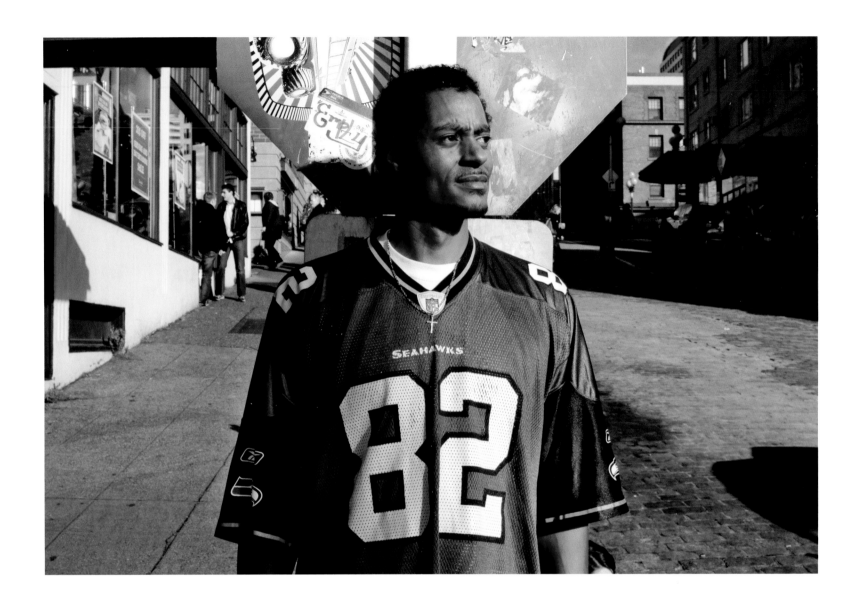

WILLIAM HAYNES, SEATTLE, WASHINGTON.

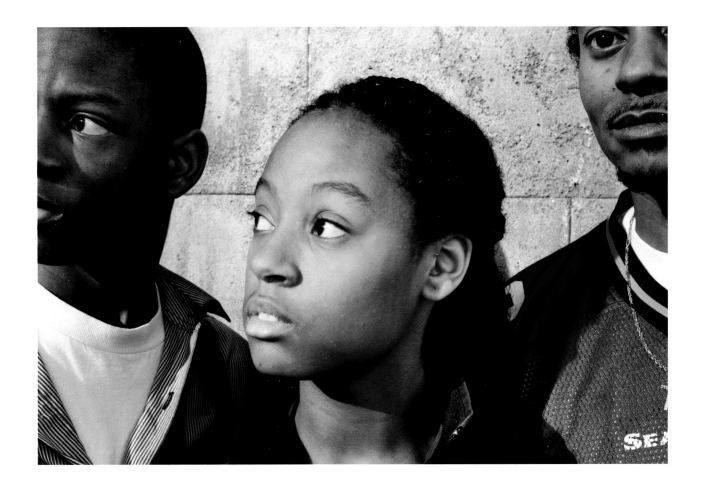

"Growing up without my father was like having a hole that was never to be filled because all the things or the questions that I would have had for him I had to find out through my own understanding and what I saw from other people like my friends' fathers or coaches or other people I had contact with in my life. Personally speaking, the lack of a father in a home, it can create destructive behavior. I know that because I was one of them. I also saw the same remedies in my own children from the time I was away from them in prison to the time I was having to rebuild my relationship with my children. So, I say that I'm blessed to have this opportunity to be in the life of my kids because now they have a much more positive outlook on life. They strive to reach higher. That wouldn't have been something they would have been doing had I not be able to be a part of their lives. For kids across the country, without that model and stern voice to be able to stand there and get their attention, they tend to drift off into this defiance stage and stay there a lot longer than they should."

WILLIAM HAYNES, SON, DEVONTE, AND DAUGHTER, LATIA, SEATTLE, WASHINGTON.

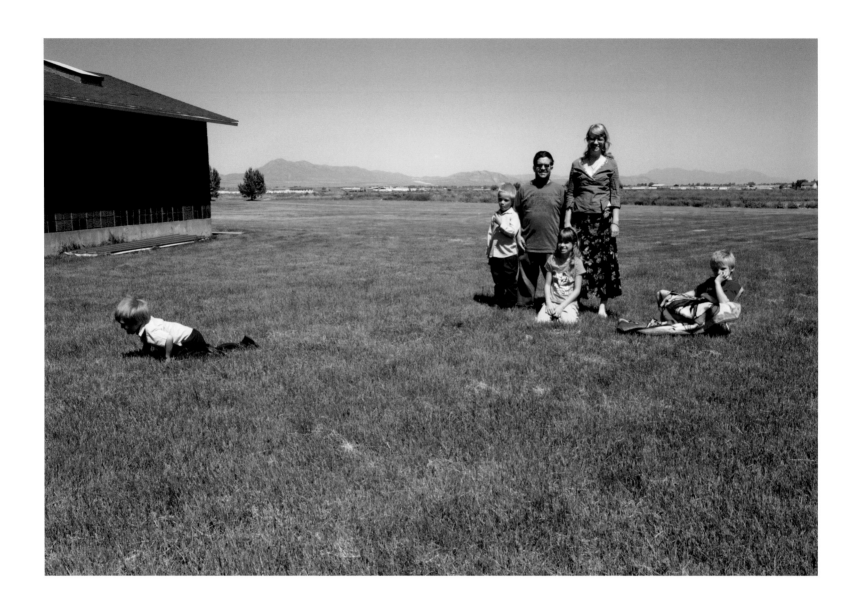

MICHAEL HENIGER AND FAMILY, LOGAN, UTAH.

"My relationship with my dad has always been good. He's always been there
for me. Taught me everything I know from mechanics to living outdoors and
stuff like that. He's always been a very big influence on my life. It is hard being
a dad. It takes a lot and lot of energy, but it's really worth it to see it in the end.
The best part about being a dad is, from what I've heard, actually being a grandad.
You be good to your kids, and you'll have some wonderful grandchildren.
So be good parents and then you can also be great grandparents."

MICHAEL HENIGER, LOGAN, UTAH.

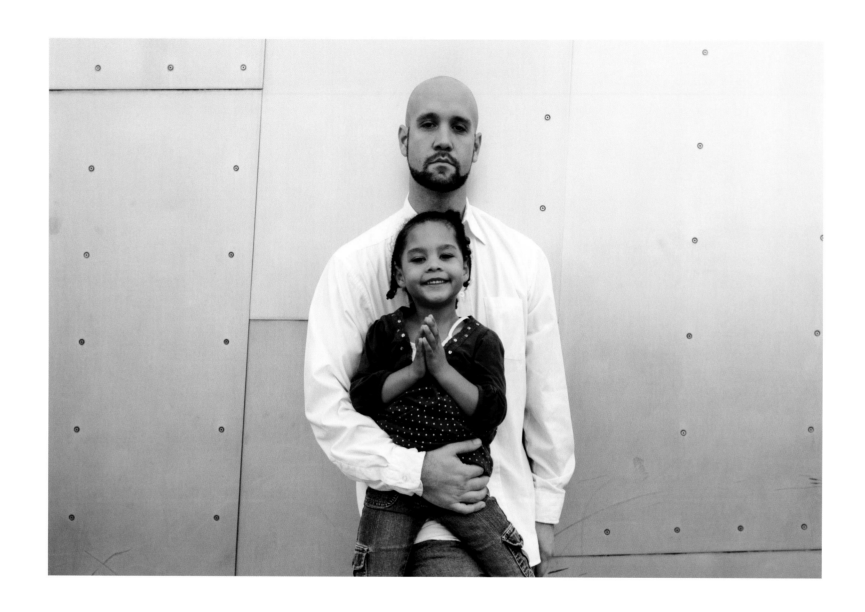

BRIAN P. JACKSON AND DAUGHTER, FATIMA, SEATTLE, WASHINGTON.

"My parents got divorced when I was about twelve. When dad and mom separated, me and my brothers all ended up going and living with him. He has been a real effective role model for me through some of my own problems. One thing he was always real heavy about was the fairness thing, that things aren't supposed to be fair. Don't get caught up in comparing myself to everybody else and what they're going on with. As it turns out, it was a big example to me that he gave mom everything. He paid her child support every month, even though we lived with him. So it was real. It helped me feel good about myself. When I was twenty-nine or thirty, after my daughter was born, me and her mom separated, and my daughter ended up living with me. That's probably when I realized I was a man. The most joyful part of being a dad is just playing with my daughter and when she just comes to me out of the blue and says, 'Daddy, I love you.'"

BRIAN P. JACKSON, SEATTLE, WASHNGTON.

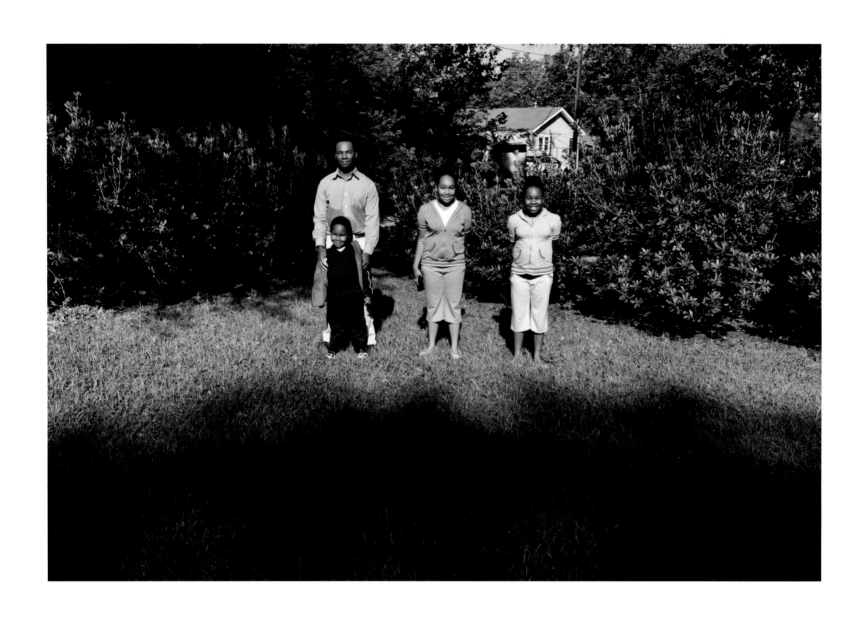

SHAWN JACKSON, DAUGHTERS, BRITTNEY AND CURTNEY, AND SON, JACOB,
BAY MINETTE, ALABAMA.

"My father was blind. He had glaucoma. From what I learned from him was just being around him and his fulfillment of being in other people's lives and giving enjoyment in just helping others. He taught me to be resilient and to work for others and always put people before you, just doing it in a Godly, spiritual way. My father was a father and not just a daddy. You hear of big celebrities and presidential nominees talking about fatherhood. It's all about what you do to make you a better father. If you can do anything that can just reach deep down inside to help your child, I think this is what changes the world. It would change the whole United States of America."

SHAWN JACKSON, BAY MINETTE, ALABAMA.

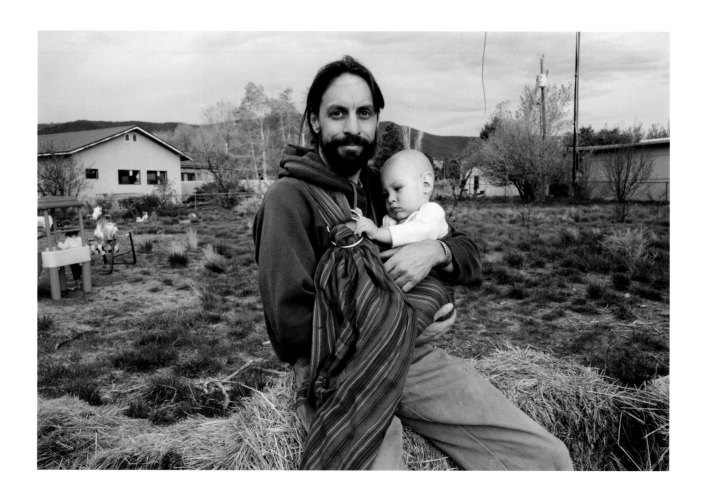

"Being a father, it's beyond words. There's a connection, and I know it's hormonal chemicals with a child. There's a smell of my baby, and there's a wholeness that I feel that I never felt before, and I feel closer to God, the Creator, you know, than at any other time in my life. I feel that having a child is a catalyst for spiritual growth and learning how to do more than self-centered things. It's a lot of sacrifice, but it's good sacrifice, and it's being present and letting go of past habits and learning patience. Really, that's where it's at."

STEVEN LAMAR AND SON, DAKOTA, TAOS, NEW MEXICO.

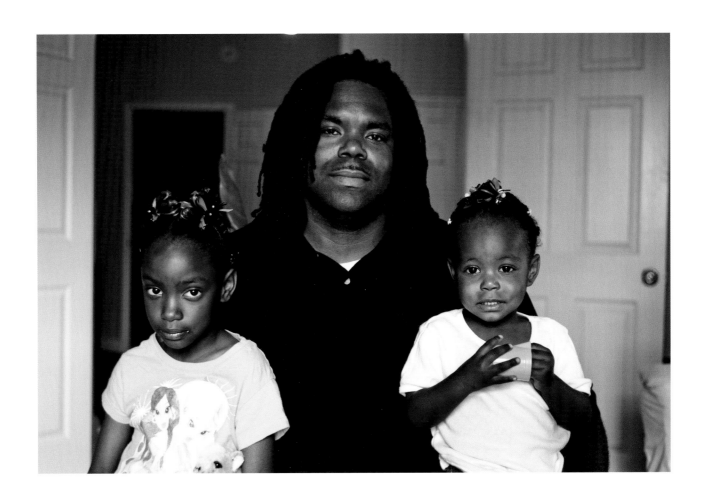

"My dad's a minister now, and I appreciate the father that he was in my life and still is, but he was in and out of my life as a child. If you put God first, you know, everything else is going to follow because through Him we can do all things, and I strongly and thoroughly believe in that. And that's being a good father, and it speaks in itself, you know?"

DANIEL LLOYD AND DAUGHTERS, NEW ORLEANS, LOUISIANA.

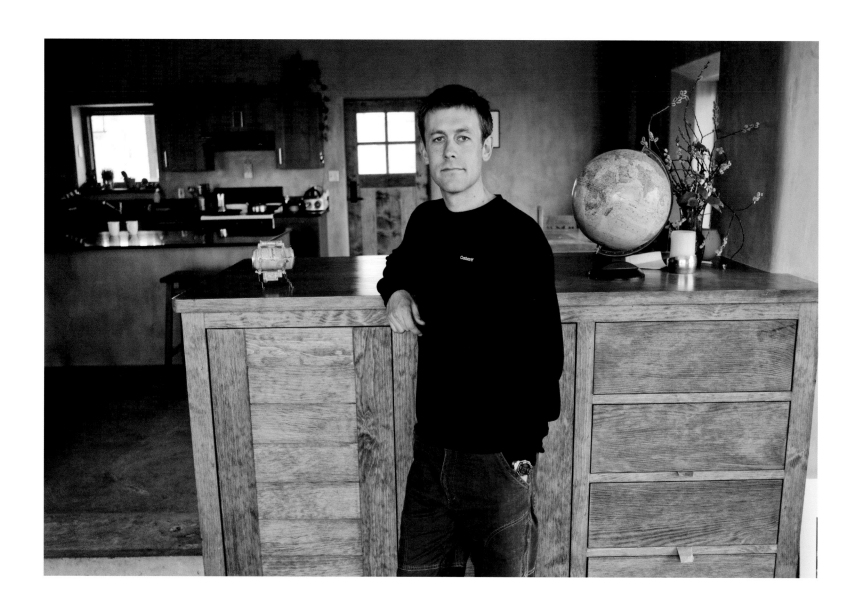

JED MAGEE, TAOS, NEW MEXICO.

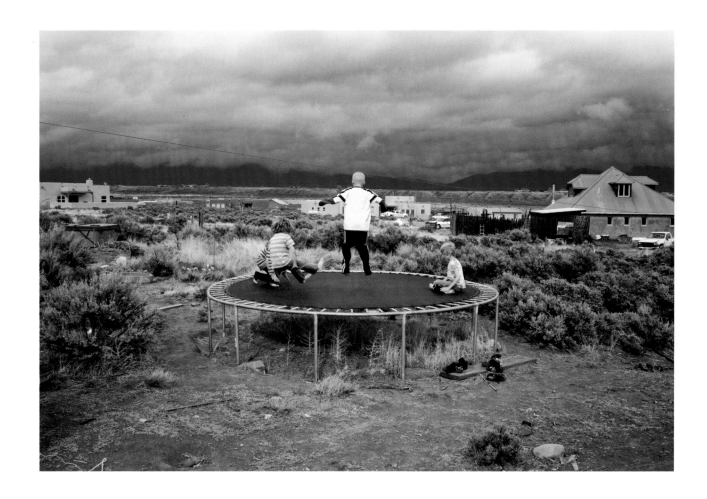

"My dad took the responsibility of being a father very deeply. It was always apparent to me that it was his number-one priority to provide not just in the material sense, but to be spiritualy and emotionally available at all times. I think I'm a very interactive dad. I've always coached their soccer teams, participated in their ski programs, and am actually the chairman of the board at their school. So I think that I'm following in my father's footsteps."

JED MAGEE'S SONS, KIERAN STORM AND SKYLER BLAZE, AND FRIENDS, TAOS, NEW MEXICO.

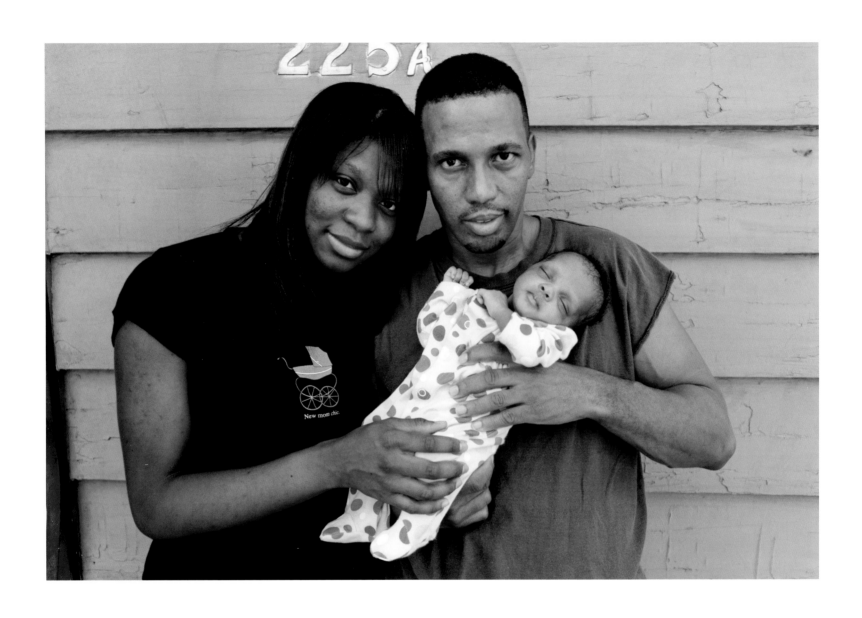

DONALD MORRELL, HIS WIFE, AND DAUGHTER, ATLANTA, GEORGIA.

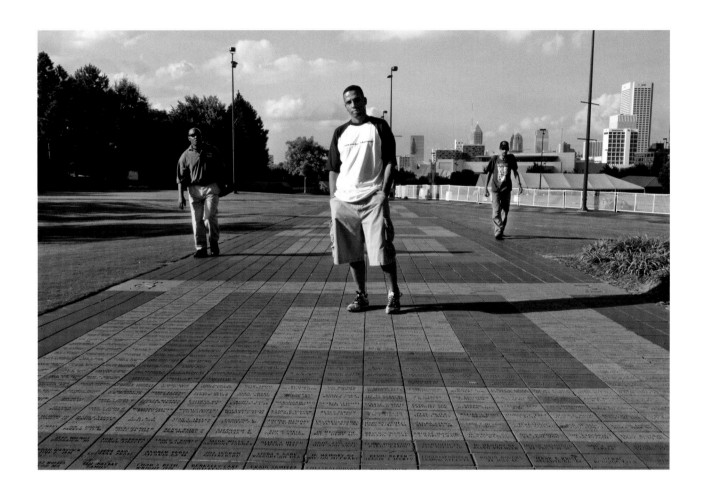

"My dad passed away like twelve years ago. Before he passed away, I would say our relationship was as good as it possibly could be, considering he was a Vietnam War vet, and he experienced some things in the war that kind of affected him emotionally and mentally. That caused a little bit of a hindrance in our relationship, and it definitely had an enormous impact on the way that I have chosen to be a parent. Regardless of any situation, you have to be a part of your child's life. If you're married, great. If you're single, still great. Just be a great dad. Stick in there. You're going to watch your child grow and develop, and it's going to be a great feeling, and your child will never forget it. It's very meaningful."

DONALD MORRELL, ATLANTA, GEORGIA.

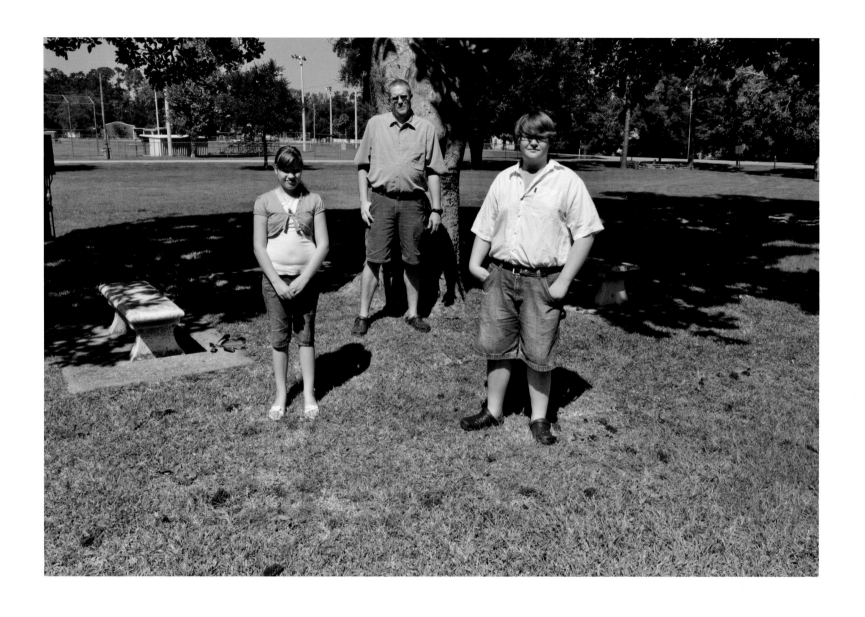

DOUG MUNGER, DAUGHTER, REBECCA MICHELLE, AND SON, DANIEL JASON,
ELBERTA, ALABAMA.

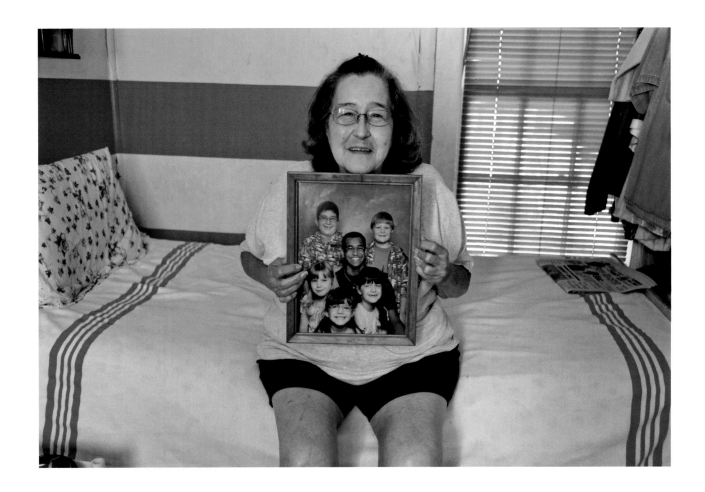

"From my experience with my second wife, I was not involved with my family for about four and a half years, my children and my entire family. It was because I was following the lead of my second wife instead of following my heart and being with my kids and my family. Once I realized that, everything got better, but it did damage the relationsip I had. Especially with my daughter. We're working on rebuilding that now. I urge every father, no matter what their situation with their ex-wife, their child's mother, the baby's mamma as they call it, just be involved somehow, some way. Their child needs that. Don't walk away from the children. They are the most precious things we have on Earth."

DOUG MUNGER'S MOTHER, ELBERTA, ALABAMA.

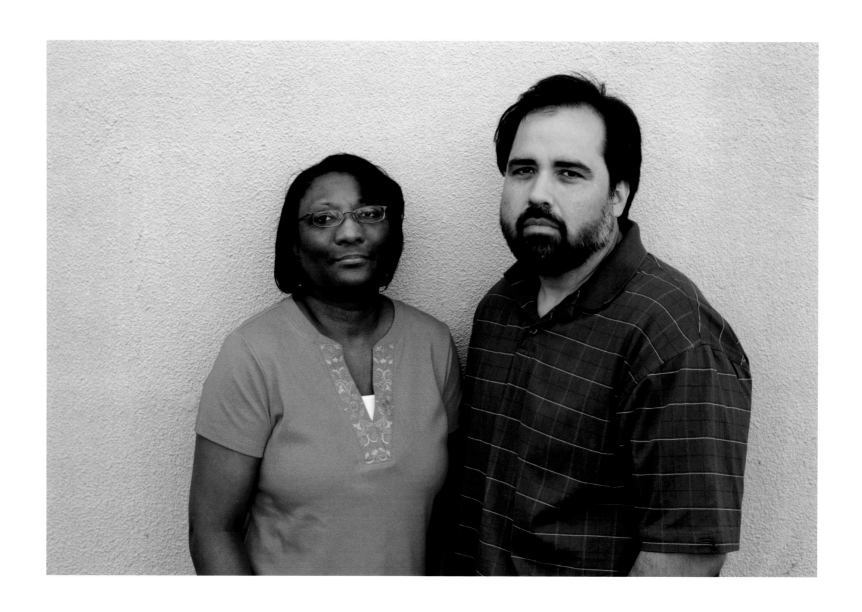

ANTHONY OROPEZA AND WIFE, SACRAMENTO, CALIFORNIA.

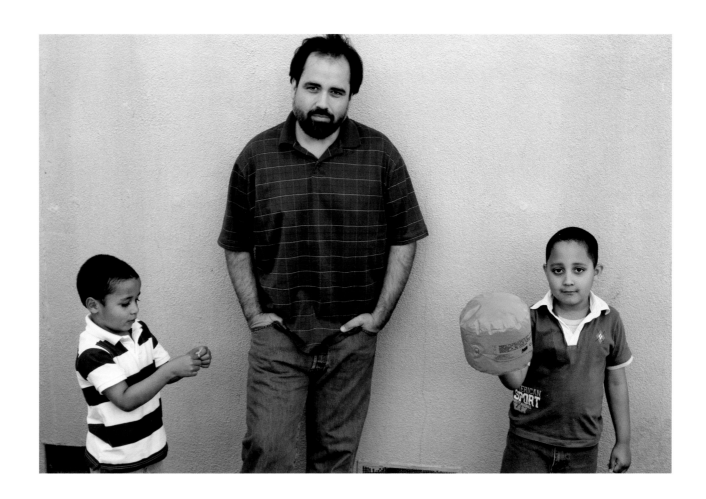

"There's no perfect dad out there. The fact that my dad wasn't around a lot impacted me. So I certainly want to be there for my kids because I remember him not being there. It is a balance of quality and quantity. You want to be there for your child as much as you can, but you also want to give your child a quality experience. So I enjoy going to my son's school and helping out in the classroom and stuff like that."

ANTHONY OROPEZA AND SONS, SACRAMENTO, CALIFORNIA.

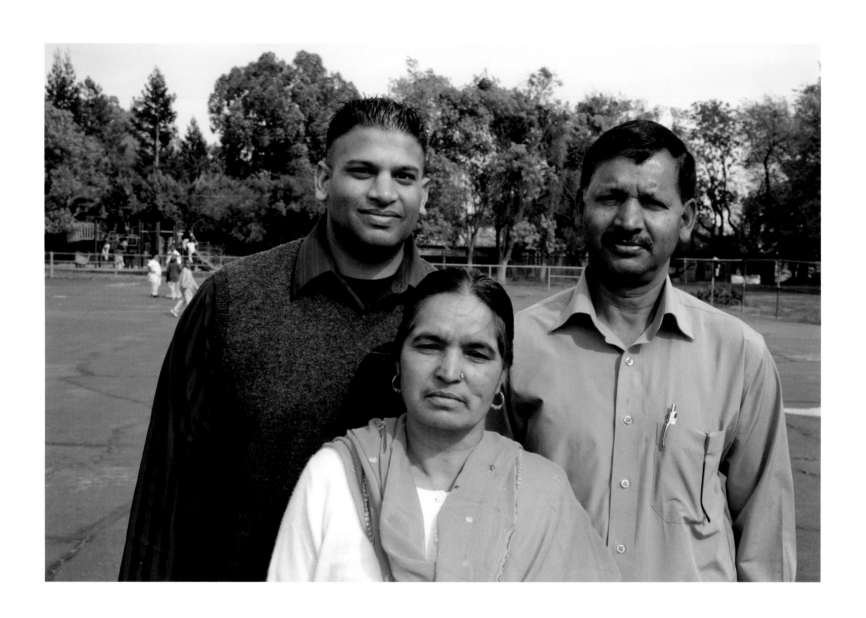

VIJAY PEGANY AND PARENTS, SACRAMENTO, CALIFORNIA.

"I come from an East Indian family, and the father and mother play a very important role in our family unit. My father was an extremely hard worker. He supported me in everything that I wanted to do. At the same time, he was extremely strict, so that was kind of difficult. But growing up as a first-generation American, it was great to have my father there. Some of my friends that are from America did not have their fathers or they've divorced, and you can see the effect that had in their life and just how they strayed, whereas my father was there to help keep me on track. I think the way people learn is by example. If your father is around or is in your life, that is how you are going to learn how to be a father, for the most part. What I did was kind of like in sports where you see another athelete, or, if you are playing basketball, you try to steal their moves. So I took whatever was good from my father and whatever wasn't good and tried to pick up on my own."

SHAREEN, DAUGHTER OF VIJAY PEGANY, SACRAMENTO, CALIFORNIA.

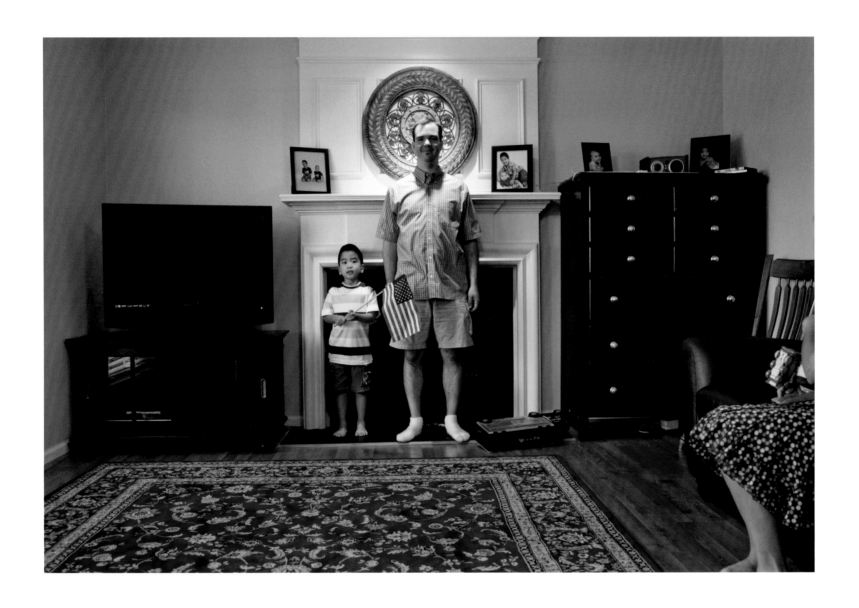

MARSHALL POTTER AND SON, ALPHARETTA, GEORGIA.

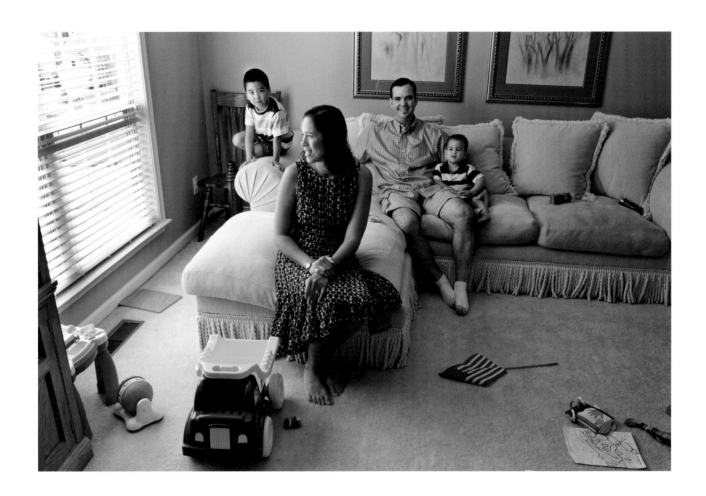

"I'm one of ten kids. I'm the oldest. One of the things my dad really focused on with us was spending quality time, making sure he got home from work early. He was always there at games, football, soccer. The second most important character trait I've picked up from him is his goal to always be improving. I think our culture pushes us a lot to define success in terms of how we do at work. I would really encourage guys to think broadly about their life, to think about what it means to be a great dad, to be a great husband, and to realize that being a good dad is what success is about. It really matters what you do there. Some day at work, they're going to replace you, but no one can replace you in what you do as a dad."

MARSHALL POTTER, HIS WIFE, AND SONS, ALPHARETTA, GEORGIA.

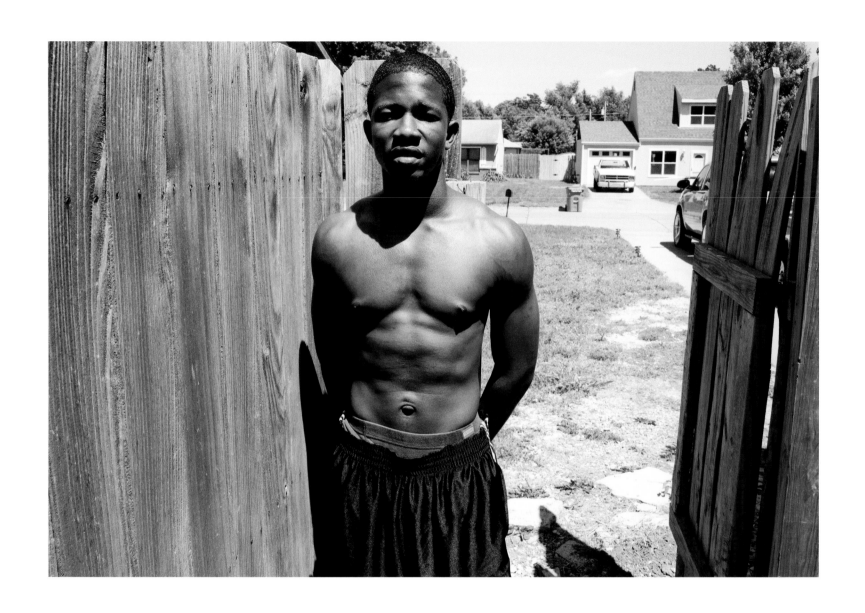

DONOVAN, OLDER SON OF CLIFFORD PRICE, MANHATTAN, KANSAS.

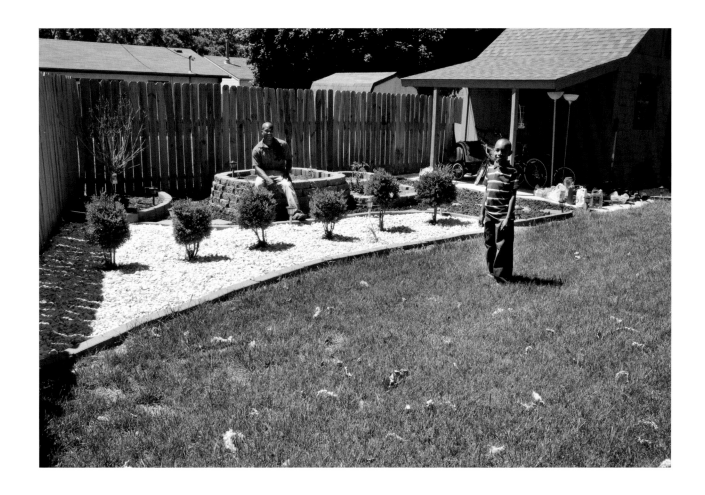

"My dad lives in Tennessee. He's a very active person. I actually took after him.
He always asks me how I'm doing and everything. He was in the Vietnam War
and was wounded and then sent to Korea until he was discharged from the Army.
Patience is one thing I learned from him and the value of spending time
with your children. The main thing for dads to know is family is first because,
no matter what happens—if they lose their job or their job leaves them,
or if they get hurt and can't work anymore—their family is still there.
So put your family first, especially your children."

CLIFFORD PRICE AND YOUNGEST SON, MANHATTAN, KANSAS.

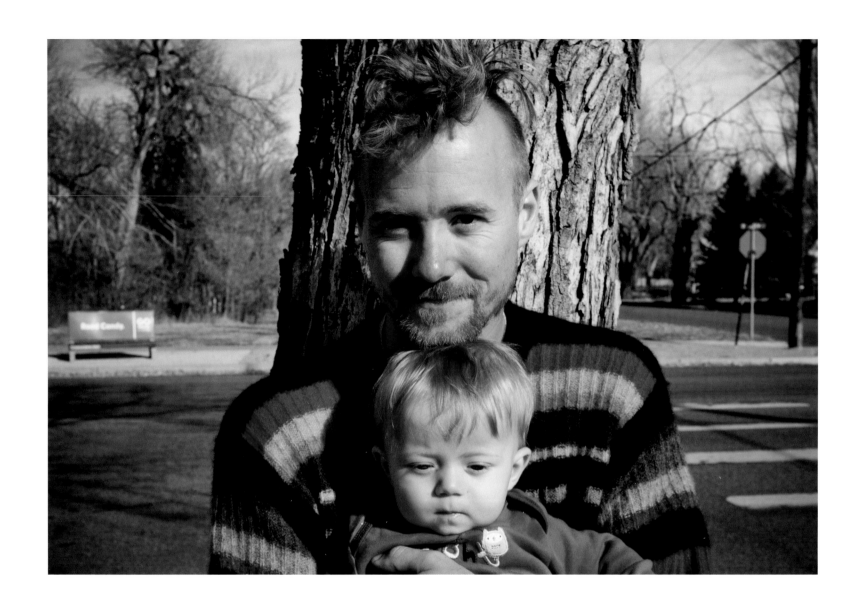

JUHHL RIDDEL AND SON, SAGE, COLORADO SPRINGS, COLORADO.

"My dad taught me a lot, like integrity and just standing up for what you believe. You know, if something's not right, you got to say something. I haven't really gotten to be a father to Sage much yet, because we're still in this custody thing. Next week I'll find out how much I get to have Sage. With the job that I do, my boss is very, very accommodating, because he actually went through the same thing with a divorce and the single-parent thing, and he understands. It's not just me anymore. I've got this little bundle of joy to raise."

JUHHL RIDDELL, COLORADO SPRINGS, COLORADO.

113

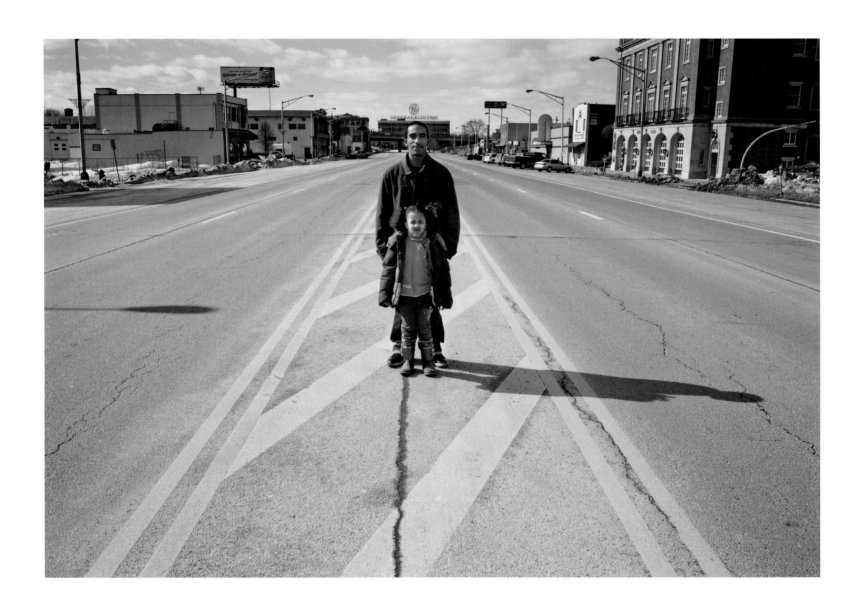

WILLIAM RIVAS AND DAUGHTER, SCHENECTADY, NEW YORK.

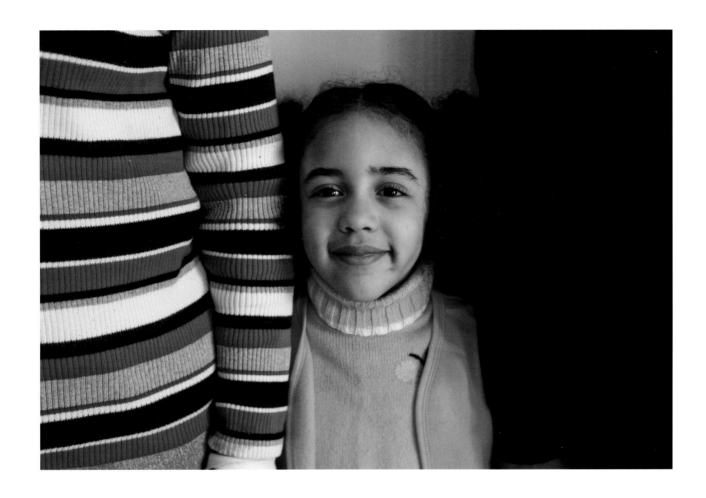

"The most challenging part of being a dad is being able to provide because, the way the economy is, it's very difficult to do what you need to do. There's not a lot of money going on. There's not a lot of help going around. I made a very bad decision, and, because of my decision, I had to be taken away from my child for a little while. I want her to know that her father was never a quitter. Regardless of the mistakes that her father made, no matter what limitations were put on me—whether it be family court, or probation, or just not having money—I never gave up trying to be in her life. Never stopped trying to be a better person and, you know, give her a better life. That's what I feel like a parent is supposed to do."

WILLIAM RIVA'S DAUGHTER, SCHENECTADY, NEW YORK.

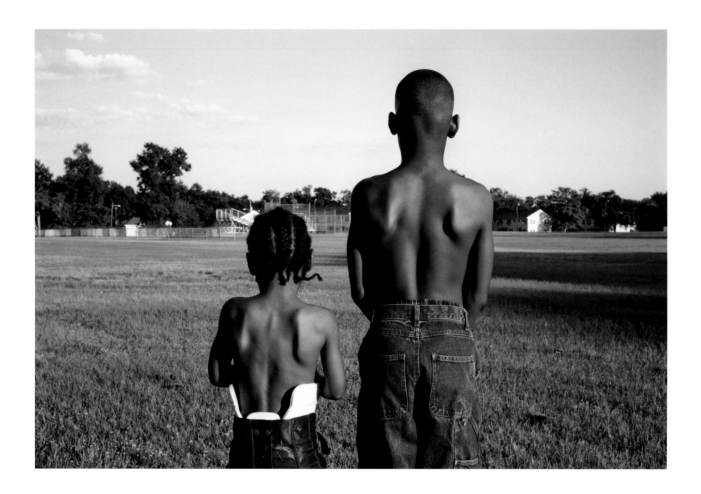

"My Mamma taught me that kids have to lay in their own bed. If they make their bed hard, they have to lay in it. She said, 'There's two things I won't come and get you out of trouble for and that's stealing and selling drugs.' I was eighteen. I did steal for the first time, and I got caught on my first time. When the jail called Mamma at home, she didn't come. She told them to keep me. I knew that I was a man when I went to jail. These are not my only children. This is my stepson and my bioligical son. I have seven more kids that don't live in my household. Right now, I'm a little over $100,000 in arrears in child support. I don't see no time soon me catching up, even in the next thirty years. I'm trying to pay my regular payment and trying to pay on the arrearage. I hope the court sees that. I'm making an effort to pay something instead of not paying nothing. Today, the way the world is, it's so hard. Gas, groceries, bills, everything is going up. But, if you're on child support, pay it. It's the best thing you can ever do."

ERNEST AND CRISTIAN, SONS OF CHRIS ROBINSON, MOBILE, ALABAMA.

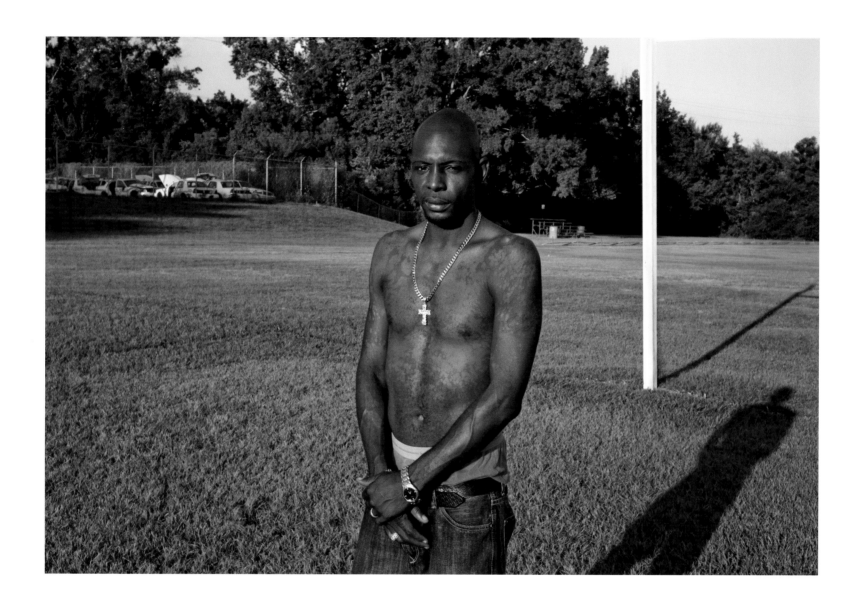

CHRIS ROBINSON, MOBILE, ALABAMA.

MORGAN STREETER, DES MOINES, IOWA.

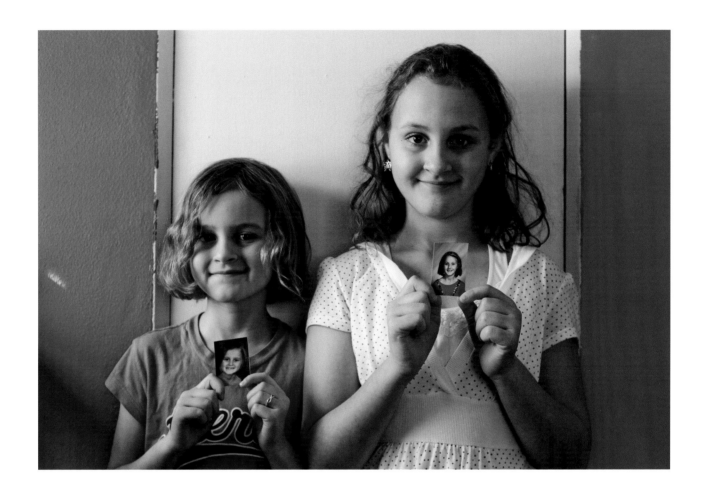

"My dad was a big spanker, so I learned that I wasn't going to do that. But I also learned to care for people and its your relationships with people that are going to matter. Not so much money, not so much wealth and what you have. Family comes first, but it's also that time together. We had supper every night together, to keep us connected, to go over the day. I've carried that on. Today, there's just not enough time, especially when you're dealing with divorce. I have my kids a little bit less than half the time, so, when the girls are here, I want to have time with them. They are getting older where they want to have time with their friends, so it's a balance. You have to prioritize and set limits and tell your boss 'No' every now and then."

MORGAN STREETER'S DAUGHTERS, DES MOINES, IOWA.

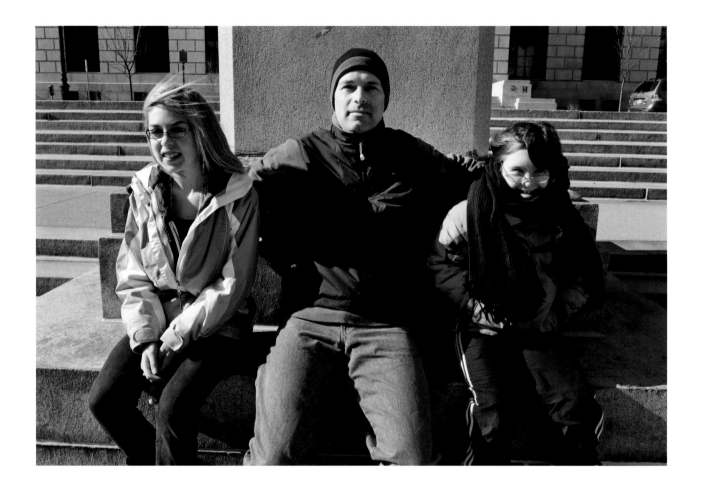

"My parents were divorced. I lived with my mom, and, through the divorce, my dad had visitations, so we usually spent Sundays with him. Even though I lived with my mom, I tend to gravitate more towards my dad. My father, he grew up on a farm, and then he worked in leather mills, and that was a very hard, stressful job. He was just busy all the time but still had some time for us kids. The work ethic was something that I really think I picked up from him. The importance of being a committed dad is huge because you see all over that the divorce rates are up. Fathers are disconnected from the family. Moms are struggling to raise their kids alone. Being the dad, you're part of the process that brought the child into this world. There's that saying, 'Anybody can be a father, but it takes a certain person to be a dad.' You have to be a part of your child's life, just to make sure that they're safe and they're healthy and everything is going fine. Dads need to know just to be there, whether you're with your spouse or not."

JIM SWART AND DAUGHTERS, CASSIE AND MADISON, ALBANY, NEW YORK.

JIM SWART, ALBANY, NEW YORK.

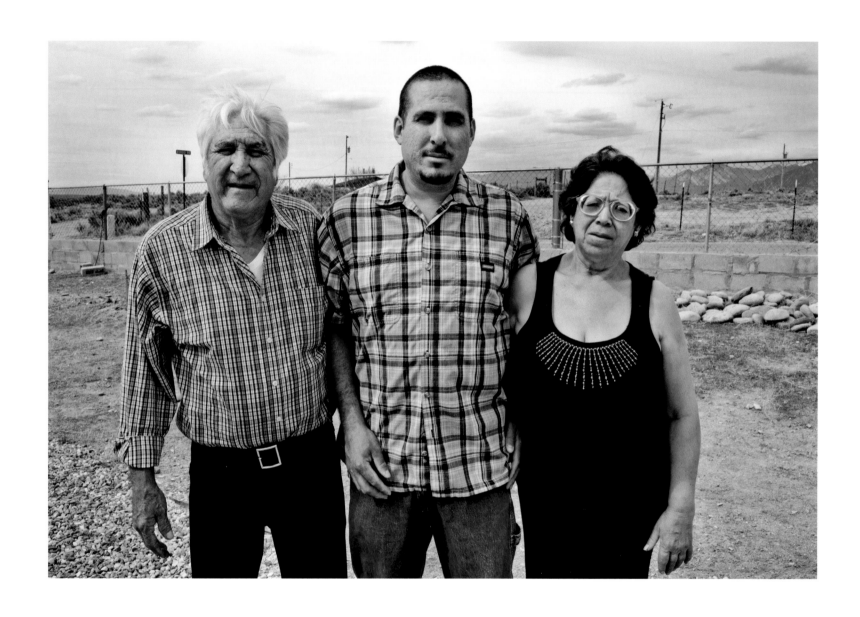

JOHN TAFOYA AND PARENTS, RANCHO DE TAOS, NEW MEXICO.

"I try to teach my daughter right from wrong. How to pick up her toys after she plays with them and be careful not to get stuff that she's not supposed to have. The tough part of being a dad is being patient. Not going on a bad temper, not yelling at her, and just talking to her with good words, and she won't grow up yelling. I want her to understand how I am teaching her now, so hopefully she says the same thing that I'm saying. Dads should bring their kids up the right way and teach them right from wrong and, if they need something, you be there for them always."

JOHN TAFOYA AND DAUGHTER, KIENNA, RANCHO DE TAOS, NEW MEXICO.

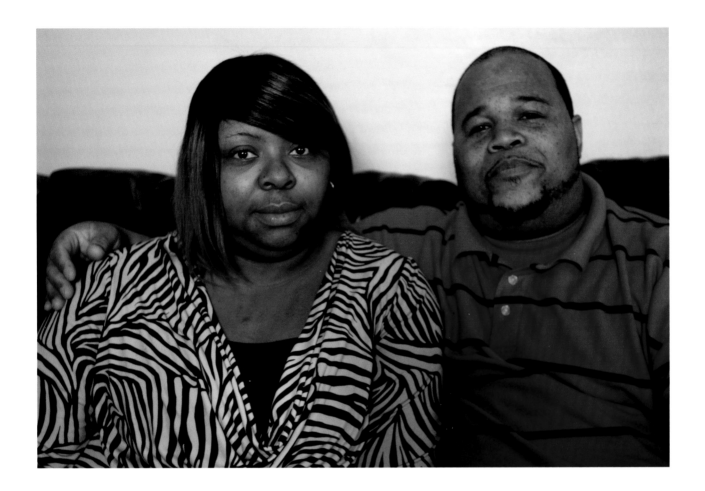

"There is a certain point in our lives where we really need to come to grips with who we really are. And, by doing that, I believe that we as men, globally, would then be better understood or begin to present ourselves in a fashion to where people would respect us more as being men and fathers. If we begin to encourage the things that the fathers *are* doing and not so much beat up on them with what they are *not* doing, I can guarantee encouraging a man releases some stressors in our lives that we will be more effective as men and fathers. So I encourage all men to come out—fathers, fathers-to-be, and men *thinking* about becoming a father. There is nothing like preparation now. Something may take place in a man's life, and they have a child. It wasn't planned, but they have a child or a seed. So let's get hold of the concept of what a father is. And if men marry into a family where a woman already has children, they know how to be a father."

JOHN THOMAS AND WIFE, MILWAUKEE, WISCONSIN.

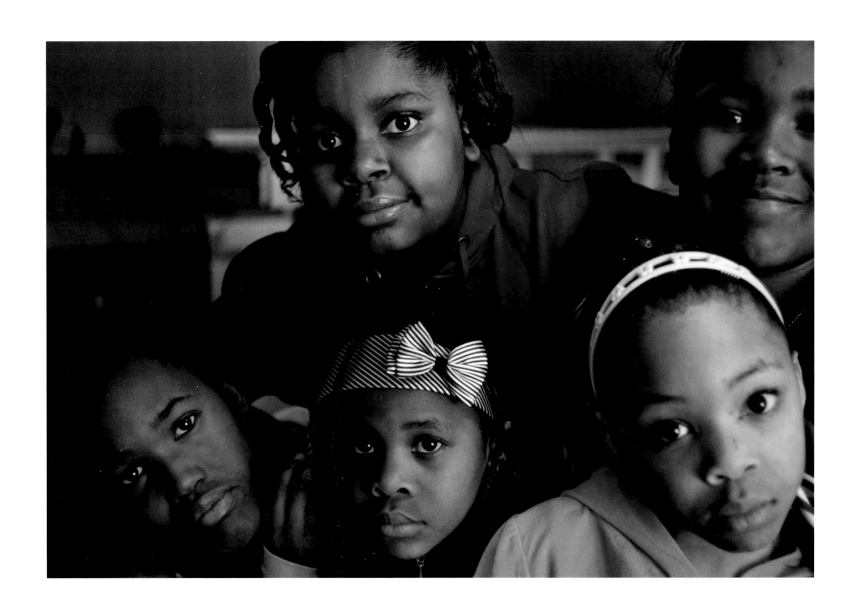

CHILDREN OF JOHN THOMAS, MILWAUKEE, WISCONSIN.

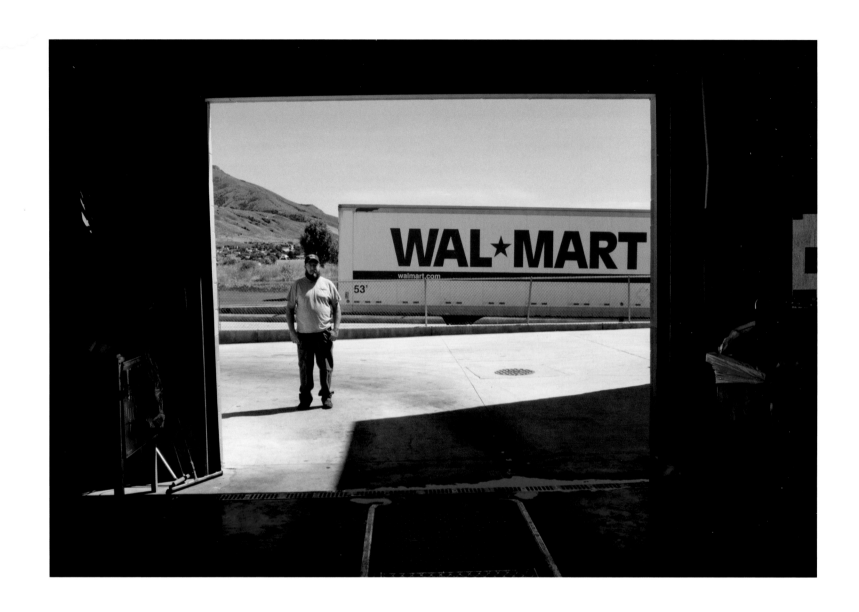

RANDY TOLMAN, BRIGHAM CITY, UTAH.

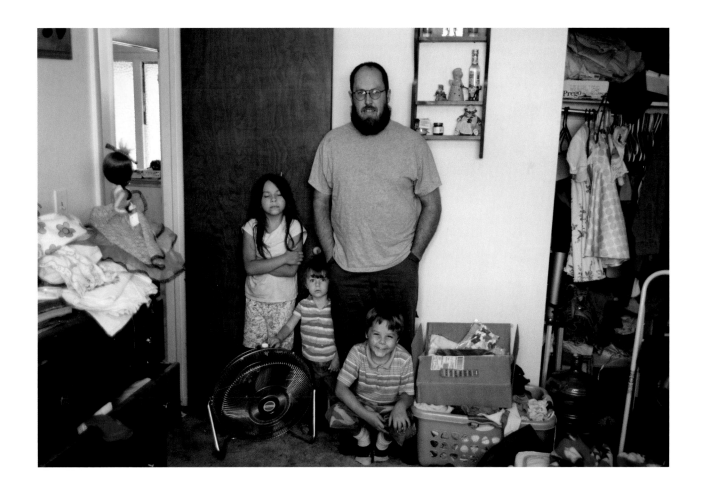

"My dad worked quite a bit. He was working on overnights, swing shifts, so we didn't see him a lot. But the time we did spend with him, he would make sure he would stay awake to spend time with us and then sleep later on. A lot of it was we communicated with notes. We would write notes to each other and leave them on the kitchen table. He would see them when he would come home from work. For a while, I was driving trucks, so I was away from home for four to five days out of the week, and I knew that wasn't something I wanted. I wanted to be here more with the kids growing up. I try to be really involved with them in the activities that they do. We lost a little bit of money when I went to Wal-Mart, but it is right here, two blocks from my house. Sometimes you have to look at the priorities and think, 'Wow, maybe we can get by without quite so much money and get a job that's closer to home.' It's harder nowadays to find a job that way, but I think I got lucky. I am able to be home with the kids more, and they can come see me."

RANDY TOLMAN AND CHILDREN, BRIGHAM CITY, UTAH.

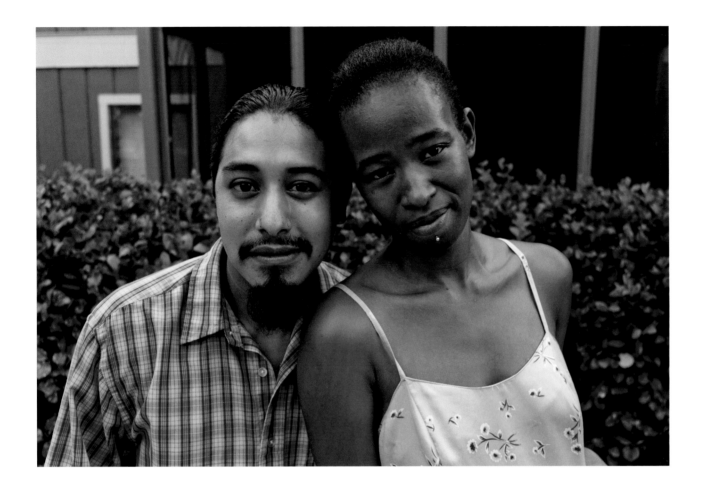

"I believe the father figure is really important in everybody's life, and I missed that part. I told myself, 'I don't want my family and my kids to suffer.' It made me work harder and also teach myself to maybe take care of my kids and don't let them go through that situation. I think our kids make a big change in our lives. If we take care of them and make women for the future or men for the future, it will teach this world maybe something different. Sometimes we don't want to have responsibilities, but, when we have them, we have to keep working and try to do the best effort. I think I'm a lucky person to be here, to have my family. I thank God for everything, for giving us some kind of strength to keep making things better."

GONZALO PAREDES TOSCANO AND WIFE, DORAVILLE, GEORGIA.

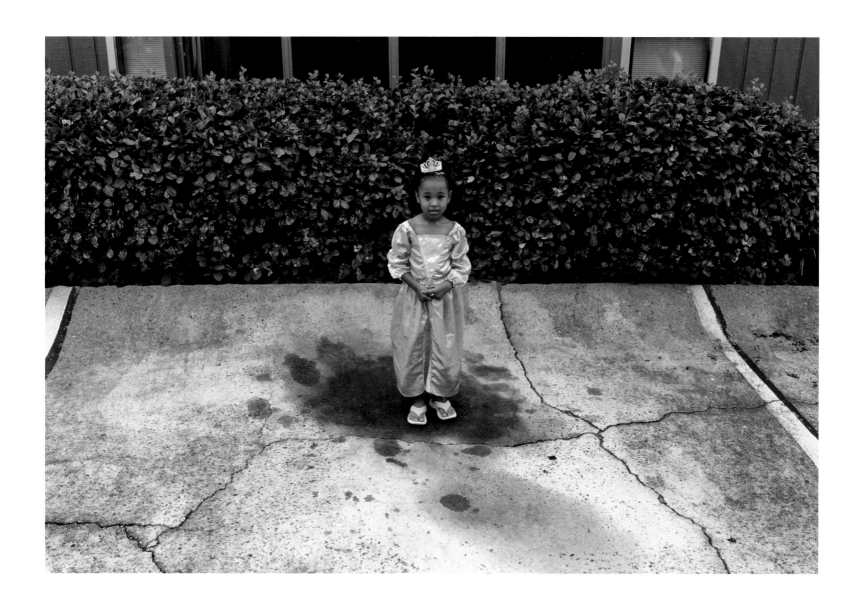

GONZALO PAREDES TOSCANO'S DAUGHTER, DORAVILLE, GEORGIA.

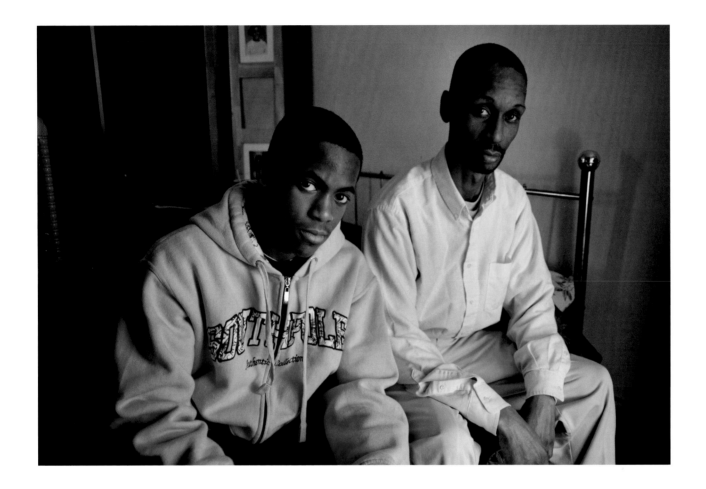

"Andrew, he's like a son to me. We hear so much about young people
these days. There is so much in a negative light that I want to add my influence
to make it a brighter and more positive light on them. I think children, after it's
all said and done, will look back and say not how much you spent on them, what
you purchased for them, what kind of house; it's what kind of time and quality
time and, more importantly, loving. Love them where they can grow, and know
that you love them. The greatest job on Earth that you have is to be a parent.
As a byproduct of one parent, my mother, raising me, I've always vowed that
I wanted to be the greatest father on Earth. Even though I'm not directly
at this time a biological father, I consider myself as a community father."

BEN WATSON AND MENTEE, ANDREW, MILWAUKEE, WISCONSIN.

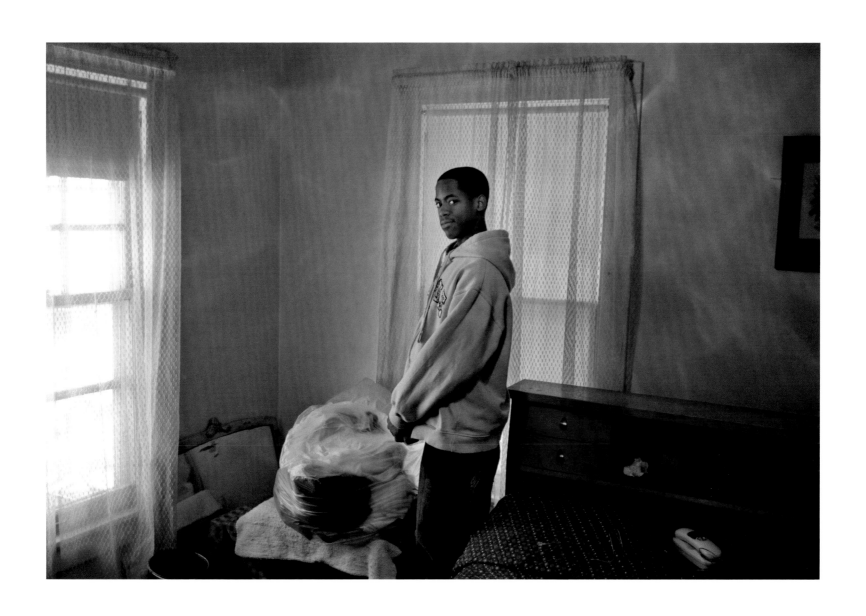

ANDREW, MENTEE OF BEN WATSON, MILWAUKEE, WISCONSIN.

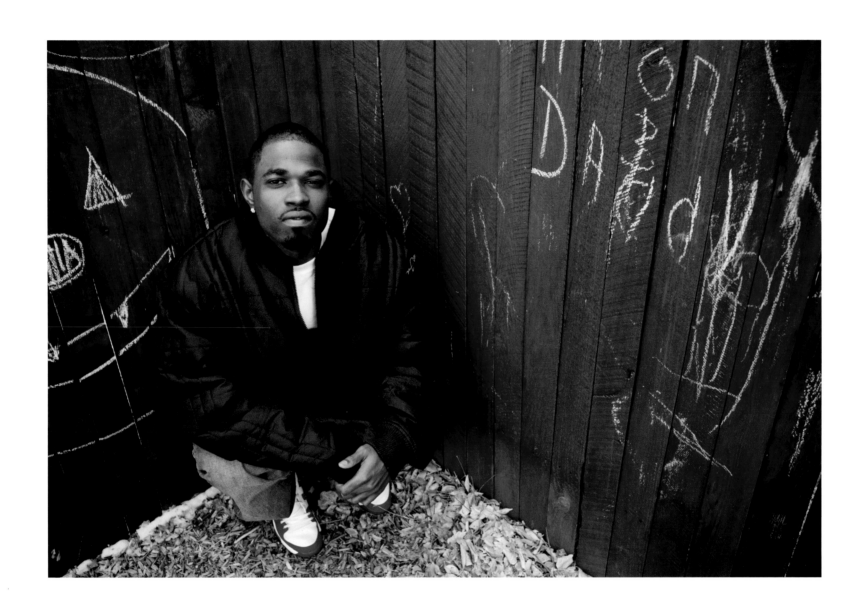

RYAN WILLIAMS, COLORADO SPRINGS, COLORADO.

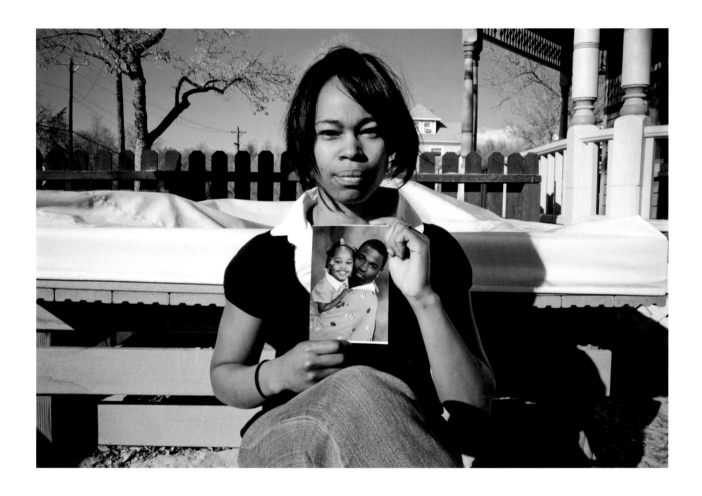

"My dad really was never around. I don't know where he is today. I was raised by my gramma. My grampa passed away. I really didn't listen to her or relate to her like I should because she was a lot older than me. Not having a dad around really influenced me with my daughter, that I know I have to be there for her, and I have to be around. My gramma raised me to take care of responsibilities. I feel like I'm a good dad. I'm not great because I've made some mistakes here and there. This is my first daughter, my first kid. It's just fun. Probably the best experience in the world was watching her be born and then cutting the umbilical cord, just being there for the whole birth process. I don't know how you cannot want to give your kid everything, just seeing what you created. Everything may not go right between you and the other parent, but you always have a strong bond with your kid. That's the most important thing—just have a strong bond with your kid, because the kid needs both parents."

RYAN WILLIAMS'S WIFE AND DAUGHTER, KIARA RENEÉ,
COLORADO SPRINGS, COLORADO.

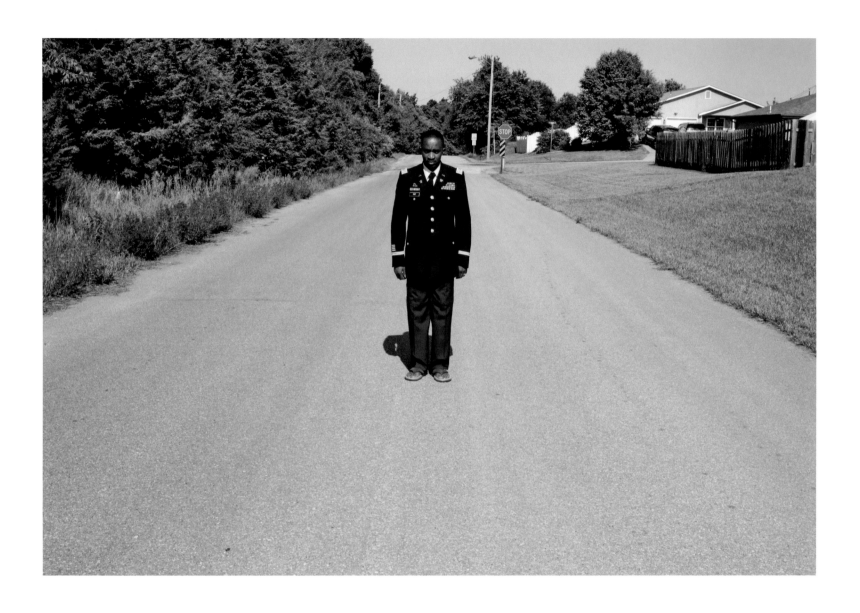

TEFLON WINT, MANHATTAN, KANSAS.

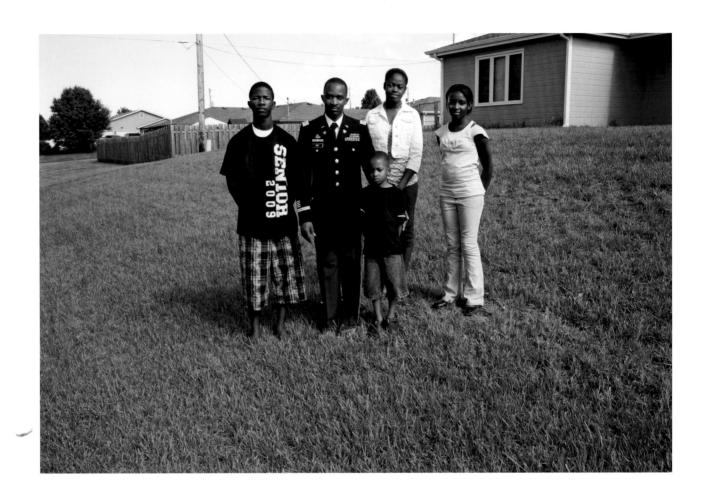

"Honestly, my father didn't play the father figure that I expected. So I learned pretty much how to be a father by looking at the examples he set and, I mean, his lack of being present. From then I said, 'When I'm a parent, these are the things I need to do so my children can be successful.' That is, being actively engaged in their day-to-day life and assisting them in whatever way possible so they can be successful. So I learned how to be a father by the absence of my father. That's a big job, being a dad to four children. You ask, 'What would you say to other dads by way of advice about fathering?' Just be there for your children. Just listen to them because, sometimes pushing your values, it's a communication thing. I'm not saying that you should let them have their own way, when you listen to them, you understand why they are thinking or doing the things they do, and then you can show them why it's wrong, not to do it. Do you understand?"

TEFLON WINT AND CHILDREN, SHANE, SHAMARA, NIKITA, AND T. J., MANHATTAN KANSAS.

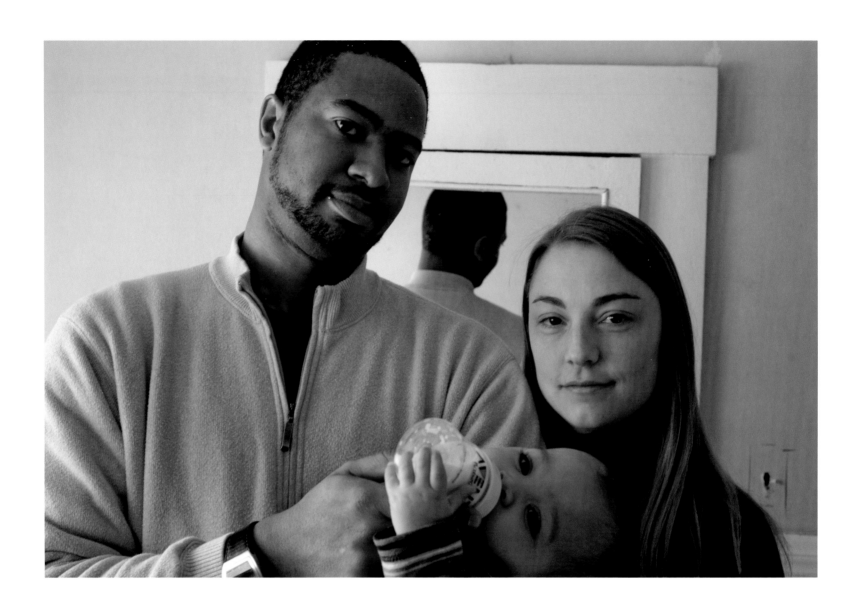

MARVIN BYNAM, HIS WIFE, STACY, AND SON, MILES,
MILWAUKEE, WISCONSIN.

• Making Room for Our Fathers

by Shipra S. Parikh

WISCONSIN FATHER MARVIN BYNUM had the following to say about fatherhood: "Look, for starters, envision what you want to be, what kind of father you want to be. Take it day by day. Keep the faith. And, three, just have fun." Another Wisconsin father, Keith Glass, Jr. (page 78–79), said, "The children need to see the mother and father at least working together—some form of togetherness. They'll feel that both of my parents care for me. It makes them walk a little straighter." Surely, there is no one recipe for successful fatherhood, but Marvin and Keith are examples of fathers who, like many others out there, are striving to figure it out, each using their own recipes to cook up "good fatherhood" for their children. Current U.S. Census data estimates that there are 67.8 million fathers living in the United States today and that approximately 25.8 million fathers are part of married-couple families raising minor children.[1]

The quest to be a good father is as old as time itself, for as long as there have existed families, children, and communities, there have existed fathers. Once upon a time, most fathers took their place as leaders in family functions, social dynamics, and child rearing. Historically, the paternal impact has known few limits, shaping everything from family life to the development of social institutions and effectively defining our cultural legacy. A shift has occurred, however, by which the modern paternal impact looks quite different today than in the past. Today, it is fatherlessness that calls the most attention to the issue of fatherhood. The very idea of fatherhood often connotes a lack of presence and minimal contributions made to children's lives, particularly when compared to mothers. With thirty-three percent (more than 24,000,000) of children living in father-absent homes today in the United States, the issue of fatherlessness is serious, considering that, forty years ago, only eleven percent of children lived without their fathers.[2] National Fatherhood Initiative (NFI) dubs this phenomenon "The Father Factor," which has

been credited for contributing to an extensive range of social problems, including poverty, incarceration, crime, and teenage pregnancy to name only a few.[3]

Scholars believe that a true understanding of fatherhood requires an integration of multiple discourses, three in particular, according to Garbarino—social science, human studies, and soul searching.[4] When discussing a topic such as fatherhood, it can be easy to get caught up in statistics (a social science), which provide a very specific picture of the events at play. It is equally important to represent the depth and breadth of the subjective experience of each child living without his or her father (human studies) as well as understand unfolding phenomena from a larger, contextual perspective (soul searching). From a social science perspective, data tell us in no uncertain terms that, whether absent or present, the impact of fathers is mightily felt in its consequences. It is all the more reason why a book such as this one is necessary—to provide a study of human life, allowing fathers to speak and be heard, their lives captured in visual moments to be shared with us so that we may know them more intimately.

Understanding fatherlessness as a social problem presupposes that we accept the importance of fathers in our own lives and in society. In this essay, I touch on aspects of each of Garbarino's three discourses on fatherhood in order to introduce the topic thoroughly. It is my hope that reading this book will empower readers to transform their knowledge into power. Our society is one we create together: let us begin to improve it by educating ourselves about fathers and fatherhood.

The Historical Context of Fatherhood

Research suggests that our conceptualization of the paternal role in Western culture has historically fluctuated and changed over time. Some authors highlight

the extreme definitions that have been applied to fathers at different points in history, painting them as either "dominant" or "peripheral" to family life.[5] Other terms used to describe this dichotomy include *cads* versus *dads*,[6] *deadbeat dads* versus *responsible dads*,[7] and *good* versus *bad* dads.[8] Seen from a larger perspective, historical data about fathers reveal four specific stages of fatherhood that have occurred throughout our nation's history, each of which has been subject to changing sociopolitical events and attitudes: (1) the father as the moral teacher; (2) the father as the breadwinner; (3) the father as the sex-role model; and (4) father as the new nurturer.

The importance of the paternal role, particularly for middle-class adult Caucasian males, is said to have originated in the colonial era of U.S. history, when a father was considered the dominant parent and assumed the role of "the moral teacher."[9] During this time, work and family life were interconnected, and fathers interacted closely and frequently with children. Paternal duties included supervision of child-rearing activities and decision-making power in economic, legal, medical matters, and, in particular, moral and religious guidance.[10] Evidence indicates that fatherhood in American Indian and African-American families during this era may have exhibited a wider range of emotional expression than that demonstrated in European-American cultures.[11]

The dominance of the father's role endured until the nineteenth century, when gender role changes and industrialization polarized parental spheres of influence. Economic demands increasingly sent fathers to work outside the home, decreasing their previous involvement in family life. Subsequently, the role of nurturer in the home and family shifted to women, and the role of breadwinner became synonymous with parental responsibility.[12] Industrial change, immigration, and poverty at the turn of the twentieth century dominated the socioeconomic climate, setting the stage for women to increase their contributions outside the family.

Although these changes did not necessarily diminish the need for the father's role in moral or other responsibilities, the industrial era heralded breadwinning as the archetypal paternal attribute, the yardstick by which fathers were judged to be good or not.[13]

Societal changes leading up to World War II ushered in a new conceptualization of fatherhood based on societal perceptions of male inadequacy, which persisted until the 1970s. Fathers' primary responsibility began to focus on providing a sex-role model, particularly for boys.[14] The conceptualization of fathers' roles in society was further complicated by prevalent psychological theories of the time. On one hand, Freudian theory emphasized the Oedipal complex and the father's importance in development, while attachment and child development theorists such as Bowlby and Mahler focused on the significance of the mother–child relationship.[15] Though psychoanalytic concepts maintained a strong influence from the 1940s to the 1960s, feminist writings opposing Freud's ideas also proliferated. In her 1942 commentary on Freud's ideas about gender roles, Clara Thompson explained that, while men and women share some basic drives, they are essentially different creatures for reasons of cultural attitudes and biology. She wrote, "Menstruation, pregnancy, and menopause can bring to a woman certain hazards of which there is no comparable difficulty in the male biology."[16] This perspective and others like it reinforced the significance of the mother–child dyad, relegating fathers to more peripheral roles in family life.[17]

The impact of social changes on men intensified during the 1960s, as illustrated by Richard Shweder's comment on men's changing roles: "Distinctions have been blurred . . . If you take away a man's economic function as breadwinner, does anything of value remain?"[18] Social movements and global economic changes reorganized traditional ways of thinking about individual roles and partner rela-

tionships, contributing to monumental changes in fatherhood. By the mid-1970s, the breakdown of the male breadwinner role and the steady growth of the number of mothers entering the labor force led to a new emphasis on equality in parenting relationships.[19] The "new father" of the 1970s and 1980s was expected to be an equal participant in all aspects of childcare, including pregnancy and childbirth.[20] Fatherhood broke new ground, as expectations of paternal responsibilities grew to include active, day-to-day nurturing of children.[21] These "new fathers," however, faced inherent difficulties, with few available socially sanctioned paternal role models and a lack of incentives to help men navigate their increased nurturing roles.[22] Faced with high expectations and nonexistent support systems, it is probable that many fathers during the latter half of the twentieth century experienced role confusion, which would only intensify for fathers disadvantaged by being married, young, low-income, non-custodial, and of minority and/or ethnic background.[23]

Despite the multitudes of changes that fathers experienced during the past several centuries, fatherhood did not emerge as a major focus in social science research until the 1970s, coinciding with notions about the "new nurturing father." Concepts of paternal involvement grew in tandem with the popularity of specific research methodologies, resulting in quantitative, narrow definitions of father involvement (i.e., time spent with children) and neglect of the broader ways in which fathers sustain involvement.[24] These trends in fathering and father-absence research, coupled with female-centered conceptualization of pregnancy and parenting that has historically pervaded Western culture, have led to a widespread ignorance of the male role in families.[25] This has subsequently influenced societal perspectives, which commonly view fathers as relatively insignificant contributors to families.[26] Until two decades ago, social science literature on fathering was dominated by what has been called the "ideological transformation of parenthood into motherhood."[27]

The Current Scope of Fatherhood

The long-standing debate about the impact of fathers in families has concluded that fathers do have a significant impact on their children,[28] recognizing both the pros of father involvement and the cons of father absence.[29] While the research scope of fatherhood has improved, it appears that our culture during the last century has merely traded a narrow view of fatherhood for a slightly less narrow view. Rob Palkovitz identified six common misconceptions about parental involvement in fathering literature: (1) more involvement is better, (2) involvement requires proximity, (3) involvement can always be observed or counted, (4) involvement levels are static and therefore concurrently and prospectively predictive, (5) patterns of involvement should look the same regardless of culture subculture, or social class, and (6) women are more involved with their children than men.[30]

The cultural toll our shifting perspectives have left us is steep. "As a cultural idea, our inherited understanding of fatherhood is under siege," Blankenhorn writes. "Men in general and fathers in particular are increasingly viewed as superfluous to family life: either expendable or part of the problem."[31] Fatherlessness or father-absent homes is currently at an all-time high, and related statistics portray dire consequences for the children of those men. Interestingly, hope springs from where there appears to be none. Amid all the statistics, shocking data, and violent images of children growing up with no consistent father figures, some researchers indicate that a different discourse offers a new, potentially more helpful view of the problem. Hillman (cited in Garbarino) observes that a father's "fundamental value to the family is maintaining the connection to the elsewhere," continuing,

> Fathers have been far away for centuries: on military campaigns, as
> sailors on distant seas for years at a time, as cattle drivers, travelers,

trappers, prospectors, messengers, prisoners, jobbers, peddlers, slavers, pirates, missionaries, migrant workers. The work week was once seventy-two hours. The construct "fatherhood" shows widely different faces in different countries, classes, occupations, and historical times. Only today is absence so shaming, and declared a criminal, even criminal-producing behavior.[32]

Garbarino's observations highlight a father's deeper purpose, from a larger perspective, which is essentially to live his parental calling the best way he knows how in order to inspire his children to understand his decisions and life choices in context. Being absent from the child's home, in and of itself, according to these authors, is not the crime itself; rather it is not living up to one's paternal duty that holds more meaning. In other words, let us not be limited by strictly scientific statistical perspectives in understanding the issue of fatherlessness. Take, for example, the case of two fathers. One lives at home but works ninety hours a week, and the other lives away from home and holds a minimum-wage temporary job. Which father's children fare better in these scenarios? From a strictly scientific perspective, the at-home father has not "abandoned" his children and contributes more money to them; the live-away father, however, may actually spend more physical time with his children, though his financial contributions are minimal. The answer may be, then, that both fathers are doing their best to fulfill their paternal responsibility, and perhaps both of their children would understand and benefit from the idea that their fathers love them.

Research has demonstrated the potential validity of the above scenarios, indicating that what children most value is the psychological connection with their father, evident in the time a father spends with them, the phone calls he makes on

birthdays and special occasions, and his remembering details about his children's hobbies and interests.[33] In fact, children's relationships with their fathers may be one of the keys to sustaining a psychological connection in spite of living apart. I have demonstrated elsewhere, in a qualitative study of involved young adult fathers, that fathers experience *validating reflections* from their children, positive interactions that serve to validate their efforts to remain involved with their child as an effective and worthwhile endeavor that prompted them to pursue continued involvement. Validating reflections came in a multiplicity of forms, including a child calling a man "Daddy," a child respecting the father's disciplinary instruction, or a child making requests for a father's time, love, and comfort that were not monetary in nature. Fathers found themselves increasingly able to participate in their children's lives in complex and profound ways as they got older, continuing the cycle of involvement and reaping increasingly complex emotional rewards.[34]

Given that fathers do not exist in isolation or engage in one-dimensional ways with their children, it has also been recommended that their experiences are best understood from a multi-dimensional and ecological perspective that encompasses other socioeconomic, cultural, and political contexts.[35] Measures of involvement should therefore be complex and comprehensive enough to represent these men accurately.[36] Consistent with these findings, previous research found that men draw from a variety of support systems and resources, both internal (i.e., personal effort, a positive outlook on life, and an acknowledgment of parental responsibilities) and external (i.e., a supportive family member) in order to build on their interest in and ability to be involved with their children.[37] In fact, fathers' abilities to stay involved despite multiple obstacles in their lives suggests that challenging circumstances do not guarantee negative outcomes for them, as some perspectives would suggest.[38] Research on social cognitive theory indicates that, while

preexisting conditions may make certain outcomes more probable than others, the course of an individual's life path may still take unexpected turns, particularly when fostered by effective social supports and tools of personal agency.[39] This theory posits that individuals act as primary agents of their own development and changes throughout life, within the context of reciprocally interacting influences, representing a view that stands in marked contrast to early theories of psychology that support behavioristic principles and unidirectional perspectives of development.[40] Social supports have been recognized as necessary to give incentive, meaning, and worth to an individual's actions and to protect against vulnerability to negative influences.[41]

These findings are valuable because they delve into an area of involvement that remains largely understudied—the ways in which fathers perceive their relationships with their children over time. These data also shed light on the way fatherhood and fathering are perceived by the larger society; often the impact of what appears to be a negative situation—father-absent homes—may be mitigated by efforts undertaken to explore the details further and find solutions from multiple sources of support.

It is evident that the relationship between fathers and their children is at stake in our culture. Each of us was given life by a father, but, in order to value that relationship more fully, we must prioritize and respect the role of fatherhood in our cultural dialogue. It is important to validate fathers' efforts and create societal institutions that encourage and assist fatherhood when necessary. Fathers tend to be consistent in their desires, which include giving their children what they didn't have, feeling recognized and validated by their children, and doing their best to stay involved out of a mutual love shared with their children.[42] The internal meaning that fathers derive from their efforts is of tremendous value for their children,

for themselves, and for society as a whole, in making involved fatherhood a continued endeavor no matter what the physical circumstances.

Notes

1. U.S. Census Bureau, "Facts for Features: Father's Day Centennial: June 20, 2010, http://www.census.gov/newsroom/releases/archives/facts_for_features_special_editions/cb10-ff11.html (Accessed July 6, 2010).

2. The National Fatherhood Initiative, "Facts on Father Absence" (2010), http://www./fatherhood.org/Page.aspx?pid=330 (accessed July 6, 2010).

3. The National Fatherhood Initiative, "The Father Factor" (2009), http://www.fatherhood.org/Page.aspx?pid=403 (accessed July 6, 2010).

4. J. Garbarino, "The Soul of Fatherhood." *Marriage and Family Review,* Vol. 29, No. 2 (2000): 11–21.

5. L. B. Silverstein, "Primate Research, Family Politics, and Social Policy: Transforming 'Cads' into 'Dads,'" *Journal of Family Psychology,* Vol. 7, No. 3 (1993): 267.

6. Silverstein (1993): 267–82.

7. M. R. Waller, *My Baby's Father: Unmarried Parents and Paternal Responsibility* (Ithaca, NY: Cornell University Press, 2002).

8. F. F. Furstenberg, Jr., and C. C. Weiss, "Intergenerational Transmission of Fathering Roles in At Risk Families." *Marriage and Family Review,* Vol. 29, Nos. 2 and 3 (2000), 181–201; E. H. Pleck, "Two Dimensions of Fatherhood: A History of the Good Dad–Bad Dad Complex," in M. E. Lamb (ed.), *The Role of the Father in Child Development,* 4th ed. (Hoboken, NJ: John Wiley & Sons, Inc., 2004): 32–57.

9. M. E. Lamb, "The History of Research on Father Involvement." *Marriage and Family Review,* Vol. 29, Nos. 2 and 3 (2000): 23–42.

10. W. J. Doherty, "The Best of Times and the Worst of Times: Fathering as a Contested Arena of Academic Discourse," in A. J. Hawkins & D. C. Dollahite (eds.), *Generative Fathering: Be-*

yond Deficit Perspectives (Thousand Oaks, CA: Sage Publications, Inc., 1997), 217–27; and Pleck (2004): 32–57.

11. J. Hamer, *What It Means To Be Daddy: Fatherhood for Black Men Living Away from Their Children* (New York: Columbia University Press, 2001); Pleck (2004), 32–57; and J. L. Roopnarine, "African American and African Caribbean Fathers: Level, Quality, and Meaning of Involvement," in Lamb (2004): 58–97.

12. R. D. Day and M. E. Lamb, "Conceptualizing and Measuring Father Involvement: Pathways, Problems and Progress," in R. D. Day and M. E. Lamb (eds.), *Conceptualizing and Measuring Father Involvement* (Mahwah, NJ: Lawrence Erlbaum Associates, 2004), 1–15; and Pleck (2004): 32–57.

13. Lamb (2000): 23–42.

14. Lamb (2000): 23–42.

15. W. J. Doherty (1997), 217–27; and L. B. Silverstein and C. F. Auerbach, "Deconstructing the Essential Father," *American Psychologist*, Vol 54, No. 6 (1999): 397–407.

16. C. Thompson, "Cultural Pressures in the Psychology of Women," *Psychiatry*, Vol. 5 (1942): 208.

17. N. Chodorow, *Feminism and Psychoanalytic Theory* (New Haven, CT: Yale University Press, 1990); M. Payne, *Modern Social Work Theory*, 2nd ed. (Chicago: Lyceum Books, Inc., 1997); and J. Teicholz, "The Impact of Feminist and Gender Theories on Psychoanalysis," in her book *Kohut, Loewald, and the Postmoderns: A Comparative Study of Self and Relationship* (Hillsdale, NJ: Analytic Press, 2001): 207–38.

18. Teicholz (2001): 208.

19. W. J. Doherty (1997), 217–27; and J. Mittelstadt, "Educating 'Our Girls' and 'Welfare Mothers': Discussions of Education Policy for Pregnant and Parenting Adolescents in Federal Hearings," *Journal of Family History*, Vol. 22 (1997): 326–53.

20. Pleck (2004): 32–57.

21. Lamb (2000): 23–42.

22. Doherty (1997): 217–27.

23. E. S. Johnson, A. Levine, and F. C. Doolittle, *Fathers' Fair Share: Helping Poor Men Manage Child Support and Fatherhood* (New York: Russell Sage Foundation Publications, 1999); W. E. Johnson, Jr., "Paternal Involvement Among Unwed Fathers," *Children and Youth Services Review,* Vol. 23, Nos. 6 and 7 (2001): 513–36; M. E. Lamb, "Parental Behavior, Family Processes, and Child Development in Nontraditional and Traditionally Understudied Families," in M. E. Lamb (ed.), *Parenting and Child Development in "Nontraditional" Families* (Mahwah, NJ: Lawrence Erlbaum Associates, 1999), 1–14; and S. McLanahan and M. S. Carlson, "Fathers in Fragile Families," in Lamb (2004): 368–96.

24. Lamb (2000): 23–42.

25. B. Featherstone, "Putting Fathers on the Child Welfare Agenda," *Child and Family Social Work,* Vol. 6, No. 2 (2001): 179–86; and M. E. Lamb and C. S. Tamis-Le Monda, "The Role of the Father: An Introduction," in Lamb (2004): 1–31.

26. K. Gerson, "An Institutional Perspective on Generative Fathering: Creating Social Supports for Parenting Equality," in Hawkins and Dollahite (1997), 36–51; A. J. Hawkins and D. C. Dollahite, "Beyond the Role-Inadequacy Perspective of Fathering," in Hawkins and Dollahite (1997), 3–16; and Lamb and Tamis-Le Monda, (2004): 1–31.

27. Silverstein (1993): 267.

28. Silverstein (1993): 267.

29. Furstenberg and Weiss (2000): 181–201; Hawkins and Dollahite (1997): 3–16; V. Phares, "Father Absence, Mother Love, and Other Family Issues That Need To Be Questioned: Comment on Silverstein," *Journal of Family Psychology,* Vol. 7, No. 3 (1993): 293–300; and Silverstein (1993): 267–82.

30. R. Palkovitz, "Reconstructing 'Involvement': Expanding Conceptualizations of Men's Caring in Contemporary Families," in Hawkins and Dollahite (1997): 200–16.

31. D. Blankenhorn, *Fatherless America* (New York: Basic Books, 1995), 2.

32. Garbarino (2000): 14.

33. Garbarino (2000): 11–21.

34. S. S. Parikh, "Validating Reciprocity: Supporting Young Fathers' Continued Involvement with their Children," *Families in Society*, Vol. 90, No. 3 (2009): 261–70.

35. Hamer (2001); A. J. Hawkins, K. P. Bradford, R. Palkovitz, S. L. Christiansen, R. D. Day, and V. R. A. Call, "The Inventory of Father Involvement: A Pilot Study of a New Measure of Father Involvement," *Journal of Men's Studies*, Vol. 10, No. 2 (2002): 183–96; W. E. Johnson, Jr., "Young Unwed African-American Fathers: Indicators of Their Paternal Involvement," in A. M. Neal-Barnett, J. M. Contreras, and K.A. Kerns (eds.), *Forging Links: African American Children Clinical Developmental Perspectives* (Westport, CT: Praeger/Greenwood, 2001), 147–74; and M. Males, "Poverty, Rape, Adult/Teen Sex: Why 'Pregnancy Prevention' Programs Don't Work," *Phi Delta Kappan*, Vol. 75 (1994): 407–10.

36. R. L. Coley, "(In)visible Men: Emerging Research on Low-Income, Unmarried, and Minority Fathers." *American Psychologist*, Vol. 56, No. 9 (2001): 743–53; Hawkins and Dollahite (1997); and W. Marsiglio, P. Amato, R. D. Day, and M. E. Lamb, "Scholarship on Fatherhood in the 1990s and Beyond," *Journal of Marriage and the Family*, Vol. 62 (2000): 1173–91.

37. Parikh (2009): 261–70.

38. W. J. Doherty, "Beyond Reactivity and the Deficit Model of Manhood: A Commentary on Articles by Napier, Pittman, and Gottman." *Journal of Marital and Family Therapy*, Vol. 17, No. 1 (1991): 29–32; and Hawkins and Dollahite (1997).

39. A. Bandura, "Social Cognitive Theory," in R. Vasta (ed.), *Annals of Child Development*, Vol. *6: Six Theories of Child Development* (Greenwich, CT: JAI Press, 1989): 1–60.

40. A. Bandura "Social Cognitive Theory: An Agentic Perspective," *Annual Review of Psychology*, Vol. 52 (2001): 1–26.

41. Bandura (1989): 1–60.

42. Parikh (2009): 261–70.

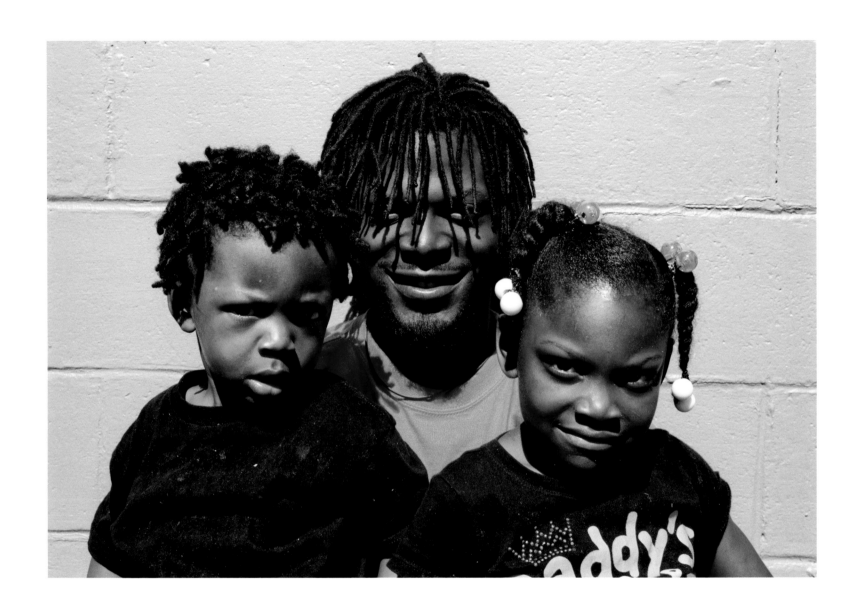

KEVIN HALL, SON, AND DAUGHTER, NEW ORLEANS, LOUISIANA.

Want Good Times Again? Try Fatherhood

by Roland C. Warren

Wʜᴇɴ I ᴡᴀs ᴀ ᴋɪᴅ growing up during the early 1970s, one of my favorite TV shows was the groundbreaking sitcom *Good Times*. Like other Norman Lear shows such as *Maude* and *All in the Family*, the subject matter and the characters were innovative for that time in American TV.

In typical Lear fashion, *Good Times* was funny and well written, but it also challenged its audience to deal with an issue that many would rather ignore: the plight of urban black families living in poverty. The program was a big hit. In fact, during its second season, *Good Times* was the seventh highest-rated show of the year, with a quarter of the American TV viewing public tuning in to watch it weekly.

I watched one of the reruns recently and was reminded of why I liked this show so much. While many were clearly amused by the antics of the character J. J. and his signature phrase, "Dy-no-mite!," I was drawn to something very different: actor John Amos and his portrayal of the family's father, James Evans.

You see, I grew up without my father, so James Evans became an aspirational role model for me at a very critical time in my life. I was inspired by how determined he was to provide for his family, despite significant obstacles, including periods of unemployment. He was a man of tremendous pride and character, who worked two jobs and would often say, "I ain't accepting no handout!" But, most importantly, he was a man who clearly loved his wife and children. This papa was no "rolling stone"; he was a solid "anchor" for his family who turned the hard times into good times. He chose fatherhood. I longed for, and wanted to be, a father like him.

But then things changed for the Evans family. After a successful third season, Amos got into a contract dispute with the producers and was dismissed from the show. Rather than replace him like so many successful shows do, the producers opted to have the father character killed in a car accident, leaving the wife as a single mother with three children. Interestingly, Esther Rolle, who played the wife, objected to this change. Apparently, one of the key appeals of the show to her was

the portrayal of a strong black father leading his family. But the producers stayed the course. They didn't choose fatherhood.

Well, when the father character was erased from the script, I quickly lost interest in the show. Its art was now imitating my life, and I didn't need yet another reminder that I was a fatherless boy. And I wasn't the only one who changed the channel. Despite several attempts to revamp the show, the producers could not get the show to work without the father. Its ratings continued to decline precipitously, and, by its sixth season, *Good Times* was no more.

I know that TV viewers' tastes change quickly. But could it be that the relatively quick decline of the show was linked to the producers' failure to choose fatherhood? We will never know because, in TV land, there are no second chances. As I viewed Lewis Kostiner's exceptional photographs of fathers and considered the book's title—*Choosing Fatherhood: America's Second Chance*—I was struck by the notion that what happened with *Good Times* is a poignant metaphor for how fatherhood has been regarded during the last four decades. Like shortsighted producers, our culture has been steadily "writing fathers out" of families and their children's lives. Alas, there is a misguided notion that fathers are not essential to the well-being of children, even in tough urban neighborhoods. As a result, one out of three children in America—and seven out of ten African-American children—live in fatherless homes.

The social science research confirms that times are less good when fathers are not active participants in the "show" that is the family. Sadly, children in father-absent homes are at least twice as likely to drop out of school, live in poverty, end up in prison, be abused, use drugs, and have emotional or behavioral problems.

But, unlike TV, there are second chances in real life. Since the 1990s a movement has formed to address our national crisis: the absence of fathers. Community-based organizations, federal agencies, corporations, churches, foundations, movie studios, prisons, and even the President of the United States and members

of the U.S. Senate and House of Representatives from both parties are taking steps to give fatherhood a second chance.[1]

I believe history is presenting the American people with an unprecedented opportunity to turn the tide on this fundamental social problem. Will we act to turn the tough times into good ones? Or will we continue to tune in idly and accept what is but does not have to be?

If people can see positive ways to make things better, they will act. Fortunately, we have learned that there are tangible steps to be taken that can strengthen fatherhood in our neighborhoods and communities. Here are some ideas:

• GET YOUR HOUSE IN ORDER

If you are a dad, the first place to start is by being the best dad you can be. Your children deserve your best, and, since fatherhood is a skill-based endeavor, you can get better at it. National Fatherhood Initiative (www.fatherhood.org) has a variety of resources to help build fathering skills. If you are a mom, you can play a vital role in helping the father of your children be a good dad. Research shows that, when the mom is supportive, dads are more likely to be involved. Rather than be a gatekeeper, a mom can be a gateway to better father involvement for her children. If you have a good grip on fatherhood, be a "double-duty dad" by using your skills and experience to mentor a fatherless child in your neighborhood or community.

• SUPPORT MARRIAGE

Three decades of research have provided clear, undeniable evidence that fathers perform best when they are married to the mothers of their children. Over the same period of time, however, we have inexplicably broken the link between marriage and fatherhood: four in ten births today are to unmarried mothers. This link must be remade. In your own life, work on strengthening your marriage, as it is the central relationship in your household. In your community, ensure that marriage does not be-

come a thing of the past; help others see the critical role that a healthy marriage plays in helping children have the best chance at a stable childhood and a successful life.

• ENCOURAGE PRIVATE FOUNDATIONS AND INDIVIDUALS TO FUND WORK ON FATHERHOOD

Many private foundations and individuals provide funding to support programs that deal with the consequences of a father's absence—poverty, crime, failure at school, gangs, drug and alcohol abuse, and more. The funding that is hardest to come by is often for programs that start upstream by strengthening families to prevent a father's absence. If you are connected to private foundations, educate them on the need to fund preventative work that connects fathers to their children. Direct a portion of your own charitable giving to such programs as well.

• DIRECT MORE FEDERAL, STATE, AND LOCAL GRANT PROGRAMS TOWARDS SUPPORTING RESPONSIBLE FATHERHOOD

Currently, billions of dollars in funding are going to government programs that are designed to help families. Most of them, however, only serve mothers and children. If these programs added an emphasis to supporting fathers, no additional taxpayer money would have to be spent to make a huge impact on fatherhood. Contact Congress and your local officials to tell them to make strengthening fatherhood a priority in publicly funded programs.

• SUPPORT OUR NATION'S "LONG-DISTANCE DADS"

Millions of fathers today, through incarceration or military deployment, struggle over long distances to be involved in their children's lives. Since a majority of men in prisons are fathers and a majority of them grew up without fathers, there is a clear father factor at play. Prisons and reentry programs must start helping men become better fathers to reduce recidivism and end the intergenerational cycle of

crime. Children in military families are also more at risk due to longer and more frequent deployment of their fathers. Accordingly, the U.S. military must see the value in supporting fathers so that our nation's military families are better off and the morale and readiness of our troops are improved.

- **Mobilze men's ministries and programs in churches and communities of faith to be father-centered**

There are tens of thousands of men's ministries and programs operating in churches and communities of faith throughout the nation, but very few are intended to help men be better fathers—they are typically more focused on "manhood" than "fatherhood." If they began to emphasize fatherhood, millions of men would be positively affected.

My challenge to everyone is to choose two of these ideas that are most closely related to your personal passion or profession and take action on them. America has never been a nation that waited for the good times to come. We have always created them. Today, a generation of children is depending on us to create the better times for them by ensuring that they have involved, responsible, and committed fathers in their lives.

We have a second chance. Let's choose fatherhood today.

Note

1. Even *AARP, The Magazine* (June/July 2012) devoted a lot of coverage to fatherhood. See, for example, the interview by Nancy Perry Graham, "America's Dad in Chief: He shares hope for families without fathers and for workers who need jobs" (14–16); the article by Ray Paprockin, "Who Needs Dad? When moms have more power and kids leave the nest, a father must rethink his role" (50–58); and the commentary by Marlo Thomas, "Make Room for Listening: What's the most important skill you can have? My dad had it" (59).

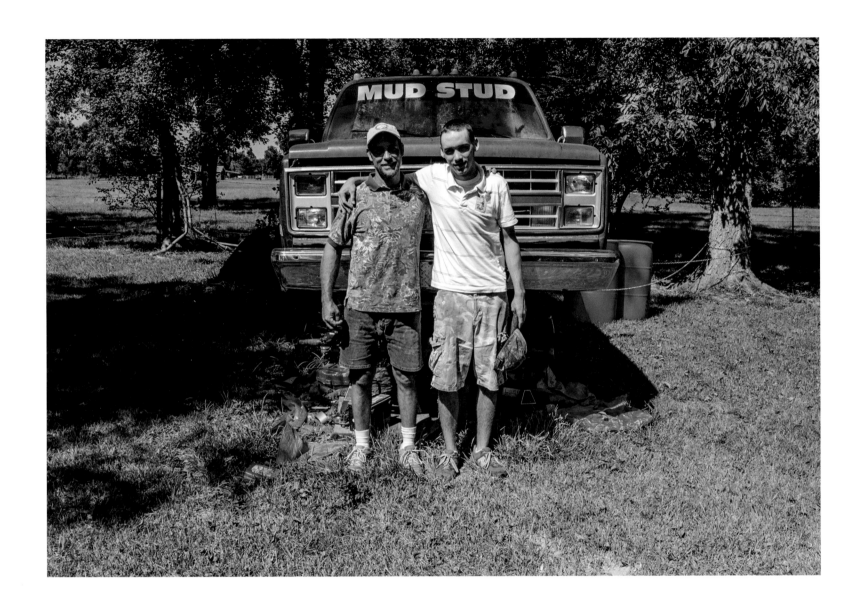

KEVIN POLK AND SON, ROBERTSDALE, ALABAMA.

• The Stories behind the Photographs

by Lewis Kosiner

PAGE 2: JOSE RIVERA, HIS WIFE, AND CHILDREN, PITTSBURGH, PENNSYLVANIA, 2007.

The two kids on the left and right of Jose seem to have their own agenda. The son on his lap spent most of his time before the picture was made playing with a big inflatable Superman (see page 201). When it came time for the picture, he quickly dropped his toy Superman and opted for the lap of the real one, his father. Jose spoke no English at all, but the kids helped, along with their mother. Jose seemed to be puzzled by the strange events going on in his house and yard, brought about by this guy from Chicago with the cameras. He was at times embarrassed by the fact that he could not speak the language of his newly found country, yet he was able to communicate clearly and precisely the love he felt for the "Wild Bunch" surrounding him. His hand on his son's chest gives it all away.

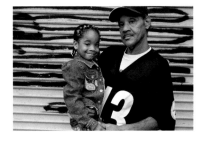

PAGE 6: KEVIN WASHINGTON AND DAUGHTER, INDIA, PITTSBURGH, PENNSYLVANIA, 2007.

Milt Scott from National Fatherhood Initiative met me at the Pittsburgh airport on October 19, 2007. This was to be my first foray into the making of pictures for the *Choosing Fatherhood* project. We drove to Kevin Washington's apartment, just a few blocks from where the Pittsburgh Penguins play in the Igloo. We met Kevin in the hallway of his building, with his daughter by his side. He told me right away that he had spent years trying to obtain custody of his little girl from her mother, who had been in and out of jail for various offenses. His daughter was the pride of his life. The apartment where the two lived was an oasis of joy in this otherwise run-down section of Pittsburgh. Her room was lovely, with a well-organized desk, a big, comfortable bed, a very nice dresser, lamps, and lots of toys. As we went out to make some pictures, she held on to him tightly, and he held on to her even tighter. I found this abstract expressionist graffiti on a door. I put them in front of it. Kevin, in true Pittsburgh fashion, had his Steelers stuff on, but you could tell his daughter was the only one he was rooting for.

PAGE 11: JOSE OCHOA, SR., DES MOINES, IOWA, 2009.

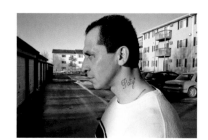

Jose had just been released from prison, and we met at his place, where his son was visiting. He had been away for about ten years and then was released four years early, and that was when his son was conceived. After his release, he violated his parole and was sent back to prison for a few additional years. He was a trainer of quarter horses as a young man and was extremely articulate and well versed in that arena. He told me that he would never go back to jail now that he had time to reunite with his son. I, of course, noticed the tattoo on his neck with the name etched inside, but not until he was out in the sun did I notice the teardrop under his eye. As a young man, he had been involved with a gang and someone had died, and the teardrop symbolized that. This was what sent him off to prison. Jose confided in me that, now that he was free again, he would never ever abandon his son. I assumed the teardrop was for the many years he spent without his child.

PAGES 12–13: BUNTHY THAP AND FAMILY, MANHATTAN, KANSAS, 2009.

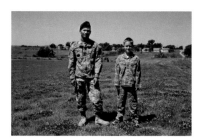

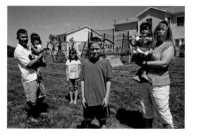

Bunthy was the father of twin girls and another daughter and son. It was as if his girls were my girls the day I photographed them. Even though Bunthy was in the Army and proudly radiant about his patriotism, from the group picture you can really tell who was in charge. His wife tolerated no excuses from anyone who did not believe in the mission of the soldiers at Fort Riley, many of whom would soon be shipped off to Iraq and Afghanistan. To her, Mr. Thap was a father who commanded the utmost respect and admiration from his children. When I asked the kids if one of them wanted to be in a picture with their father, the older daughter looked at her brother, and he knew what she was thinking. In a flash, he vanished and returned wearing a duplicate of his dad's uniform. Now he was ready to be photographed and stand side by side with his father. As they say, "Like father, like son," I am glad they are on our side.

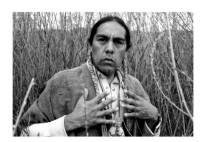

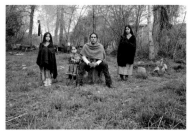

Pages 14–15: Robert Mirabal and daughters, Taos Pueblo, New Mexico, 2009.

Robert Mirabal is not just a great musician who has won a few Grammys; his hand-made flutes are also sought after worldwide. So, when I was brought onto the Taos Pueblo to meet Robert and his family, I had no idea what I would encounter. I found Robert with his three girls, each more precocious than the next. All three girls were beguiling; when they looked at you, they stared straight into your eyes, your soul. I was alone with the Mirabals on their land surrounded by the high Rocky Mountains north of town. Robert's hands tell the story of his life, his family, and his music. His stories are full of wisdom and giving. Even if the Pueblo culture he comes from is not ours, he will teach you how important it is to have a family and to give to a family. Robert and his daughters, standing among the reeds on his land, next to the Rio Grande behind their house, tell all of us how rich the traditions are that he and his people have passed on to these girls. So, while I was taking their pictures, they kept prodding me, "You must be famous, you're famous, right?" I just stared at Robert and took it all in.

Page 16: Chad Hebdon and daughters, Preston, Idaho, 2008.

I had mixed emotions with this shoot, as it was clear to me that the chaos that existed inside Chad's home was getting in the way of how I wanted to treat the image making. In the end, I concluded that Chad was a hoarder, and I accepted that and so tried in my own way to make as simple an image of him and his two daughters as I could in the yard. Compared to the overwhelming clutter and confusion of the interior of the house, the backyard was pristine and nicely organized. It was as if the age-old adage, "Outside disorder leads to inside order," was flipped. Behind my frustration was the hope that, even though he lived in chaos, at least his relationship with his girls was well thought out.

PAGE 18: HENRY, SON OF HENRY STROTHERS, SR., PITTSBURGH, PENNSYLVANIA, 2007.

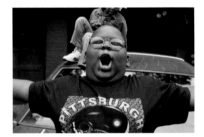

Once Henry knew his sister was angling to get down from the roof of the car be-
hind him, he exploded into full "theatrical mode." Lucky for me. Henry Sr. was
right behind, quiet and unassuming, somewhat smitten and bemused by his son's
acting abilities. Proud and flexible, the older Henry relished in every moment of
his son's confrontation with the camera. Later, we went to the park nearby, and we
all played baseball. The little girl on the roof of the car had quite an arm, and she
was always ready to upstage her magnificent brother. And, of course, they were all
Steelers fans, too.

PAGE 21: RIKI EATON AND DAUGHTER, ALEXIS, PLAINFIELD, INDIANA, 2009.

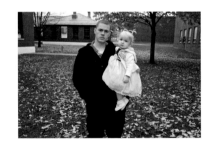

My weekend at the Indiana State Penitentiary in Plainfield, Indiana, was well orga-
nized with lots of gates and heavy doors to pass through. What was once the home of
a boy's camp had now become a place where the bad men of Indiana ended up. In
order for Riki Eaton to be given the opportunity to have his picture taken and spend
time with his daughter, who came into his life while he was a prisoner, he had to be
the opposite of what he was on the outside, a well-behaved man inside the prison.
He was, and, because of this, he was permitted to stand and hold his daughter on a
cold and damp Saturday morning in southern Indiana. I never asked him how much
longer he would be in prison or have to spend time away from his child, but I could
tell by the look in his eyes it would be entirely too long a time.

PAGE 22: DAVID MARTIN AND SON, JADON, PLAINFIELD, INDIANA, 2009.

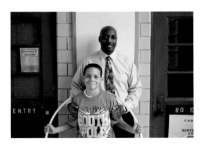

There were lots of signs all over the prison—"NO ENTRY" and "ENTRY DE-
NIED"—yet, for David Martin, the doors all around him barring him from access
to his son were gone for the moment. Jadon twirled his hoola hoop and wore an
elephant head from time to time and did what all young buys do: grapple for their

dad's attention. He got it, boy did he ever. You could tell how connected the two were and how happy David was to be with his son. It makes you wonder what he could have done to take him away from all that really matters in life, those powerful and tender hands gripping the arms of his young boy. I think the bond was so strong between the two that David's hug and warmth stayed with Jadon every second until the next time they saw each other.

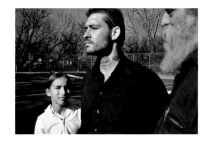

PAGE 25: DONALD BADER, DAUGHTER, ANGELICA, AND FATHER, JIM, COLORADO SPRINGS, COLORADO, 2008.

Halfway through the shoot, Donald Bader's father, Jim, asked me if I was shooting raw files or JPGs. Judging from his beard, I had already pegged him as a Colorado mountain man who knew nothing of the current state of digital image making. Little did I know. He told me that he was very upset with the local YMCA, where he lived, because he had been asking them for some time to upgrade their computer software to allow him to print raw files, as he wanted to make bigger and more resolved prints. Donald knew we instantly had this special bond. Angelica thought the entire episode was funny and just stared off into her father's face in the sun. I thought the great thing for her was that she had these two men in her life. I suspect that her heart lay somewhere in between daddy and grandpa. I immediately thought that one should never judge a book by its cover. Jim taught me a thing or two that day. It made the whole trip worthwhile.

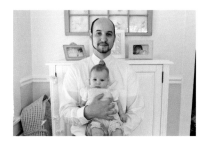

PAGE 26: SHAWN KENNEDY AND DAUGHTER, AVA JOY, MOBILE, ALABAMA, 2008.

Shawn Kennedy was an unexpected and pleasant surprise. He and his wife lived in a small and lovely vintage Southern-style bungalow in Mobile. I had spent a few days with his father-in-law, who was taking Milt Scott from National Fatherhood Initiative and me around to meet the fathers in the area. Shawn had his beautiful

baby girl in his arms, whom he carried with him all over the house. He even wore a shirt and tie for the picture. After I took the picture, I sat with him at his dining room table, and we talked. He said he was always open to learning how to become a better father. He told me had taken some classes with NFI and learned a great deal about small things about fatherhood he never thought about. He was very clear with me: his family's faith in the Lord gave him the strength to be a good and loving dad. I imagined he would be, always. (See page 48.)

PAGE 28: MALCOLM AND MICHAEL, SONS OF MICHAEL TAYLOR, MILWAUKEE, WISCONSIN, 2008.

Just as siblings compete for the attention of their fathers, both Malcolm and Michael competed for my attention while I was visiting them in their home in Milwaukee—whether it was showing me how much stronger the other one was by lifting weights on their father's flat bench press in the living room or getting my attention at the breakfast table while I made the image of the two of them. They piled the stack of *Ebony* magazines neatly on the table and proceeded to stare me down. The little one behind the chair was jumping on his toes to get above his older brother and make sure he was in the picture. But they were most at peace when their father's big arms held them close. This seemed obvious to me.

PAGE 31: MARVIN CHARLES AND FAMILY, SEATTLE, WASHINGTON, 2008.

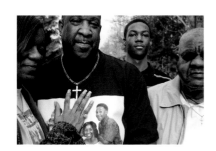

Marvin Charles had a wonderful little office in downtown Seattle. He met Milt and me there, and we passed a good deal of time with Marvin traveling through the city. He spent most of his time keeping tabs on all the fathers and children in the National Fatherhood Initiative program whom he helped in his district. He picked them up and dropped them off and told them how to do this and how to do that. He never looked down on any of them, and his presence helped organize and pre-

pare the children for their everyday journeys and, for the men, fatherhood. His clients struggled daily to survive, and he knew it. He did what he could to help them along. I photographed Marvin and his wife, son, father, and daughters (see page 47), right after the presidential election of 2008. During Barack Obama's run for office, I heard many times that he was a community organizer. In Chicago, where I am from, that usually means you help get the vote out. But Marvin was a community organizer, in the true sense. He was not out there to get votes but to help kids and their dads. In his son's eyes, Marvin could easily have been elected Mayor of Seattle. Marvin carried his family's picture around with him all day long on his T-shirt, right in front of his heart.

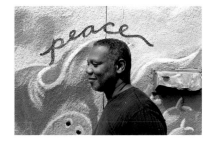

PAGE 33: ANTHONY MAIDEN, SACRAMENTO, CALIFORNIA, 2008.

The school that former NBA superstar Kevin Johnson founded in Sacramento seemed to inspire all those who studied and worked there. I visited right before the 2008 election that saw Barack Obama ascend to the presidency, and his campaign pictures were plastered all around the school's hallways. When I asked someone in the administrative office of the school if there was someone who could show me around, they suggested I talk to Anthony Maiden, the proud father of a first grader, who happened to be at the school that day. From the moment I met Anthony, I was at peace with photographing him because of his decision to be with his kids, and it was a non-issue for me to place him under the very word "peace," as if it were a halo, which was painted on a far corner of one of the classroom buildings.

PAGES 34–35: JONATHAN COUGHLIN AND FAMILY, MANHATTAN, KANSAS, 2009.

It was hard to imagine that, just a few miles from this serene picnic pond next to the U.S. Army base at Fort Riley, troops were training rigorously before they were sent off to fight in Iraq and Afghanistan. They were all members of the 1st Army

Brigade. It was a strangely quiet and removed landscape. Jonathon Coughlin's family was what I always imagined the perfect American family to be: three boys and two girls and a loving mother. Jonathon had two families, however, and he was proud of each. Of course, his children were his family, and he lit up whenever they ran in and out of my picture field. He would kindly let them know that they needed to behave. The boys grew restless, as the twin girls took it all in. Rarely would a photographer be given the gift of photographing a family such as this. You could tell that, with Jonathon and his wife in their lives, these kids were going to do well. Jonathon was also a father to the soldiers under his command. He lamented to me that, in many ways, they had to come first, sometimes above his own family. His job was to train his troops well and keep them alive. He was so proud of them. They, too, were his children. When I left Fort Riley, I was so proud to be an American and happy I had a chance to meet and photograph Jonathon and his family.

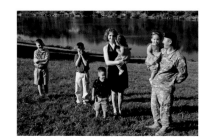

PAGE 37: JOHN TAFOYA AND DAUGHTER, TAOS, NEW MEXICO, 2009.

The commune in Taos where John Tafoya lived with a few other families took me back to the late 1960s and early 70s when I traveled the country and was caught up in the whole idea of communal living. In essence, each child had many mothers and many fathers (see page 96), surely a choice in lifestyle that would lead to numerous discussions, both pro and con. It was late in the day when I arrived, and the light was fading quickly. I urged someone to find John and his daughter before the light was gone. In traditional "hippie" fashion, I was met with words like "cool man" and "take it slow," as John would be with me soon. He was sitting up in a tree with his daughter, discussing the leaves with her. When he finally came down, he was calm and cool and ready to go. His daughter was really not interested in this event or perhaps just shy. My thoughts were, "Nice picture," so I guess in the end the timing was perfect.

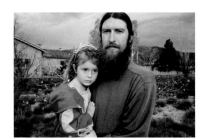

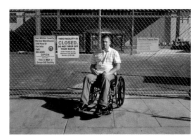

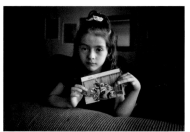

PAGES 38–39: REYNOL RUIZ, AND DAUGHTER, NATALIE,
REDWOOD CITY, CALIFORNIA, 2008.

When I arrived at the home of Reynol Ruiz, I was struck by the fact that Reynol was so young, too young to be in a wheelchair for the rest of his life from an accident. I scrambled to fugure out how I was going to take his picture without focusing on the wheelchair and the accident. Only the kids in the house spoke English, so I asked, "What would be the best way to make this picture?" No one answered, so I took Reynol outside and pushed him down the street a ways, over the railroad tracks, and placed him in front of a chain-link fence in front of a small factory. The signs on the fence had words like CLOSED and NOT A DROP OFF FACIL-ITY, in some ways reflective of where Reynol was at this point in his life. When we returned to the house, his daughter, Natalie, ran up to me with a picture of her father taken before his accident, posing on his very fast motorcycle. She told me that she now had to take care of her father because of this "very bad" motorcycle. I knew then what had happened.

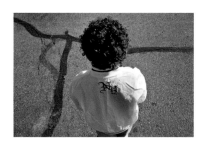

PAGE 40: PRINCE, SON OF JUSTIN LAUGHLIN,
COLORADO SPRINGS, COLORADO, 2008.

Prince was all decked out in full New York Yankee regalia and was all cleaned up and clearly ready for his photo op. His dad had just been evicted from his apart-ment, so we had to meet at a friend's house. I saw the tar-patched markings on the ground in the parking lot by the housing complex and immediately was brought back to my time as a student at RISD with Aaron Siskind and Aaron's photographs. Aaron later became a mentor and close friend. So Prince stood by patiently with his father, looking out of place wearing his baseball dream team. I wanted so badly to take him to a Yankee game. Maybe one day I will, or, better yet, maybe one day his father will.

PAGES 43: JOEY PRADO AND CHILDREN, EL PRADO, NEW MEXICO, 2009.

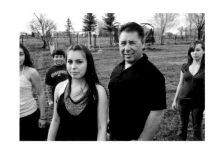

Joey and his son seemed to be relatively at ease in this photograph. What is most noticeable to me is the competition among the daughters for dominance in the image. Of course, I managed to cut off the one girl on the left-hand edge of the frame, but her presence is still felt. There existed this tension as to who was going to "play through" and be the focus of attention between the other two girls. It reminded me of my own two girls and their visual presence and subconscious competition with each other whenever I photograph them together. Most fathers who preside over mostly girls seem to let them spar for attention and then spend most of their time with the boy child. That's not always the case, but, right after the photo shoot, the girls went to get ready to go out, which meant make-up and hair, while Joey and his son just threw the ball around in the backyard.

PAGES 44: EMILIANO RAMOS AND DAUGHTERS, HALF MOON BAY, CALIFORNIA, 2008.

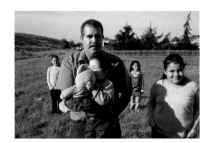

Emiliano said barely anything the entire time we were together. He posed in the living room, then in the kitchen, and then the backyard. As you can see, the backyard is quite lovely, and just over the ridge behind the family is the Pacific Ocean. He worked in the fishing industry, and he and his family live in a wonderful community that is partially subsidized by the State of California for those who work with fish. He has four daughters, all of them very quiet, too, and compliant. They did whatever I asked of them, except for the youngest, seen chewing her teddy bear. She was clearly the boss and in control. When I asked Emiliano if we could take one more set of pictures in a different location, he looked at his youngest and asked her straightforwardly, "Is that all right with you, dear?" I knew right away who ruled the roost in this family. Being the good father that he was, Emiliano let her decide. By the way, we made no more pictures.

PAGE 47: MARVIN CHARLES'S DAUGHTERS, SEATTLE, WASHINGTON, 2008. (See page 31.)

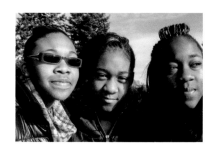

PAGE 48. FAMILY PHOTO, SHAWN KENNEDY'S HOME, MOBILE, ALABAMA, 2008.

Throughout the history of photography, photographs have been made that simply record the fact that an earlier photograph was made for a specific purpose. The new photograph in many instances seeks to define or clarify what the original image depicts. The technique has often been referred to as "a picture within a picture." Sometimes the new image can be in direct contradiction to what is depicted in the original photograph, which is not the case here. What I found to be most interesting about the family portrait in Shawn Kennedy's living room was the proportions of all those included in the family portrait, so elegantly placed on the end table. It had become apparent to me that, after talking with Shawn (see page 26) and hearing about his own doubts and questions on his fathering abilities, he learned most about overcoming them from the man he respected the most: his own father. That is Shawn's dad in the center of the family portrait, once again larger than life, even in this precise and delicate family grouping.

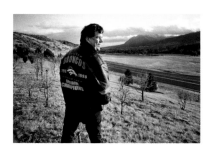

PAGES 52–53: WADE ANTENER, DAUGHTER, TIFFANY, AND DOG, DIAMOND, COLORADO SPRINGS, 2008.

Landing in Denver all I could think of was, Could I get a shot of one of the fathers with Pike's Peak in the background? This was paramount in my thoughts, since Colorado Springs was my destination. Pike's Peak brought me back to my childhood memories of the song "Sweet Betsy From Pike," a tune that has stayed with me. As kids we all wanted to be pioneers. So taking Wade Antener out to an open space by the highway with the mountain as a backdrop was an easy thing for me to arrange. Wade was all the more obliging, and his young teenage daughter watched

and held on to their little black dog, as I photographed her dad. Wade and I talked. I asked him what he did. He said whatever it takes. Two jobs now, many hours each day. His primary work was as a cook. He told me he worked to help his daughter, so that, one day, she would fly over that mountain and have a wonderful life somewhere else. It's funny how positive one can be, like Wade, when the only real choice we have is to take care of our responsibilities as a parent, as a father. I understood what he meant when he said this to me. The shoot didn't last too long, Wade had to get back to work.

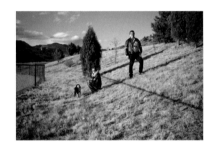

PAGES 54–55: MIKE BEERBOWER AND SONS, DES MOINES, IOWA, 2009.

As we entered Mike's home, there was a very old man at the kitchen table playing cards—and that was Mike's father—and some of his friends on the couch in the living room. The house was small and seemed built out of heavy-duty cardboard. It was on the outskirts of Des Moines, in one of those areas you read about where there are meth labs and drug abuse. As I entered the bedroom where Mike's boys were hiding, I was overwhelmed with the Elvis shrine. Elvis was everywhere. The light was to die for, and the boys were ready and eager to pose in any way and do anything I asked of them. On the bed they sat, while Elvis looked down along with Jesus and his friends at the Last Supper, via a postcard. There was Mike in the kitchen standing with his hands in his pockets. On the wall behind him was this year's Christmas decoration. I will never forget this home, and I can still hear the "Hound Dog" in the front yard.

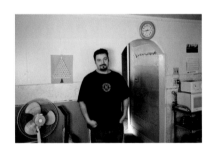

PAGES 56–57: PETE BARLEY, GRANDFATHER, AND FAMILY, MILWAUKEE, WISCONSIN, 2008.

Pete's wall of respect sits atop the fireplace mantel in his home. He is a grandfather raising and caring for many kids on the edges of Milwaukee. I did not explore

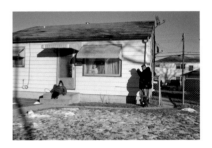

the ins and outs of all this, but I assumed that his presence in the life of all the kids (his grandkids) in the house meant that, for better or for worse, they had a father figure in their lives. I assumed that all the kids in the pictures on the walls and hanging out in the windows in the front of the house with Pete standing there were his, more or less. Lucky for them. Pete was a proud American, proud of his military buddies and proud of his emotional ties to Malcolm X. Sometimes, we learn more from the pictures that people collect than from the individuals themselves. I rest my case.

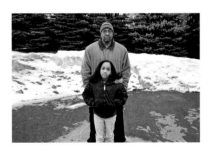

PAGES 58–59: KENNETH BRASWELL AND DAUGHTER, ALBANY, NEW YORK, 2009.

Kenneth was our lead in the Albany and Schenectady area. It wasn't until the end of the day, after visiting a few homes, that I realized he was one of the dads to be photographed. He never talked about himself during our day together, so I simply assumed he was only with the local agency. I saw the manhole cover in the street in front of his house and thought of how he would like standing alone on it. The cover appeared so small, compared to his size. So, when I asked his daughter to stand there with him on the cover, I thought for certain that the two would not fit on top the way I wanted them to. I was wrong. They fit perfectly, and the day ended with both of their steadfast gazes into my camera lens. You could tell that they needed each other.

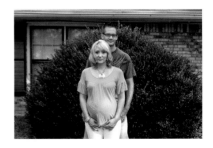

PAGES 60–61: AARON BREGENZER AND GIRLFRIEND, ALPHARETTA, GEORGIA, 2008.

The vibe was very strange around Aaron and his girlfriend. I understood originally that they were married but later came to learn they were not. They were expecting a child, however, and I also learned they did not plan to raise the child together. I then understood why Aaron might be in the NFI program, to help him work

though this. When I learned that they were together but really not, my heart saddened. I saw this line dividing them in my mind, and my first instinct was to attempt to describe this boundary that separated them in the pictures I would make. I had to think quick, so the double-yellow no-passing line in the street in front of Aaron's mother's home seemed like the best place for the couple to stand. The symbolism that the line provoked was a reminder that, even though they would be together in the creation of the baby, in the end they would not follow through with the raising. Sad, so sad.

PAGES 62–63: FREDDY CAAMAL AND DAUGHTER, GENEVIEVE,
DALE CITY, CALIFORNIA, 2008.

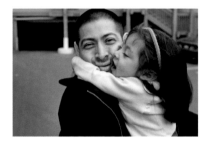

What a kiss Freddy's daughter applied as she squeezed his head hard. I sensed his hand actually crawled into the picture and held the baby up. It kept the baby from falling out of the frame. By the way, isn't that what a father should do, to offer support whenever possible? So, after this image was made, I had nothing left to say, except it's not a trick. The symbolism was poignant, and Mr. Caamal was with me all the way on this, although I don't think he ever saw the picture. Now he will, and I hope he likes it. He seemed to understand its underlying message. As you can see and feel from both images, he was a good sport about the entire episode.

PAGES 64–65: WILBURN CARVER AND DAUGHTER, SEATTLE, WASHINGTON, 2008.

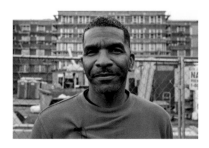

Wilburn was working right outside his daughter's school in Seattle. I think he was a painter at a construction project across the street. When I asked our local guide where we were and what building we were meeting in, I was told this structure was an old warehouse and that, since there was no money for new schools, many high school students from inner-city schools would be sent here. It certainly did not

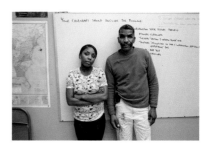

seem like a school on the inside. There were a few offices and then a whole bunch of open rooms, with many kids wandering around, with little direction. I had the sense that Wilburn's daughter was none too happy about having to stand and pose for these pictures. She stared me down quite forcefully. Nonetheless, I found the perfect place for the images, right next to a map of the United States. This map would give some geographic focus to our project. The demographics of where we had been and where we were going would be evident within the context of the map. So, clearly, the school was intended to house students who were troubled and difficult. It was as if they had been exiled from the "regular" school they should have been attending. In the end, Wilburn was there for his daughter, and that is all that matters.

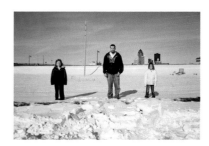

PAGES 66–67: JOSHUA CHILES AND DAUGHTERS, EMILY AND TAYLOR, DES MOINES, IOWA, 2009.

As we stood out in the cold on the edge of Des Moines, I realized that this city is much smaller than I imagined. Joshua Chiles's girls took us to this spot for the photo and spent most of their time arranging the picture, so that, of course, their father would look nice in the scene. Having two daughters of my own, I completely understood what was going on. When I saw Joshua standing there in the frame, I realized that this person could be me, was me. His daughters were the exact age difference as mine. The younger was clearly the boss, and the older one offered, for her age, astute guidance. Joshua (as in my case, too) allowed them the joy of ordering him around. He was doing what a father should do, I thought; he was empowering his children at his expense. As we left, one of the girls rolled up her pant leg and showed me her artificial leg, which she put on display in a wholly uninhibited fashion. Joshua must have taught her to not be ashamed of this, and he taught her well.

PAGES 68–69: MARTIN CORONA AND FAMILY, SAN ANTONIO, TEXAS, 2008.

Martin had four kids and a dog. They all lived by a storm-drain canal in San An-tonio. The place they lived in was small and crammed full of stuff. The kids all helped each other get ready for the shoot. They seemed very well prepared and asked me a lot of questions. They wanted to know where I was going to take all the pictures. I told them that I had already taken many of them. So the little boy took charge and told me to stand up on the balcony while he arranged his father and sisters down below in the parking lot. He said that would be a good way to take the photograph. I did what he told me to do, and he was right. His father was just so happy to be surrounded by all of his children. You haven't really seen the United States until you spend time with the Corona family by the flood canal in South Texas.

PAGES 70–71: ROLAND DAVIS AND SON, SAN ANTONIO, TEXAS, 2008.

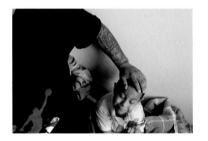

Roland's son was very shy and in the end succumbed to letting me take his picture. In all his apprehension, he took over the picture session, and, in spite of his fa-ther's firm hand pushing down on his forehead, he managed to find his own way of looking at this and the humor in it. Even though he tried to hide inside the pic-ture, he brought his own strength of personality to the pictures. Of course, there was also the strong visual impact of the tattoo on Roland's arm. At first glance, I didn't notice it, but later his arms began to be the dominant visual element in the pictures. I do remember that Roland's wife wanted the picture made inside the house, while I opted for standing in the sunlight outside the front door. So you win some and some you don't, at least that is how I felt. Maybe next time I'm out there, I'll spend more time in their living room.

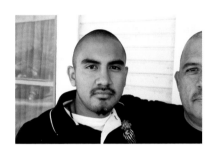

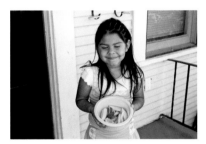

PAGES 72–73: VINCENT ESCOBENDO, FATHER, AND DAUGHTER, SALINA, SAN ANTONIO, TEXAS, 2008.

Vincente Escobendo was either divorced or separated, or maybe he and his wife never were really together. I could not figure it out. I met him at his father's house in an area near downtown San Antonio. The inside of the home smelled of burning candles and incense. There was a beautiful little memorial to his recently passed-away mother in the living room, on which his father kept vigil with brilliant candles. I never really knew if Vincente lived with his dad. My sense was he didn't. His daughter offered me some peaches that she'd just cut up and was carrying around in a white bowl. I knew I had to make a photo of her alone with her peaches. What photographer could resist that? I took Vincente's picture on the front porch. His father was sitting out there. I resorted to an old gimmick in portrait photography, as anyone can see. The sense that the viewer gets is that Vincente is the main feature, and his dad is there to provide a connection. I soon realized that, what I had come upon, was the basic need of a father to have a father in his life. His daughter was part of the flow chart, from Vincente's dad to him, to his daughter. The one person who stabilized everything in the household was Vincente's father, yet I cut most of him away. Maybe this says something about my father and me.

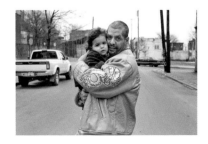

PAGES 74–75: JOSE ESPADA AND SON, ALBANY, NEW YORK, 2009.

There we were in downtown Albany, the state capital of New York, just a few blocks from the state government buildings, in a virtual gang war zone. Having lived in New York for many years when I was younger, I never realized that things could be this bad so close to where all the laws and rules were made for the people of the state. I am sure most felt as I did. To say that Jose was a Yankees

fan would be the understatement of the century. In his bedroom, there was floor-to-ceiling Yankee memorabilia. In all the other rooms were his children. All by himself he took care of them. Two of them slept, and, while a friend came over to watch them, I exited the apartment with Jose and his son and went downstairs to make our picture. As cars drove by, fast and furious, young men glared out the windows, wondering what the hell we were doing. Jose would have none of it. He embraced his son tightly, and from that moment on I realized that, in the center of all the potential violence that surrounded us, Jose's son would never have to worry, as long as his father held on to him.

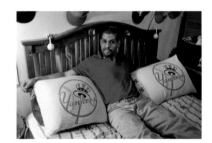

Pages 76–77: Jerre Fields, his wife, and daughter,
Pittsburgh, Pennsylvania, 2007.

It was amazing to me that, in this rugged and burnt-up neighborhood close to downtown Pittsburgh, this radiant child lived with her two very beautiful parents. They all seemed so happily oblivious to the world around them, with the burned-up shells of buildings, alleys strewn with weeds and abandoned automobiles, and floating walls engraved with history standing out of these inner-city ruins. Jerre lead his daughter out of the house, and we walked the streets. In the end, we came back to their small first-floor apartment and the little girl danced for me. I saw the green bathroom door and her red-stripped top. There was the picture, for sure. It didn't hurt that she parlayed her swagger right into the image. Her father and his stunning Senegalese wife stood by and smiled.

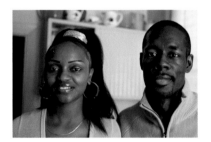

Pages 78–79: Keith Glass, Jr., his wife, Markeeta, and son, Keemari,
Milwaukee, Wisconsin, 2008.

It was very cold in Milwaukee the day I visited Keith and his son and wife at their apartment. The rooms were dark and mostly empty,, so my first thought was to

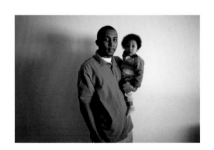

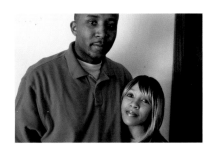

go outside into the parking lot to make the pictures. I took Keith and his son. In addition to the red shirt he was wearing, he also had a heavy winter red jacket on, still not enough protection from the zero temperatures we were exposed to. So we went back inside, and I noticed that, in the living room, behind the curtains were some window shades, so I pulled one up and then the other, and this soft and beautiful winter light poured into the room. The shadows grew on the walls, and the light wrapped around all their faces, and even the young boy was intoxicated by it. I took a few shots, first of Keith and his wife, then with his son. There was this gaze that came upon both of them, father and son, in the picture that only the exquisite quality of this winter light could help capture. You can tell, by the way Keith held his son, that this young boy will always have a strong fatherly protector in his life. The light helped show the way.

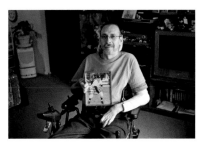

PAGES 80–81: RANDALL GONZALES AND DAUGHTER, RANDI RAIN, SAN ANTONIO, TEXAS, 2008.

First, there was the puzzle of the now-gone World Trade Center on a coffee table in the living room. That was enough to get anyone thinking, and I managed to get a quick shot of Randi Rain in the upper corner of the frame with her puzzle. Then, in the next room there was Randall. Now wheelchair-bound due to an accident, but he was in his prime with an incomparable spirit. I saw all the trinkets on the shelves and memorabilia, but what stood out most was Randall's baseball fascination. So I knew we would get along. I asked him if he knew Don Larsen, since he was such a big Yankee fan from the era. He had so much Yankee stuff around that I figured he knew. Everyone knew that Larsen threw the only perfect game in a World Series in 1956. Then, from out of nowhere, Randall took out the 8 x 10 photograph that Don Larsen signed and gave to him, and he held it in the picture I took. Of course, as proud as he was of the picture, he was more proud of the fact that his daughter had almost completed the World Trade Center puzzle that was on the coffee table, all by herself.

PAGES 82–83: STEVEN GONZALES AND SON, SACRAMENTO, CALIFORNIA, 2008.

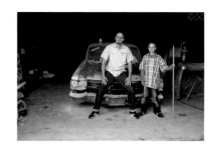

Steven Gonzales worked fourteen-hour days, seven days a week. He lived amongst the ghosts of bygone eras of vintage cars. Steven was the owner of the body shop that consumed him. He also was a father who taught his children by example. He told me that he regretted not being home for dinner every night, sometimes having to run out to give an estimate. He told me his heart hurt when he had to do this. Steven and his son took me on a tour of the body shop. We visited the paint shop, rich in the aroma of the freshly sprayed paint. His son was so proud of his dad. My presence with my camera made the young boy feel important. He knew his father had to be a very special person and that I was sent there to take this famous person's picture. Steven and his son posed so proudly in front of that blue, beat-up Cadillac. I envied that boy and the life he had with his father. When I was done, they gave me a red T-shirt with the name "RED STAR California Original" on the front of it. I felt as special as the son when I left.

PAGES 84–85: TERRANCE HALL AND FAMILY, SACRAMENTO, CALIFORNIA, 2008.

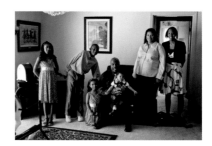

The joy of being with Terrance Hall was enhanced by the joy of spending time with his family. When I came to take the portrait of them, at first I was with only four of the kids, but, to my surprise, his wife and older daughter showed up from the pink bedroom, where they had been primping for the shoot. The little one in Terrance's arms stole the show, as far as I was concerned. Then I noticed, on the wall behind the family, the iconic picture of Cassius Clay, as I knew him as a kid. Even the photo I made earlier of Terrance with the Egyptian mummy could not compete with Mohammed Ali. I could hear the words of the renowned fighter Cassius coming out of the picture, "I am the greatest." Although it would have been hard for anyone to compete with Ali, I knew that, to his family surrounding him, Terrance was the greatest. And, of course, he never stopped smiling.

PAGES 86–87: JEFFREY HATHCOCK AND SON, WESTON, IDAHO, 2008.

Jeffrey was just back from Afghanistan and Iraq. In the back of my mind, I think that places such as Weston, Idaho, are where all the American soldiers come from: little villages and towns scattered all over the United States, with tiny city halls and grocery stores that sell gas with the name of the town above the front entrance. Jeffrey's home was adorned with American flags and pictures of his troop and buddies from the wars. He was home now, looking for something to do and some purpose to find in his life. We walked down to City Hall, and there, without the pretension of some big government edifice, I took a picture of him and his son. In the back of my mind, I couldn't help but wonder how young Jeffrey would feel one day when he understood the awards his father received for fighting and representing his country. I hope the youngster will stay in little Weston, but I know, like the photographer named Edward, that the young one will eventually up and leave and wander about. I hope he remembers that gorgeous day in June when I took a picture of him and his dad by the City Office.

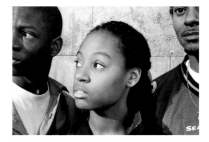

PAGES 88–89: WILLIAM HAYNES, SON, DEVONTE, AND DAUGHTER, LATIA, SEATTLE, WASHINGTON, 2008.

William did not talk the entire afternoon we were together. We wandered down by the market area in Seattle, and I took his picture just a block or so from the original Starbucks. His kids were there to help him and encourage him, and they pretty much became his voice. I think he wasn't worried about how he would be perceived in the picture and what his "real" role was in the whole scheme of things with regard to this project; he was just very quiet. He looked like he could have played for the Seattle Seahawks, as he was big and muscular and strong. His chiseled features stood out in the picture, and the picture I took of the three of them, although they seemed distracted, held them all together as family. In that image,

they seemed to be more aware than I was of where the light was coming from. The light was, in essence, reflecting off of William Haynes, at least that is how it felt.

PAGES 90–91: MICHAEL HENIGER AND FAMILY, LOGAN, UTAH, 2008.

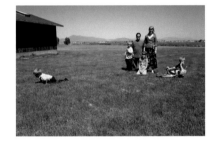

I know this picture outside is just "Lewis, the photographer" pretending to be Andrew Wyeth, and the little boy crawling away is really Christina in Wyeth's famous painting. Michael Heniger is very short. I imagine that, one day, everyone in his family will be taller. They were all getting to his height when I stopped in. Through all the chaos in Michael's house, he remained calm. Each child had his or her own space and place to hang out. The household was nervous, to say the least. Amazingly, right behind the Henigers' backyard was this huge park within view of the ski resorts to the west. What a dream for me. Michael and his wife rounded up the kids and had them all ready for the pose. Except for the little one. He was drifting away and out of the frame. Michael apologized profusely for his son's lack of attention. I told him that his son knew the picture would be stronger if he was seen crawling away. Michael seems to tower over everyone. His pride at being chosen to participate in this project gave him pause, and Michael wanted me to know how important they all are to him, even when one is fleeing the scene.

PAGES 92–93: BRIAN P. JACKSON AND DAUGHTER, FATIMA,
SEATTLE, WASHNGTON, 2008.

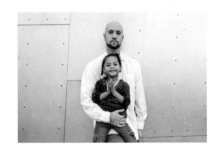

Brian seemed so stern. Earlier, I had arrived at the Rock and Roll Museum in Seattle, where we were to meet for the picture session. Most of the time, I stood inside and took in the Jimmy Hendrix video, and I marveled at the fact that Frank Gehry and rock and roll had somehow come together in this bizarre meeting of architecture and music. When Brian showed up, I was pretty "amped" up from Mr. Hendrix. So was Fatima, the little girl who accompanied her dad. We circled the

building, and I tried to find the best piece of metal in which to pose them. So this is a case where pictures can be deceiving, for, as stern and dour as Mr. Jackson appears in the photographs, he was actually truly enthralled with the whole process of this photo shoot and gave me all I asked for. I think that the way he is holding Fatima shows exactly how he feels about being her father: strong and involved.

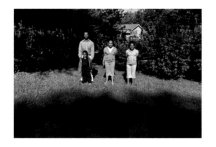

PAGES 94–95: SHAWN JACKSON, DAUGHTERS, BRITTNEY AND CURTNEY, AND SON, JACOB, BAY MINETTE, ALABAMA, 2008.

All I can remember were the spiders in the yard. They were so big, and they were everywhere, in all the trees and bushes, hanging from the gutters. I knew we were very far south, but I had no idea that I would be, for the most part, in the tropics when I was in South Alabama. I made my concerns known and also my fears. I asked, "Do they bite?" The young boy named Jacob replied, "Only other spiders, and then they eat them." His older sister, Brittney, told me that, instead of bug spray, most people in these parts use the spiders. They work better than the sprays. I felt safer after hearing that. I took the pictures with the kids and Shawn, their dad, in the front yard. They all seemed oblivious to the spiders, and, after a while so was I.

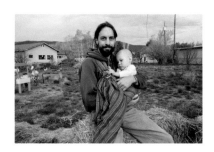

PAGE 96: STEVEN LAMAR AND SON, DAKOTA, TAOS, NEW MEXICO, 2009.

What can one say? Shades of the 1960s all over again in Taos. The Greatful Dead playing "Ripple" in the background lingered. Folks were hanging out in trees, and everyone seemed at peace with something, anything, everything. The kids in the commune had lots of parents (see page 37). Maybe it does take a village. Who knows? I have reached the conclusion that most fathers hold their kids the same way, one hand across their mid section and one under their butts. That's the "dad hold." I must say, whatever radiance occurred from the spiritual nature of this place seemed to come through in the photographs. Maybe I was just lucky that day. Yes,

this father named Steven really cared about everyone who came to his home, which he shared with many others. I wonder how the kids in the commune will adjust to life as they grow older. Probably well, as they had such good fathers in their lives.

PAGE 97: DANIEL LLOYD AND DAUGHTERS, NEW ORLEANS, LOUISIANA, 2009.

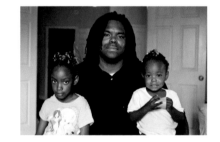

Most of the road that Daniel and his daughters lived down was gone or in the process of being redone, due to Hurricane Katrina. Whenever I have two children in the picture, it seems as though one is always distracted while the other one is in my face. Such was the case with Daniel's two little girls. I never seem to be able to get all the subjects to focus on the notion of being photographed, even when it is for posterity and I offer a treat. What do they know of posterity anyway? So Daniel, the good and strong father that he is, took the high road and expressed his contentment with the shoot by warmly engaging the lens. The little girl on his left knee was busy with me and her cup, while the show-stealer on his right knee gave me the evil eye. To her right was a perfectly framed poster of Barack Obama on the couch, not in the picture. In the end, it was clear to me that I was in the minority around these parts. Of yeah, I forgot to mention the red flowers in their hair—that's what did it for me, those flowers. I think for Daniel, too.

PAGES 98–99: JED MAGEE AND FAMILY, TAOS, NEW MEXICO, 2009.

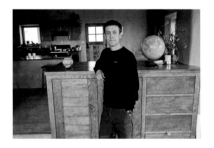

Jed had the coolest storage shed in his backyard I had ever seen, a "New Mexico Style" wood room with aluminum sections attached to it. He was an architect and worked in Taos. He showed me around his home, and I found the spot to take his picture. I especially liked the globe on the right-hand side of the frame and barely noticed the orange pop can sculpture to Jed's right. The best part of the day, however, was watching his kids play on the trampoline in the front yard right after this huge thunderstorm passed through. It was as though they were making fun of the

gods that had rained on their parade. Jed left them out there with their friends on their own, all the while watching them through the front windows. Such was the day, held together by loving and caring eyes. I envied these children.

PAGES 100–101: DONALD MORRELL, HIS WIFE, AND DAUGHTER, ATLANTA, GEORGIA, 2008.

Just a few blocks from downtown Atlanta, behind Morehouse College, is where Donald and his family lived. Actually, it seemed like quite a rough neighborhood for being so close to the school. For my first pictures, I took Donald down to Centennial Park, where the Summer Olympics were held in 1996. He stood on the pathway in the park, posing as though he owned the city, proud to be from Atlanta and proud to be a new dad. We returned to his small frame house, and his daughter was now up. It seemed to me like she was just born. So small and so innocent. I asked Donald to hold her, and he did, so delicately. I thought he might have been afraid even to touch her, as she was such an angelic little package. Her mother stood by, ready to take charge at a moment's notice. So there was Donald full of piss and vinegar posing in the park, and then there was Donald who had just become a father. It seemed to me that he was younger and more innocent than the child he was holding, his daughter. Donald was in good hands, as you can see from the picture.

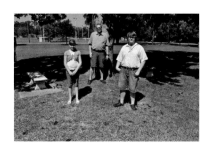

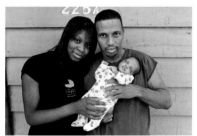

PAGES 102–103: DOUG MUNGER AND FAMILY, ELBERTA, ALABAMA, 2008.

One of my favorite pictures is of Doug's mother holding the picture of her family while sitting on her bed in the house that her great-great-grand parents had owned, dating back to the mid-1800s. There was some history there. So we went to the local baseball park, and Doug and the kids stood under a big old oak tree and took in the hot early-fall weather. It was so green and so tropical down there. I was

so enthralled with the old house that his mother owned that I could not wait to get back. There was, for me, that great sense of Southern history, full of self-assurance and righteousness. I was taken by the bedroom that was painted like the American flag. Doug was very quiet and polite. I had a lemonade and ventured around the yard. It was as if I had traveled back in time and left the United States. More or less.

PAGES 104–105: ANTHONY OROPEZA AND FAMILY, SACRAMENTO, CALIFORNIA, 2008.

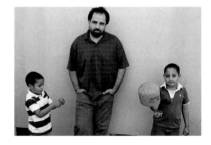

All I could think about was how to deal with the pastel-green walls surrounding the house. They seemed to soften everything and take away the focus of my work. I found a few old toys for the boys to play with in the pictures, and I asked Anthony if he had any ideas about what kind of picture I should take. He told me to do what I felt best about but to make sure that his wife and his kids looked good. He seemed most concerned about their well being and not the pictures. In many instances, I had to overcome a family's first inclinations of trepidation and perhaps a little mistrust about why I was suddenly dropped into their lives. What was I doing here? Who sent me? What would happen with all these photographs? Why were they chosen to be remembered? I thought about it for a little while and then just let loose and stuck with my first gut reaction: put them in front of the wall and let them shine. I feel the portrait of Anthony and his wife sits well inside me and on the surface. It's touching and powerful and, in some ways, quite serene. This is America now. The kids understood and went on about their business. I was quite content when all was done and couldn't wait to see the prints.

PAGES 106–107: VIJAY PEGANY AND FAMILY, SACRAMENTO, CALIFORNIA, 2008.

It's easy to see from the two images of Vijay and his parents and his daughter that tradition lives on and is very likely being passed down, from the older to younger

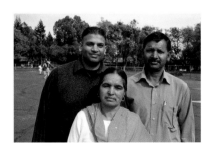

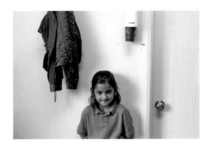

generations. Vijay's parents live in India and were visiting their granddaughter's charter school. They were so polite and respectful and proud to have their picture taken with their son. You could feel their pride. It was quite palpable and exuded a reverence for those who were communicating directly with them. It was nice for me to have this diversity in the project and to know that even men from India were seeking help in learning how to be a better fathers. So much for traditions. As you may be able to tell, the little girl in red was a pistol. While her dad looked on, she argued with him, in a nice way, about everything and was intent on giving me the look that she wanted me to have for my picture. Her family, of course, suggested to her that she smile more and look more accommodating. She would have none of it. In the back of my head, all I could think was to tell the elders, "This is what you get for coming to America." Not all bad, of course.

PAGES 108–109: MARSHALL POTTER AND FAMILY, ALPHARETTA, GEORGIA, 2008.

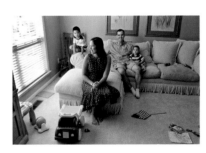

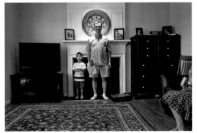

I visited Marshall Potter and his family in the Atlanta suburb of Alpharetta, where they lived. All was new and full of trees and hills and kids. Although the housing crisis in Atlanta was just beginning, and Marshall and I discussed it a bit, his main focus was on his wife and children. This family was, in essence, my grandparents' vision of the "American Dream": a young, vibrant, and diverse family with two beautiful kids living in a new subdivision. They certainly seemed intent on always looking at things from a positive perspective. What struck me the most was their commitment to God and their love of country. In most of the images I made in their home, there was always an American flag in the picture but not because I put them there. In one image, his beautiful wife, always on the lookout, stared out the window, ever vigilant. You could tell she knew her two boys just wanted to rough it up with their daddy, which they did. In this instance, I realized that the kids' mother made it so much easier for Marshall to be a complete father.

PAGES 110–111: DONOVAN, OLDEST SON OF CLIFFORD PRICE, MANHATTAN, KANSAS, 2009.

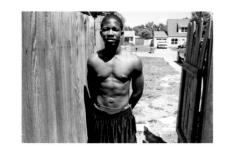

Donovan was quite proud of his father, who had served in the U.S. Army for many years and was now stationed at Fort Riley. So, when I took his little brother in the backyard and had his father sit on the garden wall behind him, the tough and rugged Army image that his father had always portrayed seemed somewhat diminished. I felt this, and I knew that Donovan wanted something more for the photo, his photo. He wanted to make sure that this tough-guy image was going to be portrayed by someone in his family, namely him. This explains the bare-chested picture by the yard gate, which, in some way, helped him exemplify and call out his feelings about being a man. His younger brother in the yard with his dad was just for scale, but the real strength in our meeting lies within Donovan, and I wonder where he got that from. I am sure, from his father.

PAGES 112–113: JUHHL RIDDEL AND SON, SAGE, COLORADO SPRINGS, COLORADO, 2008.

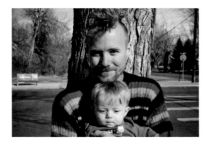

First, I tried the father and son portrait thing. Seemed to work out alright. Then I thought what was really compelling about Juhhl was his hair. I am old enough now to remember fondly how hair mattered when I was in my late teens and early twenties. Mine was much longer and less well kept, unlike Juhhl's, which was, in my mind finely cut and cropped. I wondered what all this current focus on hair really means. I even thought about whether his son would one day have the same style haircut as Juhhl. Sage, like all other young boys, wanted to be with, hold on to, and, of course, look like his daddy. From the picture of the two of them together, maybe the youngster was already going down that road. I took the photograph directly in front of the tree because the tree reminded me of the hair, or vice versa. In any case, there was much to be thankful for on that day, especially the blueness/

whiteness of the sky and softness of the wind. That "wind thing" can do a lot of damage to your hair if you are not prepared. Young Sage was just happy to be held so tightly by his father. Weren't we all?

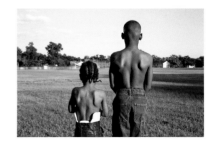

PAGES 114–115: WILLIAM RIVAS AND DAUGHTER, SCHENECTADY, NEW YORK, 2009.

They thought I was nuts when I stopped the car in the middle of this big, wide, and busy road in Schenectady and asked them to walk into the middle of the street so I could take their picture. From early on, I had always associated the United States with companies such as General Motors and General Electric. So, when I saw the opportunity to make this picture just up the road a bit from the world headquarters of GE, I immediately took advantage of it. It was hard to imagine what had happened to this grand boulevard over the years since GE ended up at its grand cul-de-sac. The road, cluttered with empty and abandoned buildings, seemed so different than what was there long ago. Still, there was this iconic symbol of General Electric rising above their heads in the background. I thought about it some more and realized that, for the little girl in the photograph, the only symbol that she needed towering above her head was her father. And there he was.

PAGES 116–117: ERNEST AND CRISTIAN, SONS OF CHRIS ROBINSON, MOBILE, ALABAMA, 2008.

The image of the two boys with their back to me is my favorite in the book. I met them by their dad's house in Mobile, just across the street from an abandoned steel mill. It was warm, so we went to the park for the picture session. The little guy was all ready for me, with his football uniform on, set to tackle anything and anyone who got in his way. His older brother was a bit more reserved and shy. I had them look away from me, as I thought that, maybe, they would see their dreams be-

ing fulfilled off in the distance. Chris Robinson was elegant and superbly adorned in the late afternoon Alabama light. His two sons were part of the the rest of the family of five more kids, so seven in all. I had no idea what was going on in all their lives, so I just focused on the pictures, which was far less complicated. It's amazing how complicated we can allow things to become. The boys had a good time.

PAGES 118–119: MORGAN STREETER AND DAUGHTERS, DES MOINES, IOWA, 2009.

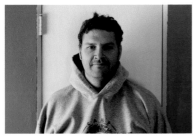

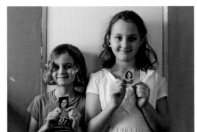

I asked the two little girls to get the best pictures they had of themselves in their rooms. They are holding up what they brought back. They said to me, "Why are you taking a picture of us holding a picture of us?" I told them that this was an old photographic tradition, the idea of the picture within the picture. They said, "We understand." Then the little one asked, "But which picture is the real picture?" At that point, I knew she really understood, and I told her that, one day, she would be a great photographer. Morgan, their dad, took it all in stride and stared head on into the lens. He had been busy showing us around Des Moines that day and was glad just to stand there and have his picture taken in the house. The walls were very blue, and his daughters asked me if I liked that color. Of course, I said, "Yes." Then they wanted to know if they were going to be in the book. I said, "Maybe," and they said, "Aw, come on now."

PAGES 120–121: JIM SWART, ALBANY, NEW YORK, 2009.

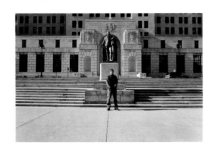

In all the years I lived on Long Island, I had never been to Albany, the state capital. All the counties of the state were emblazoned in stone around the entire perimeter of the state capital building. There was George Washington in the background with Jim Swart standing steadfast in front of him, protecting the state from all that would come its way. But the real story here was how Jim looked after his children, who rallied around him on this cold February day on the plaza of New York's cen-

ter of government. It was a lesson in both the essence and heart of government and the essentials of fatherhood. The girls were so proud of their dad and the fact that he was chosen to participate in our project. As Jim stood under George, I knew that George, too, would approve of all that Jim is doing to help raise his kids. From the father of our country to the father of one family, a blessing in liberty was bestowed. I saw George wink and nod his approval.

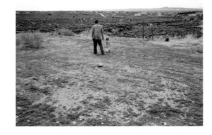

PAGES 122–123: JOHN TAFOYA AND DAUGHTER, KIENNA, RANCHO DE TAOS, NEW MEXICO, 2009.

The picture of John Tafoya and his daughter, Kienna, seems so corny that it could be so easily dismissed. That was my first thought. John lived with his parents in a rather tough area of Taos. In many ways, the grandparents were providing the role-model relationship for Kienna that all young children need from their parents as they grow up. John was a bit nervous and unsure about the photo shoot, and I struggled to find a way to make a few pictures. Finally, I looked out the bedroom windows and saw the view from behind the house, the rolling landscape and the mountains off in the distance. So I asked John to take his daughter's hand and walk with her off into the yard, which for me became the gesture and metaphor for the guidance that every child needs in their life when they are exploring their world of growing up. Seems corny, but, in some ways, it is so basic that the sentimentality shakes itself loose and allows this father-and-daughter bond to thrive.

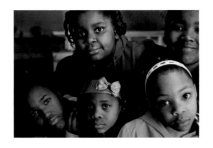

PAGES 124–125: JOHN THOMAS AND FAMILY, MILWAUKEE, WISCONSIN, 2008.

There were so many kids in the house that the whole scene was overwhelming. I went room to room, and every room was packed full of child-like energy and lots of verbal pomposity. I thought the best way to describe all of this would be to make one image of all the girls stacked up against each other. That was easy to do, as

they were all so eager to get in front of the lens. The image of John and his wife on the couch was a different story, much more reserved and formal. Both parents were proud of their kids and happy to be looking at me, square on. When I viewed the files from this day, I picked the one that sent the most straightforward message. Little did I know that John's hand on his wife's shoulder would appear to be so subtle and forcefully caring. He managed in the end to slip his arm over her shoulder and asked me if this was all right to do. I thought he wanted me to know that he was the protector of all these women who had taken over his life and challenged him to rise to the occasion. The young girls loved him, and all he had to do was give them a "look," and they toed the line. He was the dad they all wanted and needed.

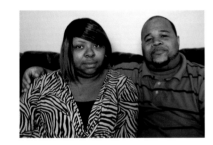

Pages 126–127: Randy Tolman and children, Brigham City, Utah, 2008.

Randy worked at the tire center for Wal-Mart in Brigham City. What could be more American? I took advantage of that fact and knew that, if I somehow made the truck in the picture with the company logo on it the focal point of the image, everyone would know that this picture was made in the United States, even if most everything Wal-Mart now sells is made in China. Such is the modern age. Randy was happy to have this job at Wal-Mart. I was happy to be with him and meet the children. In the bedrooms, there was hardly room for the kids and all their stuff, never mind this nutty photographer and their father. At first, I wanted to clean the joint up a bit, but then I realized that would become too daunting a task, so I succumbed to the chaos. Chaotic, it was, yet underneath all the disorder was the children's relationship to all the disorganization. They were unfazed and probably thought that, for the most part, the room was really not so cluttered. Randy placed his head evenly between the edge of the door and the small shelf on the wall. I snapped the shutter and moved on. The oldest girl shut her eyes.

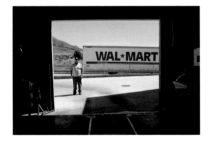

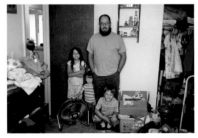

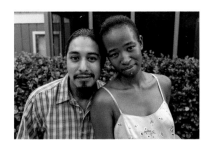

PAGES 128–129: GONZALO PAREDES TOSCANO AND WIFE, ALPHARETTA, GEORGIA, 2008.

First, I met the king and the queen. There was Gonzalo and his beautiful wife staring me down. I could only imagine what I was going to encounter as I was about to meet their little girl. She came running through the building complex's parking lot with a friend, wanting to know if she was too late to have her picture taken. She was all dolled up and wanted everyone to know that she was ready to be the little princess in all the pictures. She certainly was just that. I was up on the second-floor balcony when she showed up, and, looking down, I saw this oil spot in the parking space where she was standing. I had her stand in it just to prove that she could make anything that was ugly around her look quite beautiful. What do you think? She even placed a small and lovely tiara on top of her head. Her pink princess dress simply made the day perfect. Ganzalo was quite pleased.

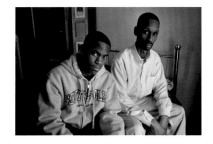

PAGES 130–131: BEN WATSON AND MENTEE, ANDREW, MILWAUKEE, WISCONSIN, 2008.

Ben Watson is not Andrew's father but rather a friend who has served as Andrew's surrogate dad for many years. So, for Andrew, Ben might as well be his father. I met the two of them along with Andrew's grandmother in Milwaukee at her house. She showed me all around the home and proudly held and displayed the awards and medals her daughter and late husband had earned in the U.S. military. She was a delight to be around. Andrew sat with Ben on the bed in his room. I made the image of the two of them, and then I took Andrew into the guest room and watched as the sunlight hoped around and about all the off yellow walls. The young boy gave me quite a look, as if to say, "You really don't know what I know." He would have been right, no doubt. There was a certain magic to this picture that comes along, just like Andrew, only once in a very long while.

Pages 132–133: Ryan Williams, his wife, and daughter, Kiara Reneé, Colorado Springs, Colorado, 2008.

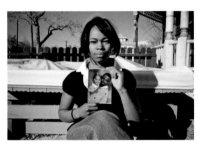

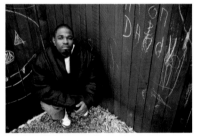

I met Ryan and his wife at a halfway house in Colorado Springs. Ryan would spend time with Kiara there every weekend under court-ordered supervision, after his wife brought her by. It was so sad that the two of them could not find a way to live their lives together for the sake of their daughter. So the image of her mother holding the photograph of Ryan and his daughter was especially difficult for me, a father of two girls. I have lived with and loved both of my girls since they were born, and I could not imagine life without them or Annie, my wife. I sensed that, while she was holding this picture of Kiara, she, too, longed for Ryan to come back. So did Kiara, I am sure. But the image that struck home for me had Ryan placed in a corner of the backyard at the center, with the word "Daddy" in chalk on the fence wall. This said it all. There was Ryan, wedged into the corner, all the while doing his best to understand why life had turned on him this way. I felt he wanted to be the "Daddy" word that had found its way onto the stained planks. Hopefully, they will work it out one day. Perhaps they already have, and Kiara will be whole again.

Pages 134–135: Teflon Wint and family, Manhattan, Kansas, 2009.

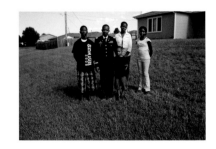

Teflon was from Jamaica, and he was stationed at Fort Riley. He was in the U.S. Army. It took a while for me to figure this all out and how this lively Jamaican and his family ended up in Kansas. It was, for me, the reverse of the *Wizard of Oz*. Nonetheless, here they all were, and they were very proud to be represented in our project. As is usually the case, the photographer is the last to know what is going on. So, in the quiet moments I have with my subjects, we usually talk, and I ask a few questions and so do they. To my surprise, Teflon was really only concerned about one thing: he had left his regular Army shoes in the house and had his sandals on. He was worried he could get into trouble for being photographed with his sandals on instead of the proper shoes. I thought about this and realized it was truly

amazing that, with all the self-serving issues people bring into each other's lives, here was this Jamaican, proud as could be of his family and being in the United States military, and all he could think of was the disrespect he might cause while wearing improper shoes. I imagined that he must have been a very good role model for his children and family. I know I am right about that.

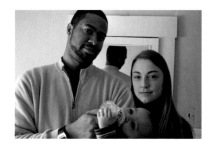

PAGE 136: MARVIN BYNAM, HIS WIFE, STACY, AND SON, MILES, MILWAUKEE, WISCONSIN, 2008.

Marvin Bynam and his wife were law school students in Milwaukee. They lived in a small "Milwaukee Style" brick bungalow. The first floor was full of Prairie Style wood moldings and furniture. It was dark, and it would have been difficult to make a picture down there. Upstairs, the light poured in, and, as we wandered around the rooms, next to the tub in the bathroom there was this beautiful and rich natural light. I had the family stand there. Marvin was a bit nervous and hadn't exactly figured out what I was doing and why I was there. I asked him to feed their baby while I made the picture. He was focused on me and at the same time concerned about his child. They were just such a complete couple. Lots of positive vibes and love infused the aura of the home. Marvin's wife hardly said a word, but in this image one can clearly see the depth of her wisdom. She was proud of Marvin and certain that their child would do well in life with their support.

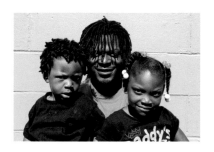

PAGE 150: KEVIN HALL, SON, AND DAUGHTER, NEW ORLEANS, LOUISIANA, 2009.

Kevin Hall lived with his mother in one of the lower wards of New Orleans. It was clear to me from the outset that Kevin was confused and torn with regard to his fathering role with these two children, whom he literally carried about. He was built like a linebacker and lived in a neighborhood still decimated by Hurricane Katrina. He didn't talk much, and, when he did, it was just pleasantries of the day. His daughter was very curious, and his son seemed to question what I was

doing and why I was there. It was as if Kevin knew that he had to be ready to have his picture taken with the kids but didn't understand why. There was an old man across the road who engaged me a bit after the shoot. He told me that Kevin tried hard to be there for his kids, but in the big picture he was really confused about what he was supposed to do to be a father—he was so young. His children seemed to be unaware of just how bad things were around them. I knew at one time this neighborhood must have been teeming with life, but the houses were few and far between now. It was tough enough to survive there anyway, and the last thing they needed was the big storm. Kevin's son seems to be saying, "What's going on?," and his daughter seems to say, "I understand."

Page 156: Kevin Polk and Son, Robertsdale, Alabama, 2008.

It was a beautiful late-September day in this small South Alabama town. When I arrived at the home of Kevin Polk, I sensed I was going to find the kind of relationship between a father and son that every young man wants. Although, at first glance, appearances can sometimes deceive, seeing the yard with an area dedicated to auto repair and rebuilding made me think about what I had missed growing up. What young boy does not want to rebuild old trucks with his dad and then tape the words MUD STUD on the windshield? I would have given anything to have had this experience with my own father. Need I say more? When they put their arms around each other's shoulder while they posed in the backyard, it certainly was heartfelt and sincere. What I really wanted to do was drive the truck. They told me that, once the engine was rebuilt, I could come back and take the beast for a spin.

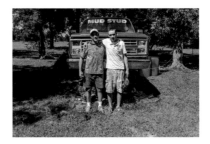

Page 201: Jose Rivera and sons, Pittsburgh, Pennsylvania, 2007. (See page 2.)

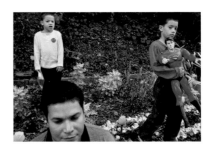

192

• Suggested Readings and Viewings

by Derrick M. Bryan

THE FOLLOWING books, articles, films, documentaries, and television sitcoms, situation comedies, and family dramas offer introductions to some of the key research and cultural topics related to responsible fatherhood.

Father Involvement:

Day, Randal D., and Michael E. Lamb (eds.), *Conceptualizing and Measuring Father Involvement, 1ˢᵗ Edition* (New York: Taylor & Francis, 2003). This comprehensive volume focuses on ways of measuring the efficacy of father involvement in different scenarios, using different methods of assessment and different populations.

Eggebeen, David J., and Chris Knoester, "Does Fatherhood Matter for Men?" *Journal of Marriage and Family*, Vol. 63, No. 2 (May 2001): 381–93. This article explores the possible effects that fatherhood has on the lives of men in a range of experiences.

Glazer, Dana H., *The Evolution of Dad,* Dane-Gramp Productions (2010). This documentary offers a comprehensive look at fatherhood in contemporary American society. It masterfully explores issues of care, gender roles, masculinity, and the work-family balance. It examines the past, present, and future of fatherhood in the U.S. while exploring how fathers are more than household providers.

Gray, Peter B., and Kermyt G. Anderson, *Fatherhood: Evolution and Human Paternal Behavior* (Cambridge, MA: Harvard University Press, 2010). This book offers a multicultural and evolutionary approach to the issue of fatherhood and the effect it has on men.

Lamb, Michael (ed.), *The Role of the Father in Child Development, 5th Edition* (Hoboken, NJ: John Wiley & Sons, 2010). This book presents a current summary of the state of fatherhood across cultures, classes, economic systems, and family formations. This classic guide offers a single-source reference for the most recent findings and beliefs related to fathers and fatherhood.

Lipschutz, Marion, and Rose Rosenblatt. *Fatherhood USA*, PBS: Incite Pictures (1998). This three-part mini-series, originally broadcast nationally on PBS in 1998 and hosted by then Senator Bill Bradley, documented common stereotypes of fatherhood, how fathers balance work and family life, and how fathers and mothers build strong relationships with their children.

Tamis-LeMonda, Catherine S., and Natasha Cabrera (eds.), *Handbook of Father Involvement: Multidisciplinary Perspectives* (New York: Routledge, 2002). This book offers a multidisciplinary approach to the study of fathering and to the interpretation of behavioral patterns that characterize ecological systems that include—as well as extend beyond—family units. It offers insight into the nature and meaning of fatherhood and father involvement by questioning longstanding assumptions about fathers' roles in the lives of families and children.

Father Absence:

Blankenhorn, David, *Fatherless America: Confronting Our Most Urgent Social Problem* (New York: Harper Perennial Press, 1996). This book dissects America's fatherhood crisis, pointing to several critical problems: fatherless homes, readjusting the traditional roles of fathers and fatherhood, and the continual questioning, "Are fathers really necessary?"

Bryan, Mark, *The Prodigal Father: Reuniting Fathers and Their Children* (New York: Clarkson Potter Publishing, 1997). This book details a carefully conceived plan to help men negotiate the sensitive and potentially explosive path back into the lives of their children.

Coles, Roberta L., and Charles Green (eds.), *The Myth of the Missing Black Father* (New York: Columbia University Press, 2010). This book showcases the diversity of African-American fatherhood in contrast to the often one-dimensional portrayal of black fathers as being largely absent single fathers. Sections explore key categories of black fathers in contemporary society and some of the challenges they encounter.

Marsiglio, William, Kevin Roy, and Greer Litton Fox, *Situated Fathering: A Focus on Physical and Social Spaces* (Lanham, MD: Rowman & Littlefield Publishing, 2005). This book focuses on the link between fathers' experiences and the social organization of space. The authors provide a powerful framework for understanding the social conditions that foster or undermine involved fathering.

Reflections on Fatherhood, ABC NEWS Productions (October 15, 2007). This *Nightline* documentary looks at how unique fathering can be, including the influence that Barack Obama's father had on his life by his absence and the effect that John McCain's father had on his life by being present.

Gay Fatherhood:

Ivanova, Julia, *Fatherhood Dreams*. InterimFilm Production (2007). This film explores the controversial topic of gay men becoming fathers by speaking with four homosexual dads who have dedicated their lives to raising happy, healthy children. From adoption to co-parenting and surrogacy, Ivanova's eye-opening film explores all the options that are open to gay couples who long to experience the joys of parenthood, and the film doesn't flinch when addressing some of the more tender issues related to the topic.

Lewin, Ellen, *Gay Fatherhood: Narratives of Family and Citizenship in America* (Chicago: The University of Chicago Press, 2009). This book chronicles the lives of gay men, exploring how they cope with political attacks from both the "family values" right and the "radical queer" left, while also shedding light on the evolving meanings of family, gay identity, and fatherhood in twenty-first-century America.

Mallon, Gerald P., *Gay Men Choosing Parenthood* (New York: Columbia University Press, 2003). This book reveals how very natural and possible gay parenthood can be. It investigates what factors influence this decision. How do the experiences of gay dads compare to those of heterosexual men? How effectively do professional

services such as support groups serve gay fathers and prospective gay fathers? What elements of the social climate are helpful and hurtful?

African-American Fathers:

Clark Taylor, Kristin, *Black Fathers: A Call for Healing* (New York: Doubleday, 2003). This book presents a discussion of fatherhood in the black community and the need for black fathers to become stronger, more positive paternal presences in their families. In addition, the author dismantles the stereotype that fathering has become "optional" within the black community.

Coles, Roberta L., *The Best Kept Secret: Single Black Fathers* (Lanham, MD: Rowman & Littlefield Publishing, 2010). This book blends a case-study approach and detailed personal narratives to reveal the neglected face of single African-American custodial fathers committed to raising their children. Long ignored by researchers and misunderstood by agents of key social institutions, these men share powerful and intimate stories about the joys and struggles of fatherhood in a society conditioned to expect less of them.

Connor, Michael E., and Joseph White (eds.), *Black Fathers: An Invisible presence in America, 2nd Edition* (New York: Routledge Academic, 2011). This book offers a broader, more positive picture of African-American fathers. Featuring case studies of African-descended fathers, this edited volume brings to life the achievements and challenges of being a black father in America. Leading scholars and practitioners provide unique insights into this understudied population.

Hamer, Jennifer, *What It Means to Be Daddy: Fatherhood for Black Men Living Away From Their Children* (New York: Columbia University Press, 2001). This work explores the larger forces that define the social world of fathers and looks at what "significant others" expect of men as fathers and how they behave under these circumstances. It then presents an analysis of the particular parenting roles and functions of fathers, using narratives of individual men to tell their own stories.

Pitts, Jr., Leonard, *Becoming Dad: Black Men and the Journey to Fatherhood* (Chicago, IL: Agate Publishing, 2006). The author presents an unflinching investigation, both personal and journalistic, of black fatherhood in America.

Ross, Dana, *Black Fatherhood: Reconnecting with Our Legacy* (Phildelphia, PA: Pure Quality Publishing, 2005). Using research and interviews from hundreds of black fathers around the world, this book sets out to dispel myths about black men in their roles as fathers, despite the mounds of questionable and derogatory statistics that have surfaced. It is an intriguing and touching look at black fathers, from their time of enslavement to the present.

TV Programs on Fatherhood:

The Adventures of Ozzie and Harriet

A situational comedy of 435 episodes (October 3, 1952 to September 3, 1966) that aired on ABC. Program creator: Ozzie Nelson. Directors: Ozzie Nelson and David Nelson. Originally a popular radio show starring the real-life Nelson family (father, wife, and sons), on television it attracted even larger audiences and remains the longest-running show in television history. Each week's episode strove for realism in conveying the joys and concerns of everyday American middle-class life, and the Nelsons became identified as an ideal WASP (white, Anglo-Saxon Protestant) family during the 1950s (when the Nelsons were based in suburban Chicago) and 1960s (after they moved to suburban Southern California) as viewers watched the children grow up under the guidance of nurturing, loving parents.

The Andy Griffith Show

A sitcom of 249 episodes (October 3, 1960 to April 1, 1968) that aired on CBS. Program creators: Aaron Ruben and Sheldon Leonard. Writer: Arthur Stander. A widowed sheriff, Andy Taylor, raises his son, Opie, with the help of Aunt Bee in the fictional small town of Mayberry, North Carolina, which was based on real small

town life in Mount Airy, North Carolina, the hometown of Andy Griffith, who played Sheriff Taylor. The strong relationship portrayed between father and son and their community remains alive and well among viewers of re-runs even today. Though the show never won an award, it was a major hit that *TV Guide* ranks as the ninth-best show in television history.

The Cosby Show

A comedy of 201 episodes (September 20, 1984 to April 30, 1992) that aired on NBC. Program creators: Bill Cosby, Cordell Frances, Michael J. Lesson, and Ed Weinberger. The winner of a Primetime Emmy Award for Outstanding Comedy Series, this show presented the often humorous events in the life of the Huxtables, an affluent African-American family living in Brooklyn, New York. The father, an OBGYN, and the mother, an attorney, shower love and wisdom on their five children even as they must deal with their children seeking out their respective identities and sense of independence and fit within the family structure.

Father Knows Best

A sitcom of 203 episodes (October 3, 1954 to May 23, 1960) that aired on CBS. Program creator: Ed James. Originally a popular radio series on NBC radio (August 25, 1949 to March 25, 1954), the television version became ingrained into American pop culture for its portrayal of the everyday problems of the "wholesome" Anderson family, living in the fictional suburban town of Springfield, somewhere in the Midwest. Nearly each episode followed a familiar script: the father, an insurance agent, after coming home from work and exchanging his suit for a comfortable sweater, is bombarded by one or more of his three children: a cute daughter in elementary school, an irresistible but goofy son in middle school, and an annoying teenage daughter in high school. The mother, meanwhile, remains the steadfast giver of sensible action and advice and is supported by her appreciative husband.

Good Times

A sitcom of 133 episodes (February 8, 1974 to August 1, 1979) that aired on CBS. Program creators: Michael Evans and Eric Monte. Chief producer: Norman Lear. This mid-season replacement became an instant, ground-breaking hit for its range of characters and subject matter: a poor African-American family trying to make the best out of life while living in a notorious housing project in Chicago. The show was a spin-off of *Maude* (September 1, 1972 to April 22, 1978), which was a spin-off of *All in the Family* (January 12, 1971 to April 8, 1979) and *The Jeffersons* (January 18, 1975 to June 25, 1985).

Leave It to Beaver

A sitcom and situational comedy of 234 episodes (October 4, 1957 to June 20, 1963) that aired on CBS (1957–1958) and ABC (1958–1963). Program creators: Joe Connelly and Bob Mosher. Set in an iconic suburb in post-World War II America, the Cleaver family (Ward, the attentive father, June, the perfect housewife, Wally, the oldest son, and Theodore, known "the Beaver," the younger son) became an idealized family in which Beaver became a kind of contemporary Huck Finn. Though viewed as oppressively perfect at times, the Cleavers became an important cultural model for Generation X kids who discovered it during the 1980s and 90s. TIME magazine listed it among "the top 100 television shows of all-TIME" that never won an award.

Little House on the Prairie

A family drama of 203 episodes (September 11, 1974 to March 21, 1983) that aired on NBC. Program creators: Laura Ingalls Wilder (author of the book of the same title), Blanch Hanails, and Ed Friendly. Directors: William F. Claxton, Maury Dexter, Victor French, Michael Landon, and Leo Penn. Like the book upon which this show was based, family values, love, friendship, and faith were the principal

themes depicted in this family living on a productive farm in the fictional town of Walnut Grove, Minnesota, during the 1870s and 80s. The family was headed by a strong-willed but emotional father, a compassionate and hard-working mother, and a young daughter learning to make her way in the world.

My Three Sons

A situation comedy of 380 episodes (September 29, 1960 to August 24, 1972) that aired on ABC (1960–1965) and CBS (1965–1972). Writers: Peter Tewksbury and George Tibbles. Executive producer: Don Feddersee. Producers: Edmund L. Hartmann, Peter Tewksbury, and George Tibbles. Set initially in a fictional Midwestern town called Bryant Park and then in a sparkling Los Angeles suburb, the show follows the life of a widower, an aeronautical engineer, who raises his three sons with the help of cantankerous but loveable Uncle Charlie. The father never seemed to make a mistake as he combined good judgment, firm standards, and a calm demeanor to gabbling with any task at hand, no matter how large or small. The show was a cornerstone of American TV, second only to *The Adventures of Ozzie and Harriet* for the longest-running (live-action) family sitcom.

The Rifleman

A Western sitcom of 169 episodes (September 30, 1958 to April 8, 1963) that aired on ABC. Program creator: Sam Peckinpaw. Producers: Levy-Gardner Lavan and Arthur H. Nadd. This was among the first primetime series to feature a widowed parent, Lucas McCain, who raises his son, Mark, on a homestead near the fictional town of North Fork in New Mexico Territory. The bond between father and son is more than heartfelt; it is powerful and complements the real-life scenarios of growing up on a ranch at a time when the gun still ruled the West. The overall theme of each episode focused on people deserving a second chance.

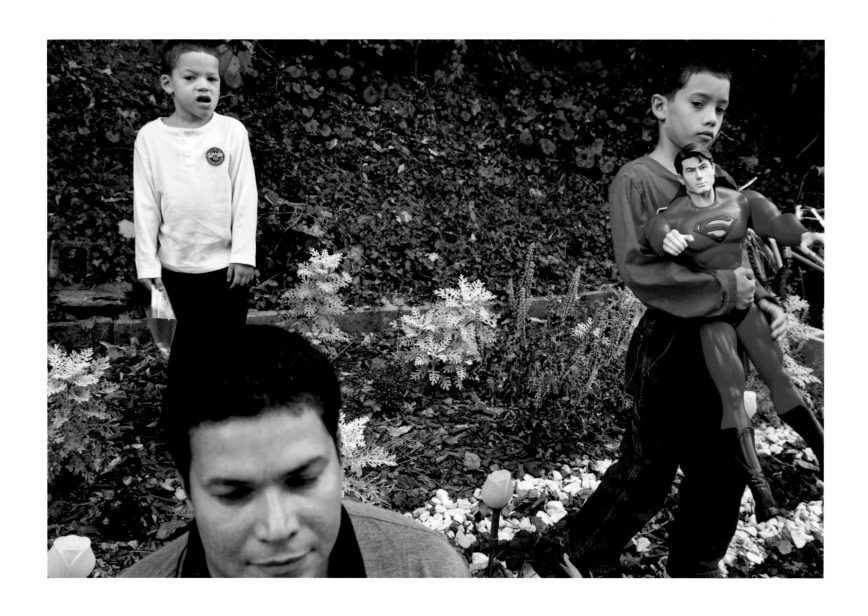

JOSE RIVERA AND SONS, PITTSBURGH, PENNSYLVANIA.

• Acknowledgments

It was my wife, Anne Neri Kostiner, whose kind heart and generous spirit brought me to this project in the first place. She took me to a charitable luncheon back in 2006 in Chicago for the Illinois Fatherhood Initiative, where I met Roland Warren, President of National Fatherhood Initiative. That was the moment when this project started. Annie encouraged me to get involved and help NFI in the best way I could. This book was the natural outcome of her efforts. She not only drove me to and from Midway Airport on more than forty occasions, but helped me sort out and understand my work, which created a firm foundation for all the images found within the book. She encouraged me to keep going and finish up what I had started. She kept me focused.

I give thanks to photographer Alan Cohen, of Chicago, and to his wife, Susan Walsh, who introduced me to Shipra S. Parikh. Alan took the time to view my work early on after I first visited Pittsburgh and Milwaukee. His positive feedback and introduction to George F. Thompson, my editor and publisher, helped to take my ideas to a much higher plain. George encouraged me, at the end of our first meeting, by quickly sketching a small map of the U.S.A. and dividing this map into six regions. He told me to go out and pick three or more cities in each region and make work there. Then I would be ready for him to consider doing my book, for I would have dealt with the United States as a whole. His guidance was instrumental and pivotal. His picture edits and text editing and overall assistance helped me to see how all this work could come together in a profound way.

Roland Warren at NFI opened all the doors for me and helped make all the arrangements with the local contacts that lead to my meeting and photographing more than 150 good men, in thirty-nine cities and seventeen states. Most of my journeys were shared with Milt Scott at NFI, who graciously met me at each city's airport and took me around to meet the fathers. I learned so much from Milt over dinners in far-away and out-of-the-way places and in our journeys in the car, where we talked at length about everything. Milt also created the interview format, and with his gentle and soft approach he and his colleagues were able to extract so

much from each dad in an honest and forthcoming way. There were others at NFI, such as Greg Austen, Ron Clark, Becky Graham, and Lisa Tate, who also lead me to some wonderful encounters.

I have had three major photographic mentors in my life: in Aaron Siskind, Arthur Siegel. and David Travis. Both Aaron and Arthur taught me what it meant to "make a picture." Most of us who went to the Institute of Design at IIT in Chicago know what that means. David and I often share lunches at Macy's in the Loop in the food court. David saw the promise in the work early on and encouraged me to keep plugging along. His essay in this book is a gift that I will forever cherish. I also wish to thank photographer Dawoud Bey, who took the time to look at my work and encourage me to press on with the book. There are also the writings of Juan Williams and Dr. Shipra S. Parikh, who have both waited patiently for the finished product. I thank them for their insight and the honesty found within their words. All of the essayists are in the good company of Derrick M. Bryan from Morehouse College and, of course, Roland C. Warren, President of National Fatherhood Initiative. And I'm very grateful to David Skolkin, for his artistry in the book's design, to others on the GFT team, for their assistance, and to Matt Kosterman, for giving his soul to this project and for his expertise in digital printing.

There are countless others in my life who I think of when it comes to this project and where I am today: my two fathers, Edward and Leon, and my wife's father, Silvio, all the other good men in my life, and fathers everywhere. Many thanks Michael Lutch, my fellow photo journeyman of forty years, whose almost daily talks have enhanced my photographic vision and passion, and to George Basta, who is a man who constantly inspires me. Then there are my two little girls, Rickie and Tess, all grown up now but both at the root of the foundation of my own sense of fatherhood. As their father, they helped me to understand that the best and truest gift I could give to them was my time. Coming home early from work or taking them out for Wendy's or to a movie were among the greatest thrills I could ever give them. It was seeing them run to me with their arms open wide and hugging me and letting me know how important their daddy was to them.

• About the Essayists

Juan Williams is a journalist, political analyst for Fox News Channel and the author of eight books, including *Muzzled: The Assault on Honest Debate* (Random House, 2011), *Thurgood Marshall: American Revolutionary* (Three Rivers, 2000), and *Eyes on the Prize: America's Civil Rights Years, 1954–1965* (Penguin, 1988), which was a companion to the Emmy Award-winning PBS series.

Roland C. Warren is President of National Fatherhood Initiative, a nonprofit organization dedicated to improving the well-being of children through education and the promotion of active and responsible fatherhood. He recently served on President Obama's task force on responsible fatherhood.

David Travis was Curator of Photography of the Art Institute of Chicago from 1975 to 2008, where he curated more than 150 photography exhibitions, some of which toured internationally. His many books include *Karsh: Beyond the Camera* (Godine, 2012), *At the Edge of Light: Thoughts on Photographers and Photography, on Talent and Genius* (Godine, 2003), and *Edward Weston: The Last Years in Carmel* (The Art Institute of Chicago, 2001).

Shipra S. Parikh, Ph.D. and L.C.S.W., is a researcher and psychotherapist in private practice, specializing in children and families. She serves as an academic advisor and adjunct professor at Loyola University Chicago and the University of Chicago. Her research publications in the area of fatherhood include *The Other Parent: A Historical Policy Analysis of Teen Fathers* (Praxis, 2005) and *Validating Reciprocity: Supporting Young Fathers' Continued Involvement with their Children* (Families in Society, 2009).

Derrick M. Bryan is an assistant professor in the Department of Sociology at Morehouse College. He received his Ph.D. in sociology from the Ohio State University, and his current research and teaching focus on men and families and the social, emotional, cultural, and psychological consequences of racial oppression and social inequality for persons of color (in particular, African-American males) in various domains in society (in particular, crime, education, family, and work).

• About the Author

Lewis Kostiner was born in Montréal, Québec, Canada, in 1950 and was raised in Montréal before his family moved to Westbury, Long Island, in 1962. He earned his B.A. in liberal arts, with an emphasis in photography and creative writing, at Brown University in Providence, Rhode Island, where he also studied at the Rhode Island School of Design with Aaron Siskind, Harry Callahan, and Emmit Gowen. He completed his M.S. in photography at the Institute of Design within Ilinois Institute of Technology in Chicago, where he studied with Arthur Siegel, Garry Winogrand, and Geoff Winningham. After he left Brown, he assisted Aaron Siskind for many years and traveled with him worldwide. From 1973 to 1981 he was an adjunct professor of photography at Columbia College Chicago, and he is currently a faculty member in the Department of Photography at the School of the Art Institute of Chicago. His photographs are in the permanent collections of, and have been exhibited at, the Art Institute of Chicago, Center for Creative Photography, Museum of Contemporary Photography, and Museum of Modern Art, among many others. Lewis is married to Anne Neri Kostiner, and they have two daughters, Rickie and Tess. His Website is www.lewiskostiner.com.

• About National Fatherhood Initiative

NATIONAL FATHERHOOD INITIATIVE (NFI) is a nonprofit organization dedicated to giving America's children a brighter future by educating and engaging fathers. No other national issue is as pervasive and destructive as a father's absence, which is strongly linked to poverty, teen pregnancy, juvenile delinquency, abuse, suicide, and a host of other issues. After 1960, our nation's communities saw a fourfold increase in father-absent homes, and the effect on our nation's children and families is clear. Today, one in three children are growing up without a father—in the African American community, it is two out of every three children—and teen pregnancy, suicide, child abuse, and juvenile delinquency are more prominent than ever. NFI has been working toward a better future for children and parents since 1993 when, Don Eberly, a former White House adviser and prominent social thinker, as well as several other scholars met to discuss the growing problem of father absence in America. In 1994, Don Eberly founded National Fatherhood Initiative. Since its founding, NFI has reached millions of fathers via skill-building resources, public service announcements, NFI's Website, and other important tools and initiatives. Today, NFI is working through organizations in all fifty states to continue to give kids what they desperately need: an involved, responsible, and committed father. NFI's Website is www.fatherhood.org.

• About the Book

Choosing Fatherhood: America's Second Chance was brought to publication in an edition of 2,500 hardcover copies. The text was set in New Baskerville, the paper is Lumisilk, 170 gsm weight, and the book was professionally printed and bound in Singapore.

Editor and Publisher: George F. Thompson

Manuscript Editor: Sherri Byrand

Editorial Assistant: Carmen Rose Shenk

Proofreader: Purna Makaram

Book Design and Production: David Skolkin

Special Acknowledgment: Roland C. Warren, President, Vincent DiCaro, Vice President of Development and Communication, and Blaire Brachfield, Special Assistant to the President, National Fatherhood Initiative.

Published in 2012. First Edition.
Printed in Singapore on acid-free paper.

George F. Thompson Publishing, L.L.C.
217 Oak Ridge Circle
Staunton, VA 24401-3511, U.S.A.
www.gftbooks.com

20 19 18 17 16 15 14 13 12 1 2 3 4 5

The Library of Congress Preassigned Control Number is 2012937155.

ISBN: 978-1-938086-05-2